REMBRANDT'S CENTURY

REMBRANDT'S CENTURY

James A. Ganz

FINE ARTS MUSEUMS OF SAN FRANCISCO

DELMONICO BOOKS · PRESTEL
MUNICH LONDON NEW YORK

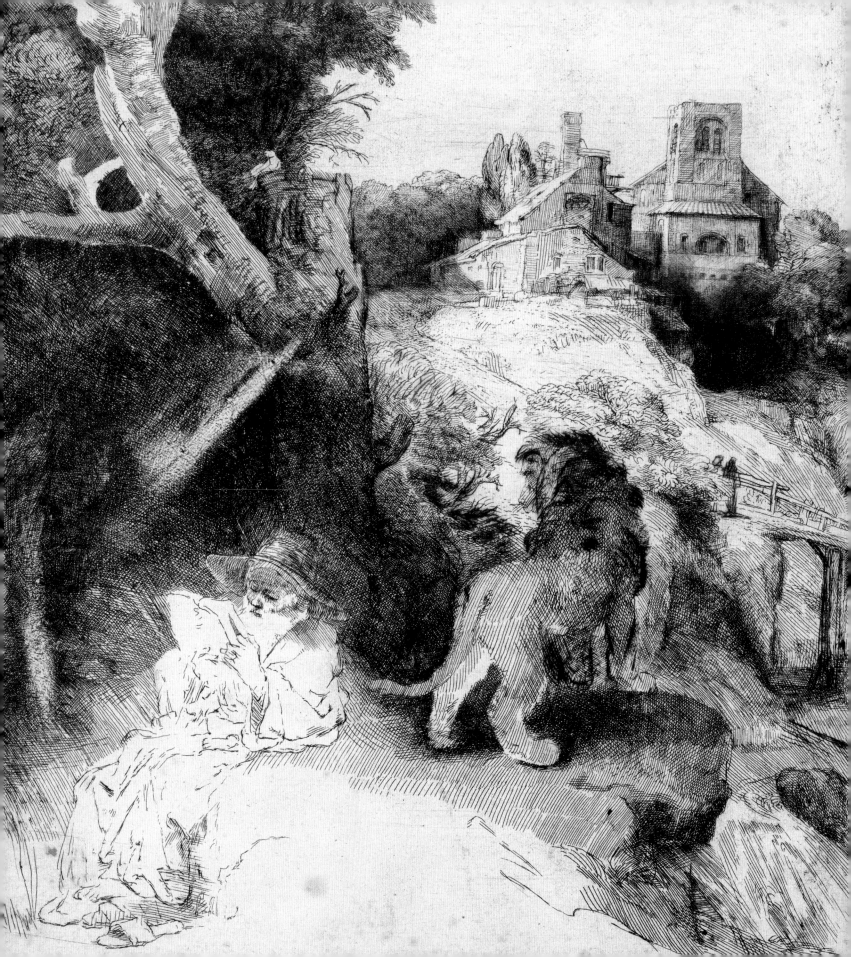

Contents

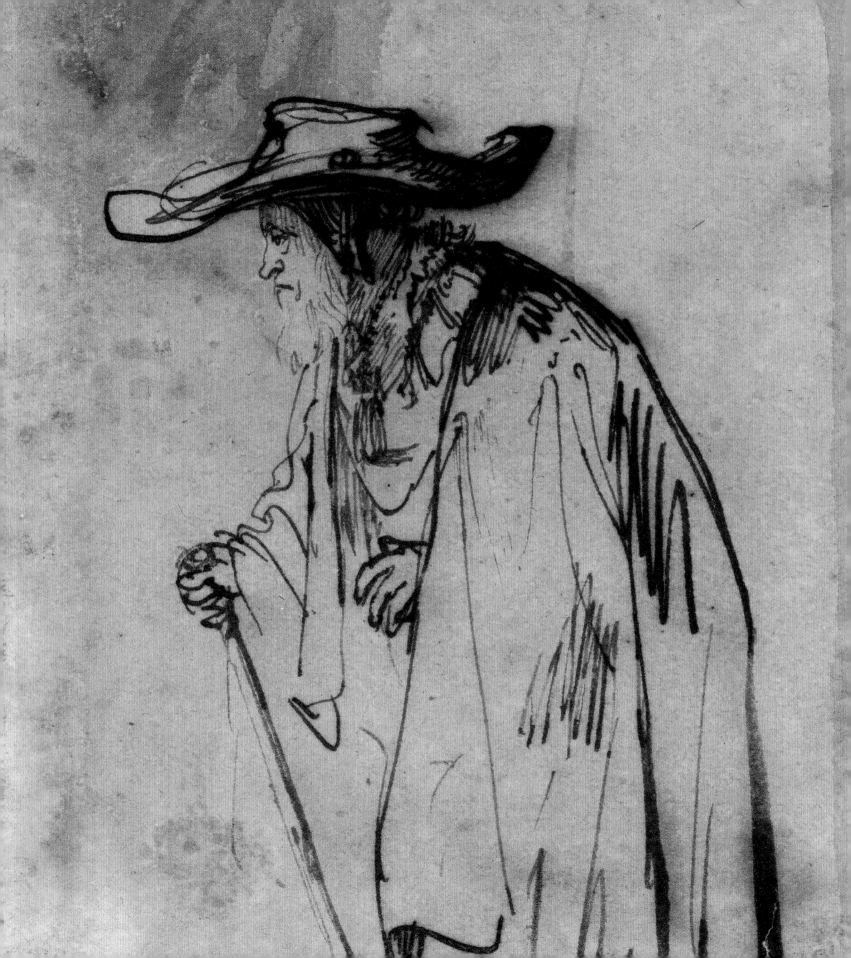

Foreword

If one were to assemble the great minds of Europe during the 1600s, embracing the century's cultural, scientific, and political luminaries, the group would form a breathtaking pantheon. Milton, Molière, Galileo, Descartes, Spinoza, Philip IV of Spain, Queen Christina of Sweden, and Louis XIV would all be present —and in their company would be Rubens, Van Dyck, Rembrandt, Vermeer, Bernini, Poussin, and Velázquez, to name only a few of the major artists of this astounding era. It was an age of splendor and brilliance, and the center of this economic and aesthetic prosperity was sometimes called the "Dutch Miracle."

In 2013, we are delighted to shine the spotlight on seventeenth-century art with two remarkable exhibitions in San Francisco. The de Young Museum is the first American venue for *Girl with a Pearl Earring: Dutch Paintings from the Mauritshuis*, a tour of works from the Royal Picture Gallery Mauritshuis, The Hague. And complementing these masterpieces, *Rembrandt's Century* showcases the important collection of works on paper in our own Achenbach Foundation for Graphic Arts that is housed in the Fine Arts Museums of San Francisco's other venue, the Legion of Honor. Its curator, Dr. James A. Ganz,

vii

FACING Rembrandt van Rijn, *Study of a Bearded Old Man with a Wide-brimmed Hat*, ca. 1633–1634, detail of fig. 32.

gives us a fascinating look into the world of baroque printmaking, with the etchings of Rembrandt van Rijn at its core. His inspired visual medley of prints and drawings includes familiar masterpieces and lesser-known gems and the introduction of exciting new acquisitions.

Of the many great collections within the Fine Arts Museums of San Francisco, the treasure trove of prints, drawings, and illustrated books assembled by Moore and Hazel Achenbach—which arrived at the Legion in 1950—is truly inspiring. It is a testament to the breadth and depth of their collection that, after countless exhibitions over the past sixty-three years, *Rembrandt's Century* features a number of Achenbach prints never before displayed. It is my pleasure to share this beautiful exhibition and catalogue with you.

Diane B. Wilsey
President, Board of Trustees
Fine Arts Museums of San Francisco

REMBRANDT'S CENTURY

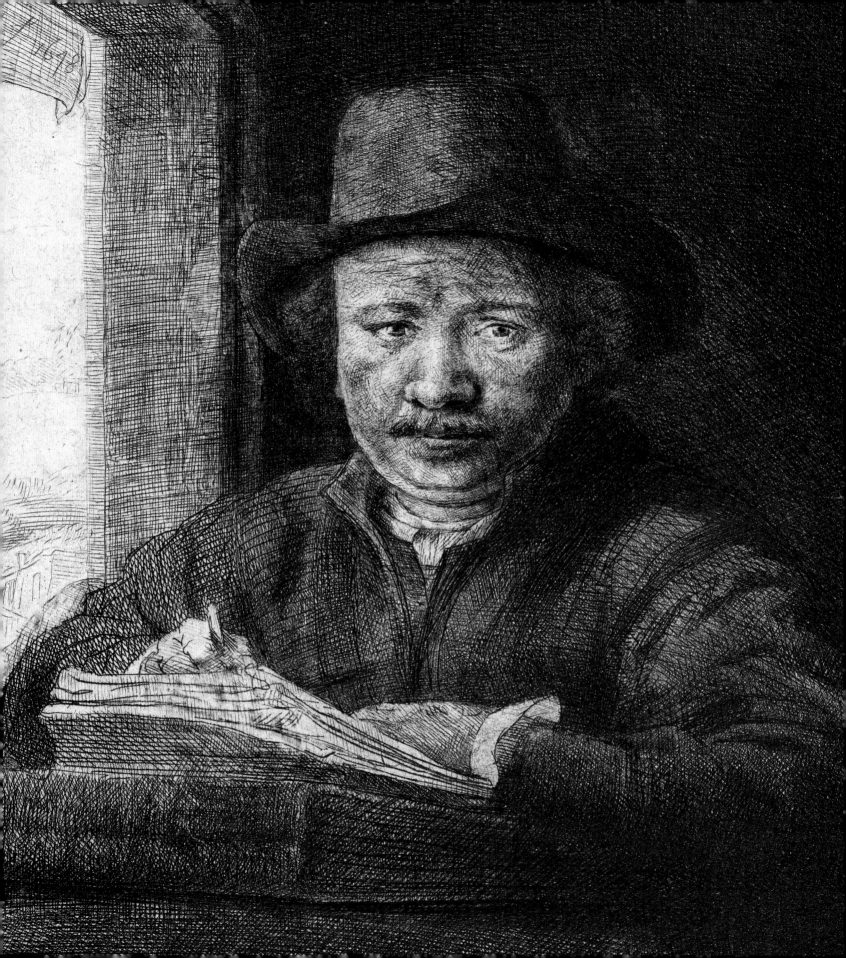

INTRODUCTION

When the monarchs of Egypt erected those stupendous masses, the pyramids, for no other use but to record their names, and by which their purpose was not answered, they little suspected that a weed growing by the Nile would one day be converted into more durable registers of fame, than quarries of marble and granite.[1]

This ingenious declaration of the supreme resilience of works of art on paper opens Horace Walpole's *Catalogue of Engravers* of 1763. Notwithstanding his confusion of paper and papyrus, two unrelated materials that developed quite independently of one another, Walpole's argument that the most mobile of multiples—prints—offers greater longevity than sculptural or architectural constructions is perfectly accurate. Unlike a painting or any singular monument that may be subject to disaster or desecration, a print edition benefits from the simple truth that there is strength in numbers. Indeed, it is entirely conceivable that within a month of production, an edition of fifty engravings might be dispersed among every major population center in Europe. Further, a printing matrix such as a copper plate or woodblock could travel easily from one place to another, allowing several editions to be printed in different locations. In a sense, the print publishing industry functioned as a virtual information superhighway long before the invention of modern communication technologies. Writing in the pre-Internet era of the 1950s, Metropolitan Museum of Art curator William M. Ivins, Jr., co-opted

FACING Rembrandt van Rijn, *Self-Portrait Drawing at a Window*, 1648, detail of fig. 10.

1

the evocative phrase "net of rationality" from the field of geometry to describe the lingua franca of engraving that had evolved into a highly refined international style of professional reproductive printmaking by the middle of Rembrandt's century.[2]

More than any other fine objects, prints circulated extensively throughout the seventeenth-century art world, broadcasting artistic, political, and scientific developments far and wide. Besides Florence, Venice, and Rome, the imperial court of Rudolf II at Prague and the cities of Antwerp and Haarlem were among the most important centers of printmaking around 1600. In due course, Paris would emerge as a leader in artistic production and the primary market for prints under the celebrated "Sun King" Louis XIV. But prior to the Anglo-French invasion of the Republic of the Seven United Provinces in 1672, during the period coinciding with the career of Rembrandt van Rijn (1606–1669), a Dutch "Golden Age" was fueled by the rapidly expanding economy of the Northern Netherlands and a growing population with disposable income. In the wake of the Dutch Republic's split from the Catholic Southern Netherlands, an influx of Flemish manufacturers, merchants, craftsmen, and artists poured into a number of cities in the most prosperous province of Holland. Amsterdam, Leiden, Haarlem, Delft, The Hague, and Utrecht soon emerged as important capitals of art and commerce.[3] And from tulips to seashells, prints to paintings, collecting became the Dutch national pastime, if not obsession.

Among the most vigorously collected and studied artistic products of the Dutch Golden Age, Rembrandt's etchings are the focus of this collection of seventeenth-century works on paper. Although weighted toward the Dutch and Flemish schools, this survey also incorporates a selection of prints and drawings produced in Italy, France, and England from the 1590s to circa 1700. In a series of thematic sections, Rembrandt's works are presented in the context of the exceptionally rich print culture of the late mannerist and baroque eras.

Rembrandt was exposed to a progressive culture of books and prints from a young age. His birthplace of Leiden was a center of humanistic scholarship and home to the oldest university in the Netherlands. After attending the local Latin School, Rembrandt was briefly enrolled at the university before he withdrew at age fifteen to study painting, first with Jacob von Swanenbergh in Leiden, and subsequently with the history painter Pieter Lastman in Amsterdam. His career took off back in Leiden in the mid-1620s when he worked in proximity to Jan Lievens, a prodigious young artist who also had apprenticed with Lastman. As his commissions and reputation quickly grew, Rembrandt began to take on his own students.

Rembrandt moved his workshop to Amsterdam in 1631 and within two years was engaged to Saskia van Ulyenburgh, the first cousin of a painter and art dealer (fig. 1). She became a favorite model and gave birth to four children before her premature death in 1642. Only Titus, a son born in 1641, survived to adulthood. Rembrandt's romantic involvement with Titus's nursemaid, Geertje Dircx, ended in an acrimonious breakup that incited on one side, the mistress's claim for alimony, and on the other, the artist's scheme to have her committed. He eventually settled down with his young maid Hendrickje Stoffels, though he could not marry her without jeopardizing a trust left by Saskia for his son.

The artist's personal life was marked not only by amorous entanglements but also by a failure to live within his means that contributed to his declaration of insolvency in 1656.[4] Rembrandt's financial distress coincided with a period of general economic hardship in Holland following the First Anglo-Dutch War. A detailed inventory of his assets, including an extensive art collection,

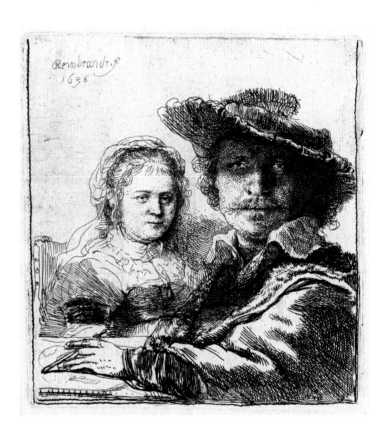

FIG. 1. Rembrandt van Rijn, *Self-Portrait with Saskia*, 1636. Etching, 10.6 × 9.4 cm (4³⁄₁₆ × 3¹¹⁄₁₆ in.).

preceded a series of public auctions to benefit his creditors. The inventory has been a boon to Rembrandt scholars, revealing the breadth of his taste for the old masters as well as the art of his own time. His large print cabinet held works by and after many of the artists represented in this volume, including Hendrick Goltzius, Anthony van Dyck, Peter Paul Rubens, Wenceslaus Hollar, Jacques Callot, and Jusepe de Ribera.

Rembrandt had prospered in his early years as a fashionable painter of portraits as well as biblical and mythological subjects, and his repertoire later expanded to include landscapes. Eventually his paintings fell out of fashion, and rather than change with the times, he continued to pour his energy into intensely personal works that would find acceptance only after his death. His activity as an etcher began in the mid-1620s and extended throughout his career; he made close to three hundred prints in all. Painters such as Rembrandt and Van Dyck (fig. 2) generally favored the medium of etching, the technique of scratching a design through a wax ground and then using an acid solution to bite the lines into the exposed areas of a copper plate. If engraving is tantamount to sculpting in metal on a miniscule scale, etching, at its most basic level, is closer to drawing.

Unlike Rubens, who tried his hand at etching on perhaps only one occasion (fig. 3) but collaborated extensively with reproductive printmakers such as Christoffel Jegher (fig. 4), Rembrandt exploited etching as a medium for original expression and as an independent art form; rarely do his etchings reproduce his paintings. As a technician he developed into a true maverick, freely experimenting at every stage of the process.[5] Rembrandt's etchings spread his influence well beyond his immediate students and cut across geographical and cultural borders to inspire generations of artists and art lovers.

NOTES

1. Horace Walpole and George Vertue, *A Catalogue of Engravers, Who Have Been Born, or Resided in England* (Twickenham, UK: Strawberry Hill [Horace Walpole], 1763), 1.
2. William M. Ivins, Jr., *Prints and Visual Communication* (Cambridge, Massachusetts: Harvard University Press, 1953), 70.

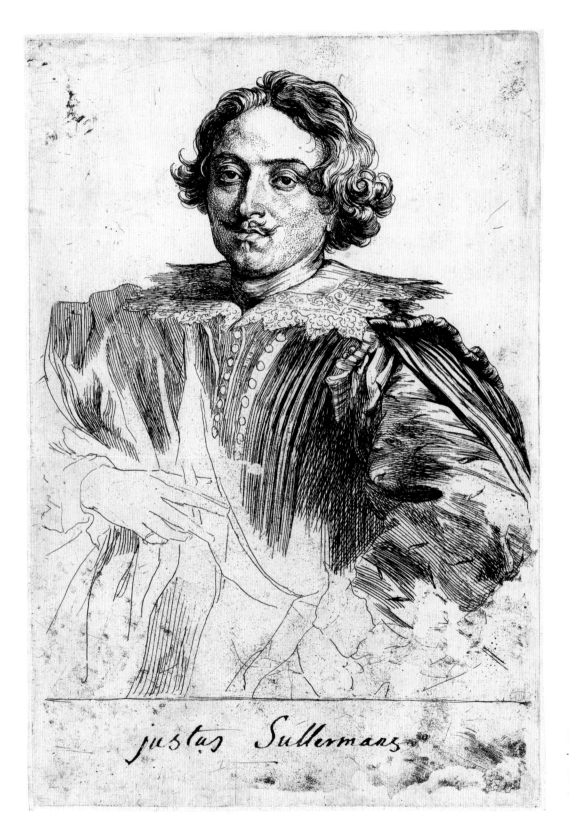

FIG. 2. Anthony van Dyck,
Justus Sustermans, from
The Iconography, ca. 1630–1632.
Etching, 25.1 × 16.7 cm
(9⅞ × 6⅜₆ in.).

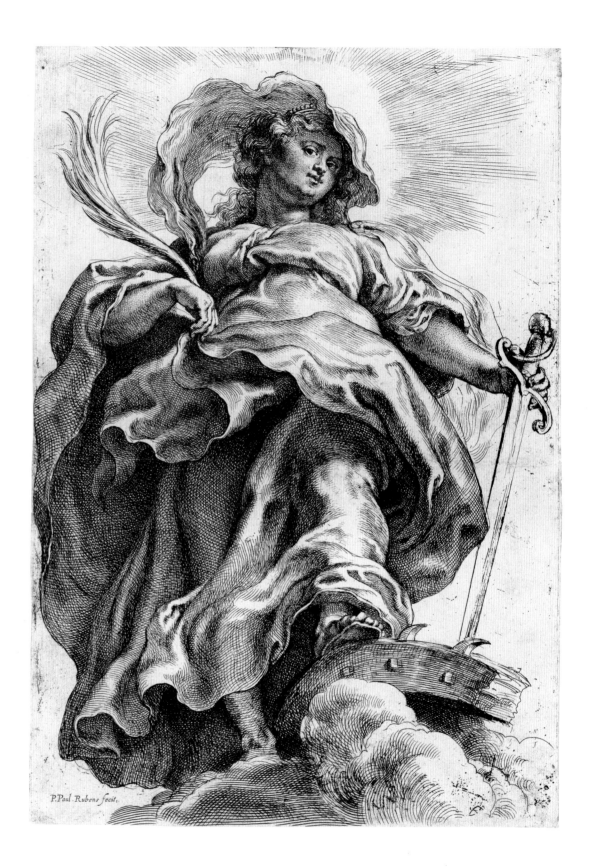

FIG. 3. Peter Paul Rubens,
Saint Catherine in the Clouds,
ca. 1625–1630. Etching,
29.4 × 19.9 cm (11⁹⁄₁₆ × 7¹³⁄₁₆ in.).

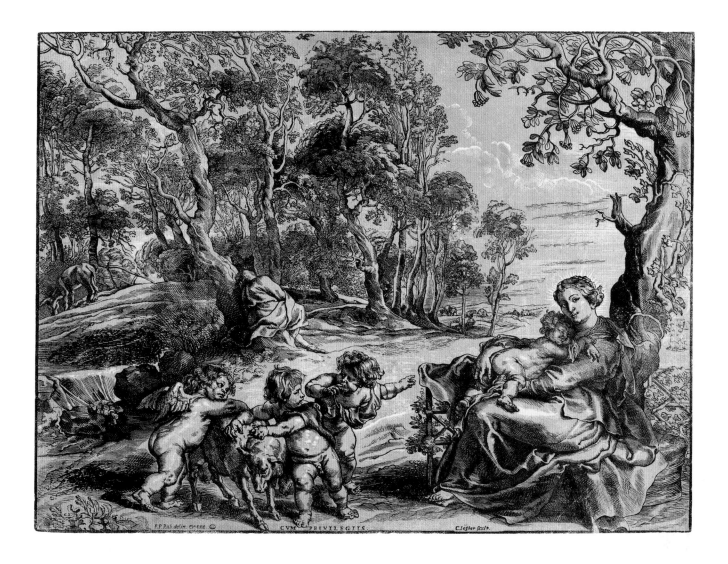

3. An overview of this period in Dutch art may be found in Ger Luijten et al., ed., *Dawn of the Golden Age: Northern Netherlandish Art, 1580–1620*, exh. cat. (Zwolle, Netherlands: Waanders Publishers; Amsterdam: Rijksmuseum, 1993).

4. See Paul Crenshaw, *Rembrandt's Bankruptcy: The Artist, His Patrons, and the Art Market in Seventeenth-Century Netherlands* (New York: Cambridge University Press, 2006).

5. For an outstanding recent discussion of Rembrandt's etching techniques, see Thomas E. Rassieur, "Looking Over Rembrandt's Shoulder: The Printmaker at Work," in Clifford S. Ackley, *Rembrandt's Journey: Painter, Draftsman, Etcher*, exh. cat. (Boston: MFA Publications, 2003), 45–60.

FIG. 4. Christoffel Jegher after Peter Paul Rubens, *The Rest on the Flight into Egypt*, 1633–1636. Chiaroscuro woodcut, 45.5 × 59.9 cm (17¹⁵⁄₁₆ × 23⁹⁄₁₆ in.).

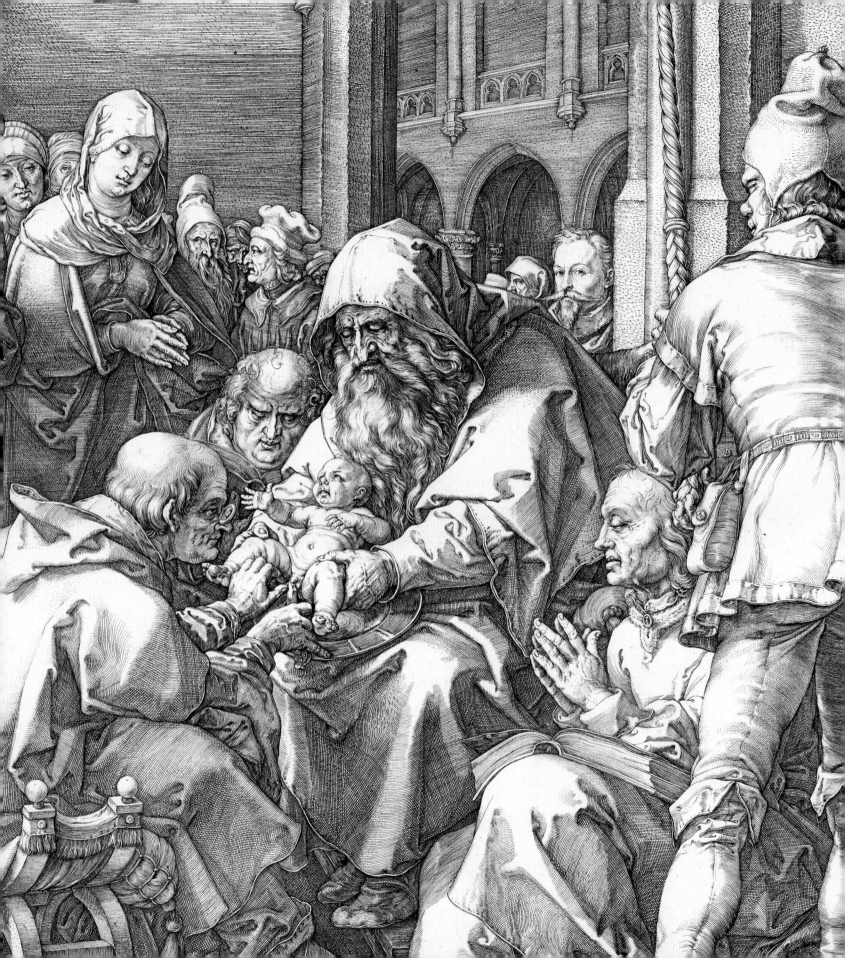

THE ARTIST IS PRESENT

Hendrick Goltzius was the preeminent Dutch printmaker at the dawn of Rembrandt's century. In one of his final performances as an engraver, the supremely self-confident artist applied his unrivaled skills of invention and emulation to a series of six engravings representing scenes from the early life of the Virgin. Of these, *The Circumcision* is the most audacious in the way that it at once sets up and tears down a spectacular illusion (fig. 5). Goltzius challenged himself to design and engrave this scene so convincingly in the manner of Albrecht Dürer (1471–1528) that it might be mistaken for an actual work by the German Renaissance master. Weaving together a dense arrangement of figures in the illusionistic space of a Haarlem church, he centers the action on the surgical ritual that was thought to foreshadow the Crucifixion. But not all eyes are focused on the main event. An interloper peers into the side chapel from the nave, looking past the hulking figure who holds the Infant Christ and effectively breaking the fourth wall of the scene. His stylish mustache and goatee set him apart, and indeed would have appeared startlingly modern to a contemporary viewer. The incongruent figure is none other than the engraver himself.

9

FACING Hendrick Goltzius, *The Circumcision*, from the series *The Life of the Virgin*, 1594, detail of fig. 5.

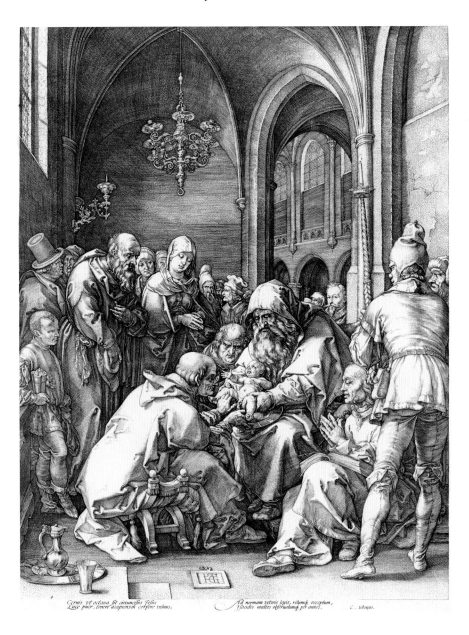

FIG. 5. Hendrick Goltzius,
The Circumcision, from the series *The
Life of the Virgin*, 1594. Engraving,
47.8 × 35.3 cm (18¹³⁄₁₆ × 13⅞ in.).

In Renaissance and baroque painting, the inclusion of a recognizable individual as a witness to a sacred scene was hardly unusual—painters from Dürer to Rembrandt occasionally even cast themselves in this role. This practice, however, is uncommon in the history of prints. According to Goltzius's friend and biographer Karel van Mander, the artist's cameo appearance was part of a scheme to prove his superiority to print connoisseurs who favored the "old masters" like Dürer. Goltzius supposedly altered several impressions by blacking out his image and monogram, and soiling and crumpling the paper to impart the patina of age. "This print then, arriving thus disguised and masked in Rome, Venice, Amsterdam and also elsewhere, was eagerly seen with great admiration and pleasure by artists and art lovers who had knowledge of these things, and was also bought at a high price by some who were happy that they had been able to obtain such a piece," wrote Van Mander.[1] Goltzius's objective was not to profit from a forgery but to demonstrate his virtuosity. To that end, "when then, after many rumors and much claptrap, the print was shown and came before the eyes of these people in its entirety and freshly printed, they stood (as the saying goes) with egg on their faces and were ashamed and bewildered for their being so cocky."[2] This episode illustrates how artists may see themselves in competition

not only with their contemporaries but also with artists of previous genera-
tions. In the print world such rivalries could have greater urgency, since plates
or blocks from earlier centuries might continue to be reprinted long after their
creators' demise, keeping the market alive for new impressions by old masters.

The turn of the seventeenth century marked a professional midlife
crisis for Goltzius, who thereafter abandoned printmaking to reinvent
himself as a painter. At around this time his former apprentice Jan Saenredam
reproduced his complex design of a painter and model (fig. 6). Every aspect
of this production bespeaks the erudition of the Dutch mannerists, from
the idealized nude to the academic subtext (a dual allegory of the sense of
sight and the art of painting), the Latin inscription (*Hæc memini nocuisse atque
oblectasse videntes*: "I recall from experience that this offers the viewer both
pain and pleasure"), and the meticulous engraving technique.[3] After Saen-
redam created the plate around 1600, it passed through at least two publish-
ers and continued to be reprinted even after the deaths of both designer and
engraver. The demand from serious collectors for prints by and after Goltzius
lasted well into the seventeenth century, and according to the inventory
of his large collection upon his bankruptcy in 1656, Rembrandt was one
such enthusiast.[4]

One of the most remarkable variations on this theme is found in Rem-
brandt's unfinished etching of *The Artist Drawing from a Model* (fig. 7), dating
from around 1639. That the artist is meant as a self-portrait is uncertain, but
Rembrandt asserts his presence in this unsigned work by revealing his dis-
tinctive draftsmanship. Although he etched the background to completion,
he left exposed the drypoint lines that he had quickly scratched into the bare
copper plate to set down the essential outlines. Why Rembrandt abandoned
the etching is unknown, but the fact that he sold impressions from the plate
suggests that he recognized the curious potency of the *non-finito*.[5] Perhaps he
was consciously following the precedent of Goltzius, who left two incomplete
engravings that were published posthumously and esteemed by collectors
in Rembrandt's time.[6] In addition, certain portrait etchings by Van Dyck

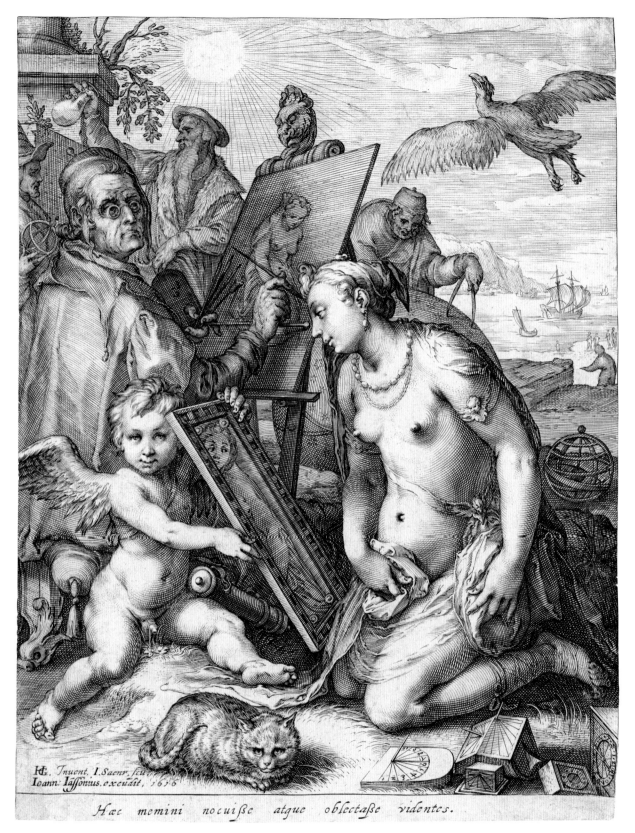

HE. *Inuent, I. Saenr, scu.*
Ioann: *Iaßonius. exeuđit, 1616.*

Hæc memini nocuißc atque oblectaße videntes.

FIG. 6 (*left*). Jan Saenredam after Hendrick Goltzius, *Allegory of Sight and of the Art of Painting (An Artist and His Model)*, ca. 1598–1601 (published 1616). Engraving, 24.1 × 18 cm (9½ × 7¹⁄₁₆ in.).

FIG. 7 (*facing*). Rembrandt van Rijn, *The Artist Drawing from a Model*, ca. 1639. Etching, drypoint, and engraving, 23.3 × 18 cm (9³⁄₁₆ × 7¹⁄₁₆ in.).

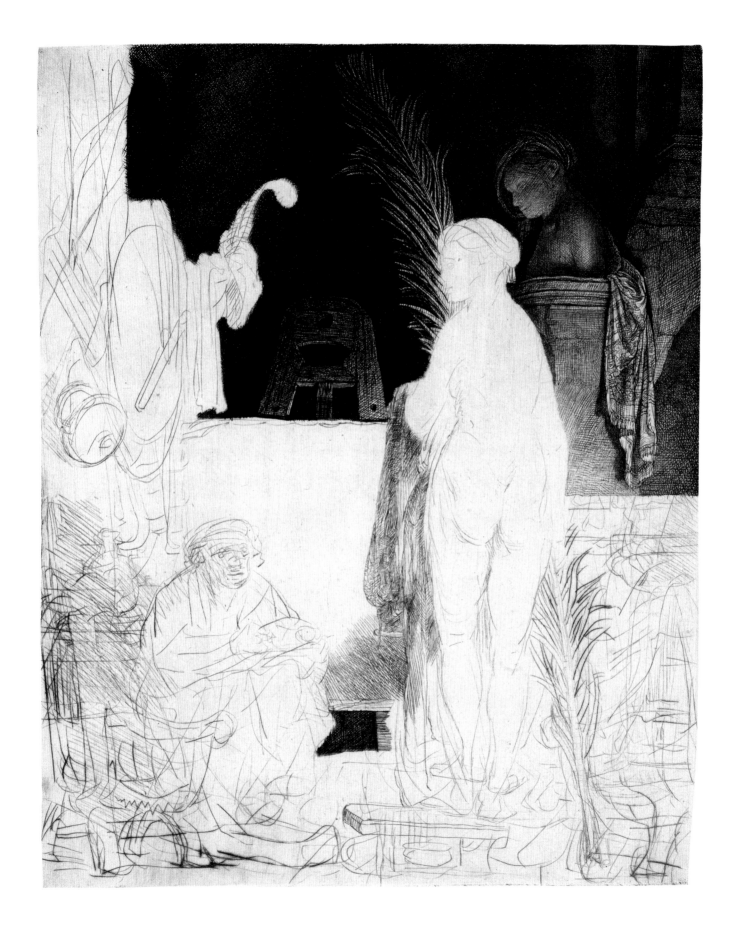

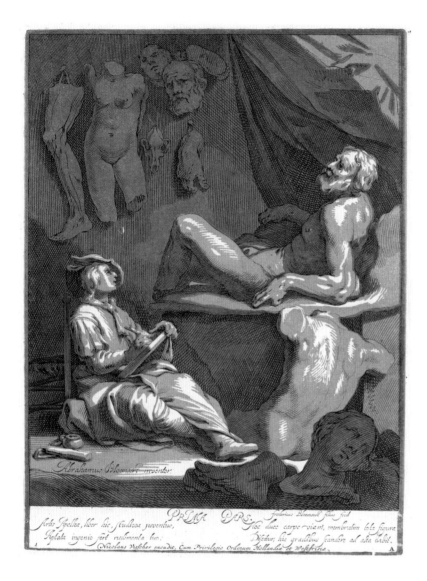

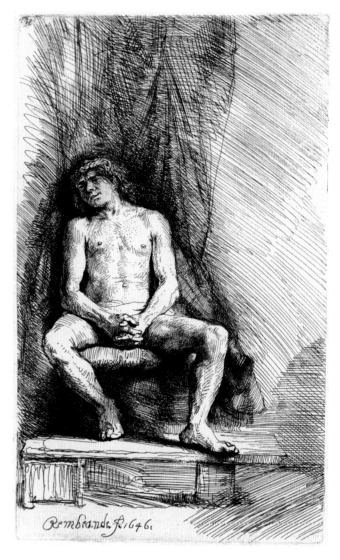

FIG. 8 (*above left*). Frederick Bloemaert after Abraham Bloemaert, *Student Drawing from a Cast*, title page for the *Tekenboek (Drawing Book) of Abraham Bloemaert*, 1650 (1740 edition). Engraving and chiaroscuro woodcut, 30.5 × 22.3 cm (12 × 8¾ in.).

FIG. 9 (*above right*). Rembrandt van Rijn, *Nude Youth Seated Before a Curtain*, 1646. Etching, 16.4 × 9.6 cm (6⁷⁄₁₆ × 3¾ in.).

(see fig. 2) that freely juxtaposed finished and unfinished passages may have provided more recent creative stimuli.

Rembrandt's print is fundamentally about drawing, the most basic aspect of every artist's education. Frederick Bloemaert's *Student Drawing from a Cast* (fig. 8) and Rembrandt's own *Nude Youth Seated Before a Curtain* (fig. 9) reveal progressive stages in the training process. Representing a contemporary student sketching plaster casts of ancient sculptures, Bloemaert's print served as the frontispiece to his father Abraham's illustrated drawing manual (*Tekenboek*).

The Latin inscription reads, "This book, studious youths, brings to your mind the appropriate rudiments of the art of Apelles; follow the road with this guide, learn piece by piece the whole figure, climbing these steps leads to the height."[7] The first step begins not with classical statuary or even modern casts, but with Bloemaert's printed anthology of body parts, faces, and figures, offered without text for the new student to analyze and copy.

Tantalizing glimpses behind the closed doors of Rembrandt's workshop are revealed in a small group of related studies by the artist and several of his pupils from around 1646 that all portray a distinctive physical specimen: a skinny, shaggy-haired young man who alternately sits, stands, and reclines on the studio floor. While his apprentices made pen-and-wash drawings of this model, Rembrandt produced three etchings that capture his varying poses. These prints may have been intended as illustrations for an informal drawing manual for use within his workshop.[8]

At no point in his career was Rembrandt at a loss for a live model, for his most reliable subject could always be found staring back at him in the mirror. He made more self-portraits than any of his contemporaries, in this way documenting his changing moods, emotions, and lifestyles, along with his aging process from the 1620s until his death in 1669 (see fig. 1; fig. 10). Rembrandt's talent in portraiture combined with his apparent vanity yielded an extraordinary pictorial auto-biography. While two-dimensional works of art generally only offer the illusion of depth, Rembrandt's many self-portraits provide pathways into his psychological state. His gaze traverses

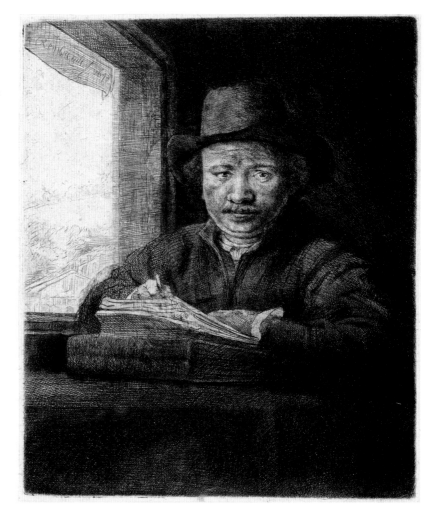

FIG. 10. Rembrandt van Rijn, *Self-Portrait Drawing at a Window*, 1648. Etching, drypoint, and engraving, 15.7 × 12.9 cm (6³⁄₁₆ × 5¹⁄₁₆ in.).

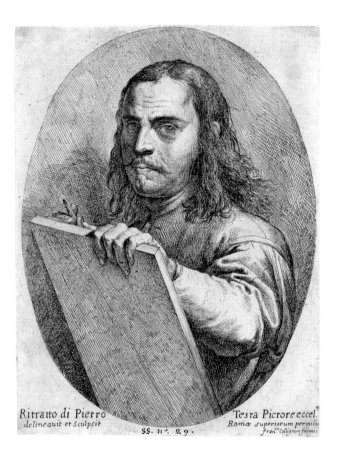

Ritratto di Pietro
delineauit et Sculpsit

Testa Pictore eccel.
Romæ .superiorum permisu
Fran.ᵃ Collignon formis

SS. nᵒ. 29.

MICHAEL MIREVELT, DELPHENSIS
PICTOR.

Pingendo ad vivum quo non præstantior alter:
Delphicus hinc Zeuxis dicitur esse novus.
Principibus magnis fuit invitatus: at ipsum
Ante alias urbes patria culta tenet.

Cum privilegio.

FIG. 11 *(above left)*. Pietro Testa, *Self-Portrait*, ca. 1645. Etching, 22.2 × 16.6 cm (8¾ × 6⁹⁄₁₆ in.).

FIG. 12 *(above right)*. Attributed to Simon Frisius, *Michiel van Mierevelt*, from *Pictorum aliquot celebrium praecipuae Germaniae Inferioris effigies* (*Effigies of Some Celebrated Painters, Chiefly of Lower Germany*), 1610. Etching and engraving, 20.5 × 12.5 cm (8¹⁄₁₆ × 4¹⁵⁄₁₆ in.).

the centuries to foster a different kind of illusion: that the artist is present. Rembrandt's directness is echoed in the single etched self-portrait by the Roman graphic artist Pietro Testa (fig. 11), in which he makes eye contact with the viewer while revealing himself in the act of drawing.

Within the vast and varied field of seventeenth-century portraiture, representations of artists of the past and present have always held a particular fascination for print collectors. Publishers like The Hague–based Hendrick Hondius the Elder exploited the demand for such images and issued large sets of engraved and etched artist portraits that could be collected as individual sheets or bound into albums. His *Pictorum aliquot celebrium praecipuae Germaniae Inferioris effigies* (*Effigies of Some Celebrated Painters, Chiefly of Lower Germany*) of

1610 consists of sixty-eight artist portraits—twenty-two derived from an earlier series published by Hieronymus Cock, and the rest, including that of the Delft portrait painter Michiel van Mierevelt (fig. 12), newly designed from scratch.[9] The format of this print, with the artist occupying a shallow space before a window opening onto a landscape, is typical of the series; the Latin inscription below reads: "Michiel van Mierevelt of Delft, painter. No one was more eminent in painting in lifelike manner. Therefore the man of Delft was said to be the new Zeuxis. He was invited by great princes: but his honored fatherland held him more than other cities."[10] Van Mierevelt's workshop, likened to a portrait factory because of its immense output, propagated images of many prominent Dutch citizens. The artist proudly holds his portrait of Maurits van Nassau, the stadtholder of the United Provinces, and his most important patron.[11]

The Flemish painter-etcher Sir Anthony van Dyck's famous series of portraits known as *The Iconography* held a special place in the print collections of artists and art lovers alike. Van Dyck expended significant effort on this project during the first half of the 1630s, but he increasingly redirected his energy to other more lucrative endeavors thereafter and left *The Iconography* unfinished at the time of his death in 1641.[12] In his early years he learned how to etch and created a handful of plates—such as the portrait of the Flemish painter Justus Sustermans (see fig. 2)—that exhibit great vigor and energy, as well as technical shortcomings resulting from his relative inexperience with the medium. Some of the prints, like his lively etched portrait of Lucas Vorsterman (fig. 13), were completed by reproductive engravers, while others were executed entirely by such professionals as

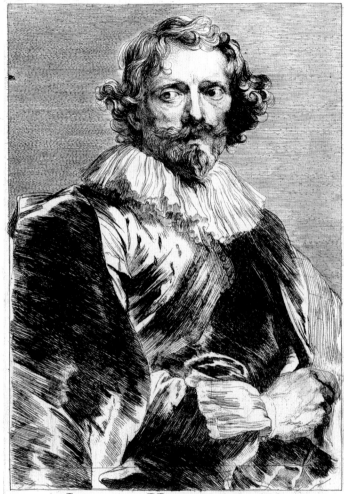

LVCAS VORSTERMANS
CALCOGRAPHVS ANTVERPIÆ IN GELDRIA NATVS.

Ant. van Dyck fecit aqua forti. *G.H.*

FIG. 13. Anthony van Dyck and anonymous engraver, *Lucas Vorsterman*, from *The Iconography*, ca. 1630–1632. Etching and engraving, 24.5 × 16.9 cm (9⅝ × 6⅝ in.).

Graueurs en taille douce au Burin et a Leaue forte

*Celuy au Burin estand vmment, vn peu de Cire blanche sur le Coste poly de saplanche chaude, frotte le derriere de son dessein comune de Ceruse en sorte qu'il ne blanchisse que peu, lattache fixe sur saplanche presse d'une pointe asses fort les Contours de ses figures, et, ils se trouuent estant le dessein merquce de blanc sur la Cire et repassant sad pointe sur lesd Contours les empraint dans le Cuiure. puis il en oste la Cire sur le feu cela fait il grauue auec le burin. Celuy a leslie sorte asa planche bien polie, et vn peu chaude il y met vn verny dont celuy quon tient le meilleur est Composé de rasine poix Gresque Cuittes auec huille de noix il laplicque auec le doigt lestend de la paulme de la main le noircit a la sumce de la chandelle puis met laplanche sur vn seu de Charbons ardans iusque a ce quelle ne sumé que peu lors il iette de leaue derriere la planche apres cela son dessein estans frotte de sanguine au derriere il en marque les Contours sur son verny comme le Graueur au burin et trace apres tout son ouurag auec des pointes dacier dur. apuyant fort cela legerem selon la grosseur et profondeur qui veut donner a traitz, puis ayant frotte le derriere de saplanche auec du suif il la met en vn lieu pinchant iette leaue forte dessus aplas *reprises a Cause des douceurs et Essoiguemc quil Couure de tems en tems d'huille doliue et suif fondu ensemble cela fait il essuye la planche en oste le verny auec Charbon doux mouille leaue Comune et retouche au burin ou il est necess cette eaue forte est composee vinaigre vert de gris solarmoniac et Comun. brayez et peu bouilles ensemble en vn pot plombé fait alenne forte par Bosse a Paris in Lisle du palais lan 1643 auec priuilege*

FIG. 14. Abraham Bosse, *The Engraver and the Etcher*, 1643. Etching, 25.9 × 32.3 cm (10³⁄₁₆ × 12¹¹⁄₁₆ in.).

Vorsterman, Paulus Pontius, and Pieter de Jode II (see fig. 23). These men made handsome livings reproducing the designs of Van Dyck and Rubens, and the appearance of the debonair Vorsterman and several others of his ilk in *The Iconography* testifies to the fame that the best reproductive engravers could achieve.

In France, the influential artist Abraham Bosse created an extraordinary pair of etchings that ostensibly reveal the inner workings of a print publishing establishment (figs. 14 and 15). *The Engraver and the Etcher* features two artisans in the foreground, an etcher at left and an engraver at right, each seated facing a window and industriously working to reproduce a drawing. Their imaginary

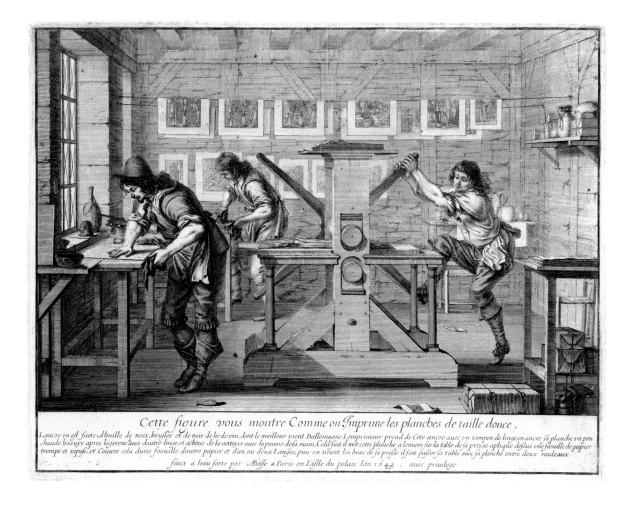

Cette figure vous montre Comme on Imprime les planches de taille douce,

Lancre en est faite d'huille de noix, bruslée et de noir de lie de vin, dont le meilleur vient Dallemagne, L'imprimeur prend de Cete ancre auec vn tampon de linge, en ancre sa planche vn peu
chaude, lessuye apres legerem/auec dautre linge, et acheue de la nettoyer auec la paume de sa main. Cela fait il met cette planche a lenuers sur la table de sa presse, aplique dessus vne foeuille de papier
trempe et reposé, et Coiure cela d'une foeuille d'autre papier et d'un ou deux Langes, puis en tirant les bras de sa presse il fait passer sa table auec sa planche entre deux rouleaux

faict a l'eau forte par Bosse a Paris en L'Isle du palais l'an 1642, auec priuilege

workspace doubles as a showroom. In the background, three prospective
customers peruse the offerings pinned to the wall. *The Intaglio Printers* depicts
three workers in the strenuous process of churning out prints on a large roller
press. Finished impressions hang above their heads, drying on suspended cords.
Didactic inscriptions below each of these images clearly elucidate the tools
and steps in the processes of etching, engraving, and printing copper plates.
Bosse went on to write a full-length treatise on etching (1645) that became
a runaway best-seller devoured by many generations of both amateur and
professional artists.

FIG. 15. Abraham Bosse,
The Intaglio Printers, 1642.
Etching, 26 × 32.7 cm
(10¼ × 12⅞ in.).

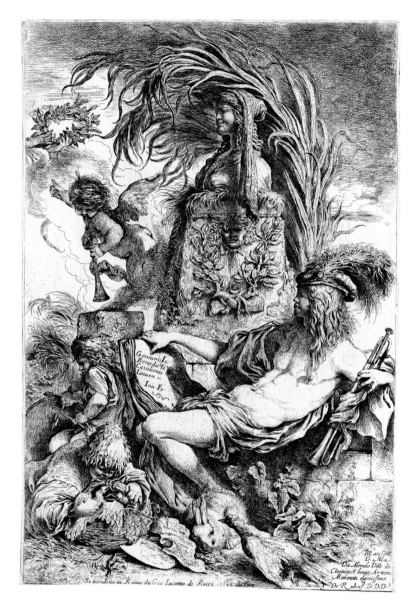

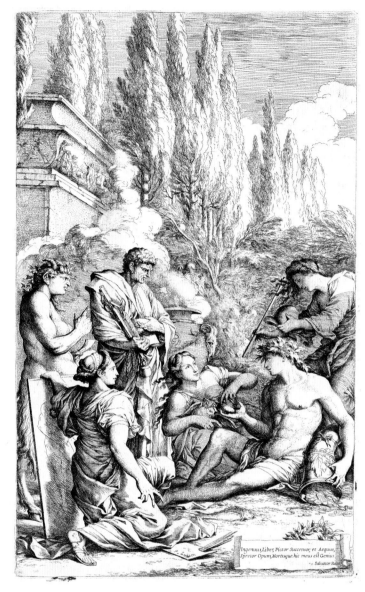

FIG. 16 (*above left*). Giovanni Benedetto
Castiglione, *The Genius of Giovanni
Benedetto Castiglione*, 1648. Etching,
36.7 × 24.7 cm (14⁷⁄₁₆ × 9¾ in.).

FIG. 17 (*above right*). Salvator Rosa,
The Genius of Salvator Rosa, ca. 1662.
Etching and drypoint, 45.9 × 27.8 cm
(18¹⁄₁₆ × 10¹⁵⁄₁₆ in.).

Bosse's prosaic etchings emphasizing the physicality of the craft as well as the division of labor within a commercial firm are far removed from the highly intellectualized representations of artistic inspiration (the "genius") by such renowned Italian painter-printmakers as Giovanni Benedetto Castiglione (fig. 16) and Salvator Rosa (fig. 17). Castiglione's "genius" takes the form of a recumbent river god surrounded by symbols of fame (trumpets), immortality (laurel wreath), productivity (birds, rabbit), learning (book), and the arts (sheet of music, paintbrushes, palette). Rosa clearly drew inspiration from Castiglione's etching for his own treatment of the theme, which places his "genius" figure in the company of personifications (left to right) of Satire, Painting, Stoic Thought, Sincerity, and Liberty. The Latin inscription on the scroll below contains the artist's credo: "Sincere, free, fiery painter, and equitable despiser of wealth and death, this is my genius—Salvator Rosa."[13]

In France, engraving was officially elevated from an industrial craft to a liberal art when King Louis XIV signed the Edict of St. Jean-de-Luz in 1660. This proclamation opened the doors of the French Royal Academy of Painting and Sculpture to professional engravers like Gérard Edelinck, a Flemish-born artist who excelled at creating meticulously detailed reproductive engravings. Edelinck was elected to the academy in 1677, the year after he made his magnificent, if mechanical, engraving of Philippe de Champaigne's self-portrait set in a landscape (fig. 18). A detail of this image appears, in reverse, at the center of an English trompe-l'oeil print medley dating from shortly after the turn of the eighteenth century, by George Bickham the Elder (fig. 19). The eclectic composition includes prints by Jacques Callot and Francis Barlow, among others, as well as a playing card and the title page from Edward Ward's novel *Sot's Paradise: or, The Humours of a Derby-Ale-House with a Satyre upon the Ale* (1699). Like Hendrick Goltzius looking out from *The Circumcision*, Champaigne seems incongruous in this setting, a phantom perhaps from another era. Still, however uneasy his appearance, it is a reminder of the virtual immortality imparted by the print medium, which allows the artist to be not merely present, but omnipresent.

Philippus de Champaigne Bruxellensis Pictor Regius, et Regiæ Pictorum Academiæ Rector : Eximiæ hujus artis excellentiâ, et christianâ pietate æque insignis

Se ipse pinxit *G. Edelink sculpsit 1676. Cum priv. R.*

FIG. 18. Gérard Edelinck after Philippe de Champaigne, *Self-Portrait of Philippe de Champaigne*, 1676. Etching and engraving, 39.6 × 33.5 cm (15⁹⁄₁₆ × 13³⁄₁₆ in.).

NOTES

1. Karel van Mander, *The Lives of the Illustrious Netherlandish and German Painters*, ed. and trans. Hessel Miedema (Doornspijk, Netherlands: Davaco Publishers, 1994), vol. 1, 397 (fol. 284v).
2. Ibid.
3. See Eric Jan Sluijter, "Venus, Visus and Pictura," in *Seductress of Sight: Studies in Dutch Art of the Golden Age*, trans. Jennifer Kilian and Katy Kist, Studies in Netherlandish Art and Cultural History, vol. 2 (Zwolle, Netherlands: Waanders Publishers, 2000), 86–159.
4. Goltzius's name appears twice in the inventory. Walter L. Strauss and Marjon van der Meulen, eds., *The Rembrandt Documents* (New York: Abaris Books, 1979), 371,

document 1656/12, fol. 34v, no. 213 ("One [book] with engraved copperplate prints of portraits by Goltzius and Muller"), and 375, fol. 35v, no. 250 ("One [book] full of prints by Frans Floris, Buytewech, Goltzius, and Abraham Bloemaert").

5. The impression illustrated here is on paper with a Strasbourg lily watermark dating to circa 1652. Erik Hinterding, *Rembrandt as an Etcher: Catalogue of Watermarks and Appendices*, trans. Michael Hoyle, Studies in Prints and Printmaking, vol. 6 (Ouderkerk aan den IJssel, Netherlands: Sound and Vision Publishers, 2006), vol. 3, 213 ("Strasbourg lily variant E'.a.b."), 292.

6. *The Massacre of the Innocents* (Strauss 206) and *The Adoration of the Shepherds* (Strauss 362).

7. Translated in Marcel Georges Roethlisberger, *Abraham Bloemaert and His Sons: Paintings and Prints* (Doornspijk, Netherlands: Davaco Publishers, 1993), vol. 1, 395.

8. Holm Bevers, "Drawing in Rembrandt's Workshop," in Holm Bevers, Lee Hendrix, William W. Robinson, and Peter Schatborn, *Drawings by Rembrandt and His Pupils: Telling the Difference*, exh. cat. (Los Angeles: The J. Paul Getty Museum, 2009), 10–19.

9. The complete series is reproduced and discussed at www.courtauld.org.uk/netherlandishcanon/.

10. Translation from www.courtauld.org.uk/netherlandishcanon/image-tombstone/59.html. "In lifelike manner" may be alternatively translated as "from life."

11. See Rudi Ekkart, *De portretfabriek van Michiel van Miereveld (1566–1641)*, exh. cat. (Delft: Museum Het Prinsenhof, 2011).

12. The best account of the complicated history of *The Iconography* is given by Joaneath A. Spicer in her essay "Anthony van Dyck's *Iconography*: An Overview of Its Preparation," in *Van Dyck 350*, ed. Susan J. Barnes and Arthur K. Wheelock, Jr., Studies in the History of Art 46, Center for Advanced Study in the Visual Arts, Symposium Papers 26 (Washington, DC: National Gallery of Art, 1994), 327–364.

13. The Castiglione and Rosa etchings are discussed in James Clifton, *A Portrait of the Artist, 1525–1825: Prints from the Collection of the Sarah Campbell Blaffer Foundation*, exh. cat. (Houston: Museum of Fine Arts, 2005), 175–180. The translation of the Latin inscription on Rosa's *Genius* derives from Richard W. Wallace, "The Genius of Salvator Rosa," *The Art Bulletin* 47 (December 1965): 474.

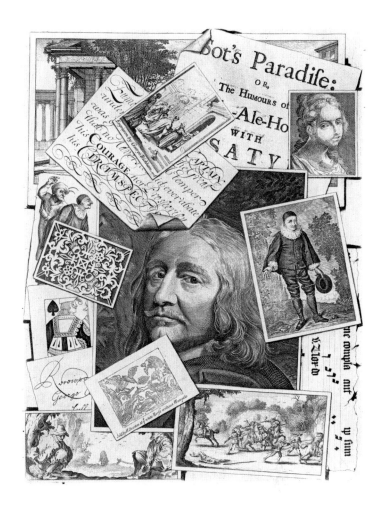

FIG. 19. George Bickham the Elder, *Sot's Paradise*, 1707. Etching and engraving, 29.2 × 21.8 cm (11½ × 8⁹⁄₁₆ in.).

PORTRAITURE

Faces and Formulas

God's handiwork, which I can visit, own and see:
I need no copy of it from a human hand.
However, there's one part of painter's art can please me:
That piece which lays its hand to slow the wheel of time,
And places the grandfather of my father's sire
Now in my sight, as if he lived today or yesterday
And allows the children of my grandchildren to inherit
The countenance that goes with me to death and to decay.
Is painter's skill not more the master than is time?
Yes, it preserves in oil these perishable things.

—*Constantijn Huygens, "Again on Painting," February 13, 1656*[1]

The transcription of a likeness . . . the capture of expression . . . the record of personality . . . the drawing of a face: a portrait is the pictorial artifact of a meeting of two minds, an intimate encounter between artist and sitter that offers a form of immortality to both. Is there any more direct application of an artist's talents of observation, analysis, and description? And yet portraiture, more than any other category of painting, sculpture, or printmaking, became susceptible during the seventeenth century to increasingly repetitive formulas and conventions. To meet an explosion in demand, the genre had by Rembrandt's day transcended its status as a specialty within the rapidly expanding art market to become an industry unto itself.

FACING Pieter de Jode II after Anthony van Dyck, *Adam de Coster*, from *The Iconography*, ca. 1635, detail of fig. 26.

Within this industry, the most crucial aspect of a portrait—the accurate delineation of the subject's facial features—was the only ingredient that could not easily be outsourced. Every other element, from its decorative framework, background, and props to the sitter's torso and hands, could be delegated by a painter to his workshop, or by a print publisher to a team of professional engravers. Any of these components could be recycled. As an extreme short-cut, it was not implausible for a face to be repainted or re-engraved, with the balance of the composition left intact. Another trick of the print trade was to simply revise the lettering that named the sitter, altering his or her identity with a few quick strokes of the burin.

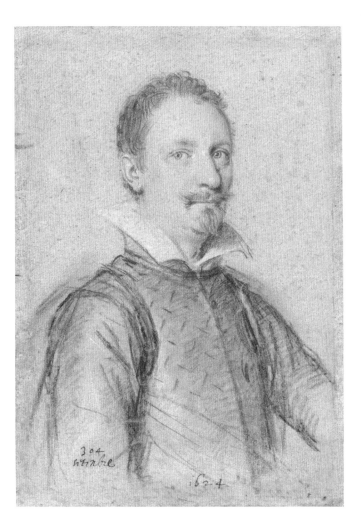

FIG. 20. Ottavio Leoni, *Francesco Centurione*, 1624. Black, red, and white chalks on blue paper, 23.7 × 16.2 cm (9⁵⁄₁₆ × 6⅜ in.).

In the early decades of the century, one of the most influential tastemakers in this field was the Italian court artist Ottavio Leoni. "In all Rome there was no one who did not have his portrait by Ottavio—whether prince, princess, gentleman, gentlewoman, or person of private rank—and not a house in which some portrait from the hand of the *Cavaliere* was not to be seen"; so wrote Giovanni Baglione in his *Lives of the Artists* (1642).[2] Of Leoni's drawings, Baglione noted, "the greater part of these are in black pencil on turquoise paper with skillful touches of (white) chalk; they have great verisimilitude, and some are touched with red pencil, so that they appear colored and made of flesh." He concluded, "They are so natural and alive, that in that genre no one could do better."[3] Leoni's sensitive *trois crayon* portrait of don Francesco Centurione on faded blue paper (fig. 20) typifies the selective finish of his drawings made from life, with the greatest attention concentrated on the eyes and progressively less detail approaching the outer reaches of the sheet. The work is dated September 1624 and inscribed with a numeral (304) that places it in a long sequence of drawings begun in January 1615 and extending through the following decade.[4]

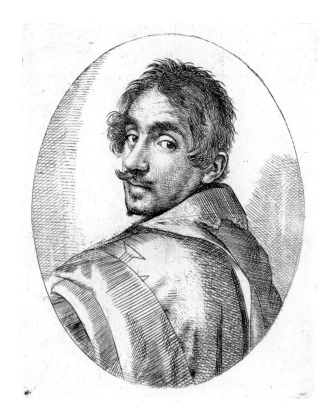

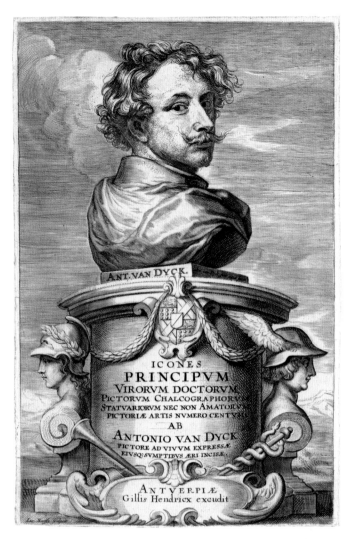

FIG. 21 (*above*). Ottavio Leoni, *Self-Portrait* (*A Knight of Malta*), ca. 1625. Etching and engraving, 14.4 × 11.3 cm (5¹¹⁄₁₆ × 4⁷⁄₁₆ in.).

FIG. 22 (*right*). Anthony van Dyck and Jacobus Neeffs, *Self-Portrait*, title page from *The Iconography*, ca. 1645. Etching and engraving, 24.7 × 15.9 cm (9¾ × 6¼ in.).

Anthony van Dyck spent much of the 1620s in Italy and would have known Leoni's portraits, which circulated in the form of engravings by his own hand. Leoni's lively over-the-shoulder self-portrait (fig. 21) has been proposed as the inspiration for the self-portrait later used as a title page for *The Iconography* (fig. 22).[5] Van Dyck went on to establish his own conventions of pose and setting that would persist well into the eighteenth century. For instance, his incorporation of a sculpted head of Aristotle in his portrait of the Flemish sculptor Andreas Colyns de Nole, engraved by Pieter de Jode II for *The Iconography* (fig. 23), was reprised seemingly ad infinitum by his many followers. The German-born English painter Godfrey Kneller emulated this prototype

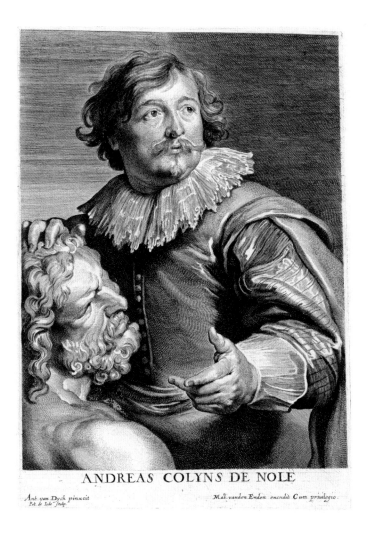

FIG. 23. Pieter de Jode II after Anthony van Dyck, *Andreas Colyns de Nole*, from *The Iconography*, ca. 1635. Engraving, 24.3 × 17.9 cm (9⁹⁄₁₆ × 7⅟₁₆ in.).

in his 1690 painting of sculptor Grinling Gibbons measuring a cast of Gian Lorenzo Bernini's *Proserpina* (The State Hermitage Museum, St. Petersburg), a canvas engraved in mezzotint by John Smith (fig. 24). By the turn of the century, when the English had become the primary producers of mezzotints, it was not uncommon for their images to be plundered by their Dutch competitors. Indeed, Smith's mezzotint was copied by Pieter Schenck, who pirated all but the face for his portrait of Pieter van der Plass (fig. 25), an obscure Dutch sculptor.

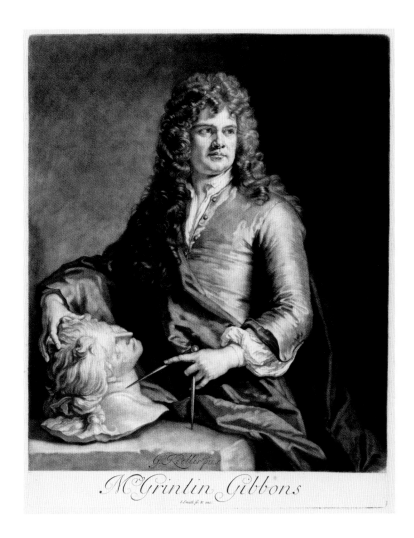

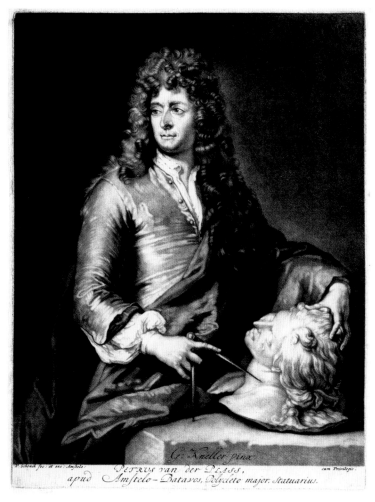

Van Dyck developed a standard repertoire of hand gestures that he and his studio assistants, as well as the engravers who worked on *The Iconography*, could apply to his portraits independently of the sitters' likenesses. According to Roger de Piles, he employed "hand models" of both sexes for that specific purpose.[6] This additive approach is hinted at in a proof impression of de Jode's engraving of Flemish painter Adam de Coster in which the sitter's foreshortened left hand resembles an oversized prosthesis slightly out of scale with his head, while his right hand is unfinished (fig. 26). De Jode was working from a

FIG. 24 (*above left*). John Smith after Godfrey Kneller, *Grinling Gibbons*, ca. 1690. Mezzotint, 34.4 × 25.9 cm (13⁹⁄₁₆ × 10³⁄₁₆ in.).

FIG. 25 (*above right*). Pieter Schenck after John Smith after Godfrey Kneller, *Pieter van der Plass*, ca. 1700–1710. Mezzotint, 24.3 × 18.2 cm (9⁹⁄₁₆ × 7³⁄₁₆ in.).

modello in which the latter detail was either lacking or required modification to fit into the frame of the print.[7]

Moving forward to France in the 1680s, where the art of portraiture flourished during the long reign of Louis XIV, a sheet of hand studies by the Antwerp-trained Nicolas de Largillière (fig. 27) that served as models for a number of different paintings suggests the ubiquity of this working method. Jacopo Campo Weyerman related an amusing, though perhaps apocryphal,

FIG. 26. Pieter de Jode II after Anthony van Dyck, *Adam de Coster,* from *The Iconography,* ca. 1635. Engraving, 23.9 × 16.9 cm (9⁷⁄₁₆ × 6⅝ in.).

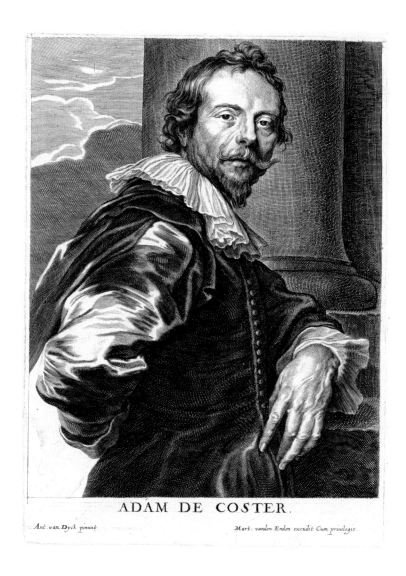

ADAM DE COSTER.

Ant. van Dyck pinxit *Mart. vanden Enden excudit Cum priuilegio.*

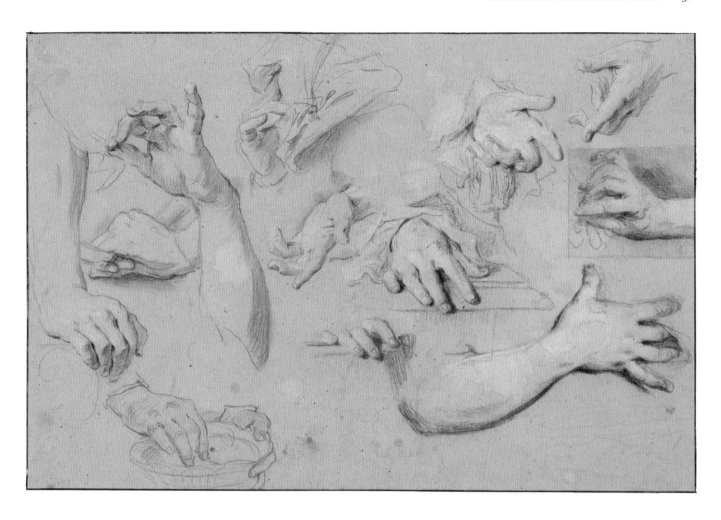

story about the late seventeenth-century portraitist Godfried Schalcken's customary use of his manservant's hands in paintings even of female models, and the indignation he met from a sitter whose hands were her only attractive feature. "The reader should note," he added with wicked delight, "that [Schalcken] had taken as his servant a coarse, thickset English peasant lad with hands like legs of mutton, so his choice was little different from that of the painter of whom Flaccus wrote: 'If a painter placed a conceited woman's head on a horse's neck . . . might one not then ask whether the painter was right in the head?' I would say not, and only a fool would disagree."[8]

FIG. 27. Nicolas de Largillière, *A Sheet of Studies of Hands*, ca. 1680–1685. Red, black, and white chalks on brown paper with one inserted drawing, 28.7 × 42.2 cm (11 5/16 × 16 5/8 in.).

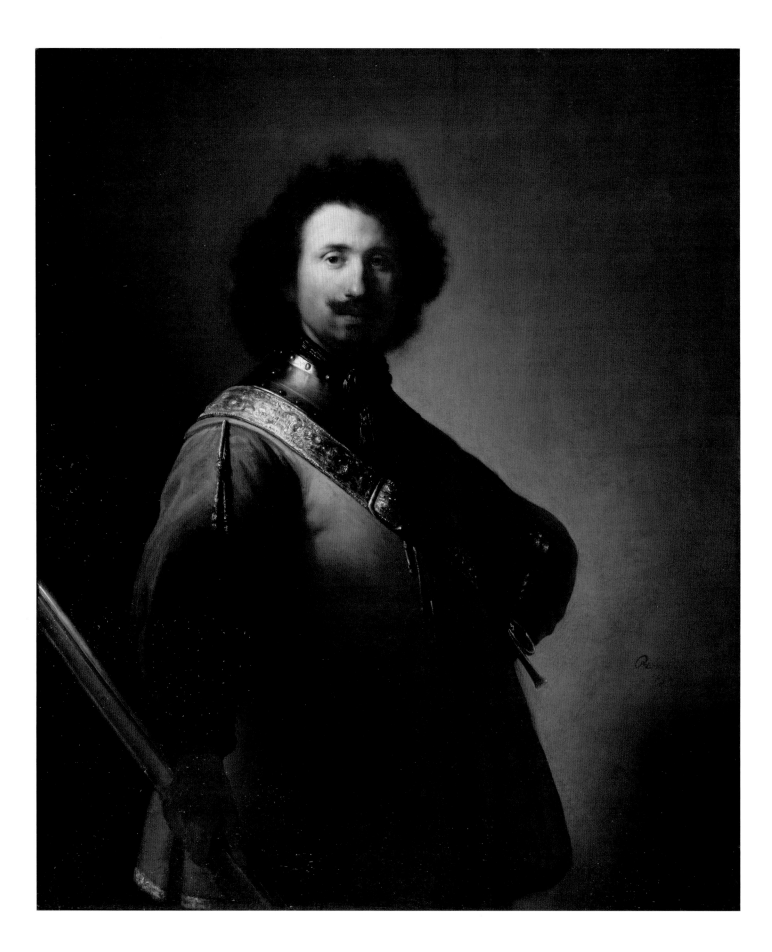

Early in his career, Rembrandt established himself as a gifted portraitist catering to a diverse clientele, including civic and religious leaders, doctors, artisans, and businessmen. One of his first commissions came from Joris de Caulerij, a lieutenant in The Hague's civic guard who made his living as an innkeeper and wine merchant (fig. 28). This work meets all of the requirements for a formal portrait, recording status and appearance while maintaining a sense of decorum and distance with a conventional pose. De Caulerij appears life-sized, and the palpable sense of his presence is enhanced by the dramatic lighting, one of the young artist's specialties.

Most of Rembrandt's etched portraits represent relatively prominent members of Amsterdam society. His portrait of Doctor Ephraim Bueno of 1647 (fig. 29) lacks the textual embellishments that usually accompanied portrait prints, such as an effusive dedication or Latin poem. The early literature describes him simply as a

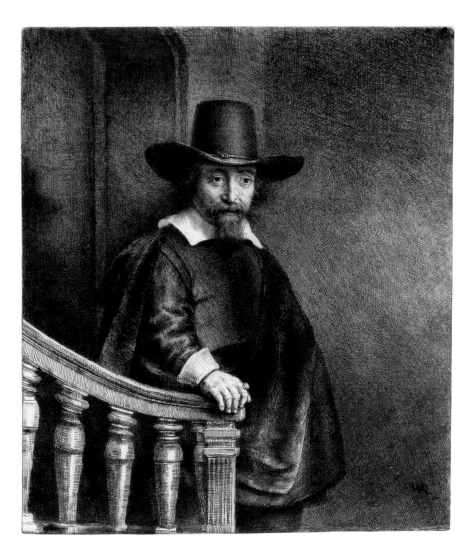

"Jewish doctor," and his identity is corroborated only by another portrait etching by Jan Lievens captioned with his name. Bueno was a leading member of Amsterdam's community of Portuguese Jews and provided funding to the Hebrew press of Rabbi Menasseh ben Israel, a mutual acquaintance of Rembrandt's who may have provided the introduction. The portrait's format, with the doctor resting his hand on the banister of an unseen staircase, does not derive from Van Dyck's ubiquitous prototypes, but appears to be

FIG. 28 (*facing*). Rembrandt van Rijn, *Joris de Caulerij*, 1632. Oil on canvas transferred to panel, 102.9 × 84.3 cm (40½ × 33³⁄₁₆ in.).

FIG. 29 (*above*). Rembrandt van Rijn, *Ephraim Bueno, Jewish Physician*, 1647. Etching, drypoint, and engraving, 20.9 × 17.8 cm (8¼ × 7 in.).

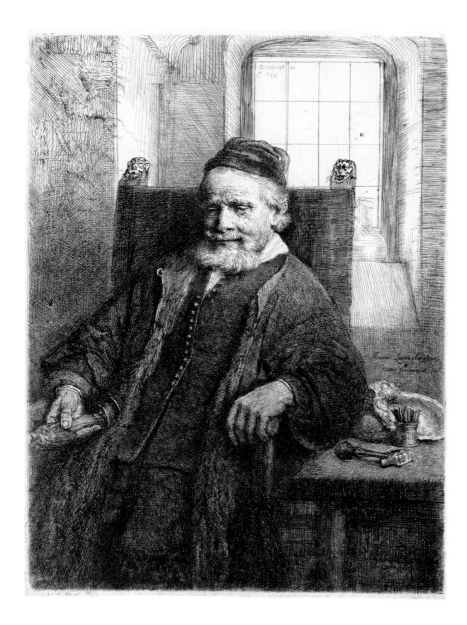

FIG. 30. Rembrandt van Rijn, *Jan Lutma, Goldsmith*, 1656. Etching, drypoint, and engraving, 19.9 × 15 cm (7¹³⁄₁₆ × 5⅞ in.).

Rembrandt's invention. Similarly, Rembrandt's etched portrait of the eminent Amsterdam goldsmith and art collector Jan Lutma dating from 1656 (fig. 30) sets his subject in a distinctive, if minimally described, interior space. Lutma appears half lost in shadow and half lost in thought as he leans back in his chair, clutching an object of his creation. The engraved inscription on the wall at right naming the sitter and erroneously identifying his place of birth—Groningen, rather than Emden—was added only in the print's second state and appears to be the handiwork of someone other than Rembrandt.[9]

Beyond commissioned portraits of identifiable sitters, Rembrandt's oeuvre includes fictive "portraits" of biblical and mythological figures as well as studies of facial expressions and physiognomy. Within this gray area only loosely categorized as portraiture is a particularly intriguing group of images of an elderly woman dating from around 1630 (fig. 31). The same model also appears in works by Rembrandt's first apprentice, Gerrit Dou, and his friend and professional rival Lievens. A seventeenth-century inventory suggests that she was Rembrandt's mother, Cornelia ("Neeltgen") Willemsdr. van Zuytbrouck, who died in 1640 when she was about seventy-two.[10] In an age preoccupied with the transience of existence—a common theme in seventeenth-century still life—the physical characteristics of old people piqued

the interest of Rembrandt and his contemporaries, and it is likely that this woman was selected to pose because of her picturesque facial features rather than her identity. In Dutch, lifelike images of single, anonymous figures were usually referred to as *tronies* (faces).[11] Although not strictly classifiable as a *tronie*, Rembrandt's pen-and-ink drawing of a bearded old man wearing a broad-brimmed hat (fig. 32), presumably a neighborhood resident out for a stroll, further reflects his youthful enthusiasm for aged subjects. At some point in its early history, the bottom portion of the drawing was cut, resulting in the cropping of the man's lower extremities and his unbalanced placement on the sheet of paper.

FIG. 31 (*below left*). Rembrandt van Rijn, *An Elderly Woman Seated (Rembrandt's Mother)*, 1631. Etching, 14.6 × 13 cm (5¾ × 5⅛ in.).

FIG. 32 (*below right*). Rembrandt van Rijn, *Study of a Bearded Old Man with a Wide-brimmed Hat*, ca. 1633–1634. Pen and brown ink on brown paper, gray wash addition by a later hand, 12.8 × 10.3 cm (5⅟₁₆ × 4⅟₁₆ in.).

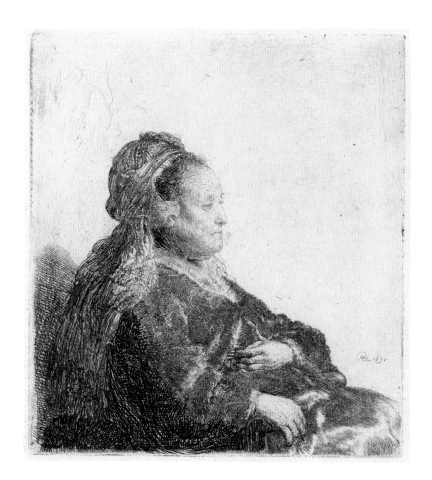

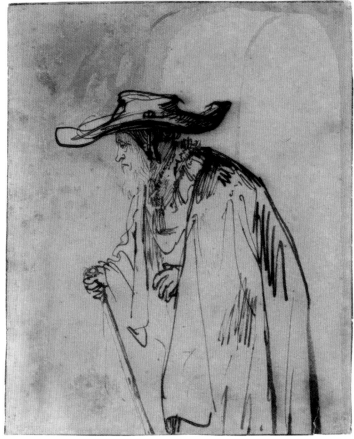

FIG. 33. Jan Lievens, *Hieronymus de Bran*, ca. 1634–1643. Black chalk, 14.4 × 13.4 cm (5¹¹⁄₁₆ × 5¼ in.).

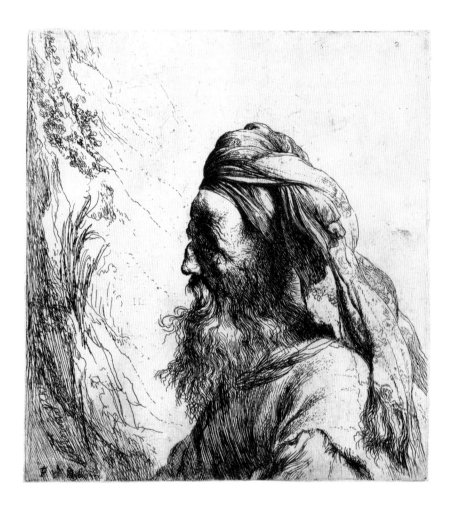

As his career got off the ground, Lievens produced commissioned portraits in a Van Dyckian mode, such as his chalk drawing of the noted art collector and military commander Hieronymus de Bran (fig. 33), as well as a large number of painted and etched *tronies* of wrinkled old men and women, many in exotic costume. Three of Lievens's *tronie* etchings of 1630–1631, including *Bearded Man in a Turban, in Profile Facing Left* (fig. 34), were copied by Rembrandt in 1635 after the two artists had gone their separate ways. Among Rembrandt's apprentices who went on to specialize in the genre was Ferdinand Bol, who worked with the master from the mid-1630s until 1642. That year Bol signed his

FIG. 34 Jan Lievens, *Bearded Man in a Turban, in Profile Facing Left*, from a series of character studies, ca. 1630–1631. Etching, 16.3 × 14.5 cm (6⁷⁄₁₆ × 5¹¹⁄₁₆ in.).

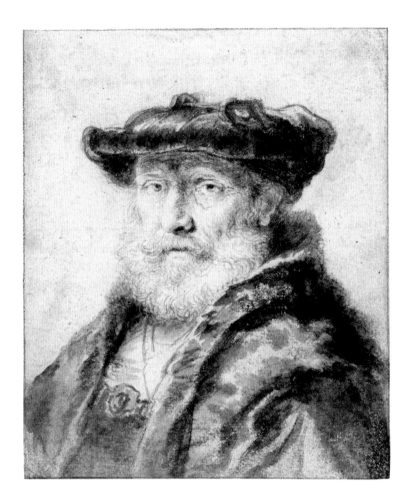

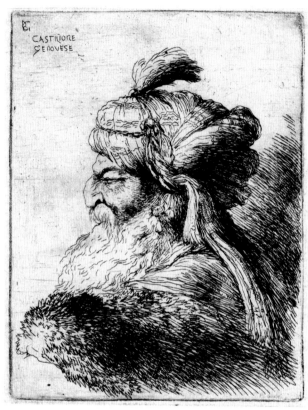

FIG. 35 *(above left)*. Ferdinand Bol, *Bearded Old Man with Beret*, ca. 1642. Gray wash with black chalk and incised transfer lines on ivory paper, 12.7 × 10.4 cm (5 × 4⅛ in.).

FIG. 36 *(above right)*. Giovanni Benedetto Castiglione, *Profile of a Bearded Man in a Turban*, from a set of small oriental heads, ca. 1650. Etching, 10.9 × 8.2 cm (4⁵⁄₁₆ × 3¼ in.).

first etchings, including at least two depicting the same dignified male model with a full beard represented in a small gray wash drawing blackened on the verso and indented for transfer to a copper plate (fig. 35). While this genre remained a peculiar Dutch specialty, Rembrandt's and Lievens's *tronies* later inspired Giovanni Benedetto Castiglione, working in Rome around 1650, to create two etched sets of picturesque "oriental" heads (fig. 36).

This baroque interest in distinctive faces, which ranged from elderly and ethnographic types to young beauties, took a turn from the exotic to

the morbid in the work of Jusepe de Ribera, a Spanish-born painter who spent most of his career in Naples. Like Rembrandt, Ribera created spontaneous pen-and-ink studies that capture physiognomy and gesture in a few deft strokes; his sketch of an elderly man wearing a toga with one upraised hand, known as "the orator," may well have been based on an antique sculptural model in Naples or Rome (fig. 37). Surely aware of the famous grotesque heads of Leonardo da Vinci, Ribera carried out two etchings of men disfigured from neurofibromatosis, a genetic disorder that was not described in the

FIG. 37. Jusepe de Ribera, *Study of a Man with Upraised Hand (Orator?)*, ca. 1625. Pen and brown ink, 19.4 × 14 cm (7⅝ × 5½ in.).

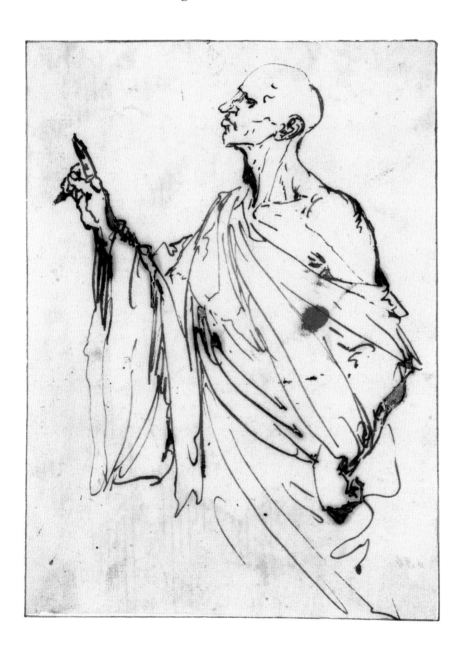

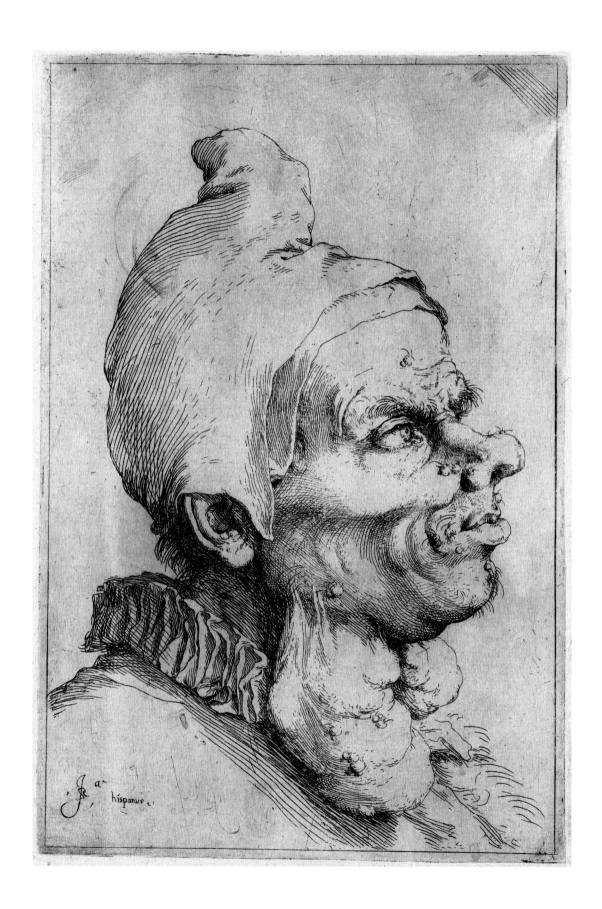

medical literature until the late nineteenth century (fig. 38). Both of these plates, along with five others by Ribera, entered the stock of the Antwerp publisher Frans van Wyngaerde, and impressions from them circulated widely. Like so many of Rembrandt's original printing matrices, Ribera's copper plates long outlived their creator and continued to yield new impressions until they were themselves old and utterly worn out.

FIG. 38 (*facing*). Jusepe de Ribera, *Large Grotesque Head*, ca. 1622. Etching with engraving, 21.6 × 14.3 cm (8½ × 5⅝ in.).

NOTES

1. Peter Davidson and Adriaan van der Weel, eds., *A Selection of the Poems of Sir Constantijn Huygens (1596–1687)* (Amsterdam: Amsterdam University Press, 1996), 168–169.
2. Giovanni Baglione, *Le vite de' pittori, scultori, architetti, ed intagliatori, dal pontificato di Gregorio XIII dal 1572, fino a'tempi di Papa Urbano VIII nel 1642* (Rome: Andrea Fei, 1642), 321.
3. Ibid.
4. John T. Spike, "Ottavio Leoni's Portraits 'alla machia,'" in *Baroque Portraiture in Italy: Works from North American Collections*, exh. cat. (Sarasota, Florida: John and Mable Ringling Museum of Art, 1984), 12–19.
5. Carl Depauw and Ger Luijten, *Anthony van Dyck as a Printmaker*, exh. cat. (Amsterdam: Rijksmuseum, 1999), 98. Van Dyck's original painting in a Swiss private collection is reproduced as fig. 2.
6. Roger de Piles, *Cours de peinture par principes* (Paris: Jacques Estienne, 1708), 230.
7. Joaneath A. Spicer, "Anthony van Dyck's *Iconography*: An Overview of Its Preparation," in *Van Dyck 350*, ed. Susan J. Barnes and Arthur K. Wheelock, Jr., Studies in the History of Art 46, Center for Advanced Study in the Visual Arts, Symposium Papers 26 (Washington, DC: National Gallery of Art, 1994), 347–349.
8. Translated by Peter Hecht in "Candlelight and Dirty Fingers, or Royal Virtue in Disguise: Some Thoughts on Weyerman and Godfried Schalken," *Simiolus* 11, no. 1 (1980): 25.
9. Nicholas Stogdon, *A Descriptive Catalogue of the Etchings by Rembrandt in a Private Collection, Switzerland* (privately printed, 2011), 208.
10. See Christiaan Vogelaar and Gerbrand Korevaar, *Rembrandt's Mother: Myth and Reality*, exh. cat. (Leiden, Netherlands: Stedelijk Museum De Lakenhal; Zwolle, Netherlands: Waanders Publishers, 2005).
11. See Dagmar Hirschfelder, "Portrait or Character Head? The Term *Tronie* and Its Meaning in the Seventeenth Century," in Ernst van de Wetering and Bernhard Schnackenburg, *The Mystery of the Young Rembrandt*, exh. cat. (Kassel: Staatliche Museen Kassel; Amsterdam: Museum Het Rembrandthuis, 2001), 82–90.

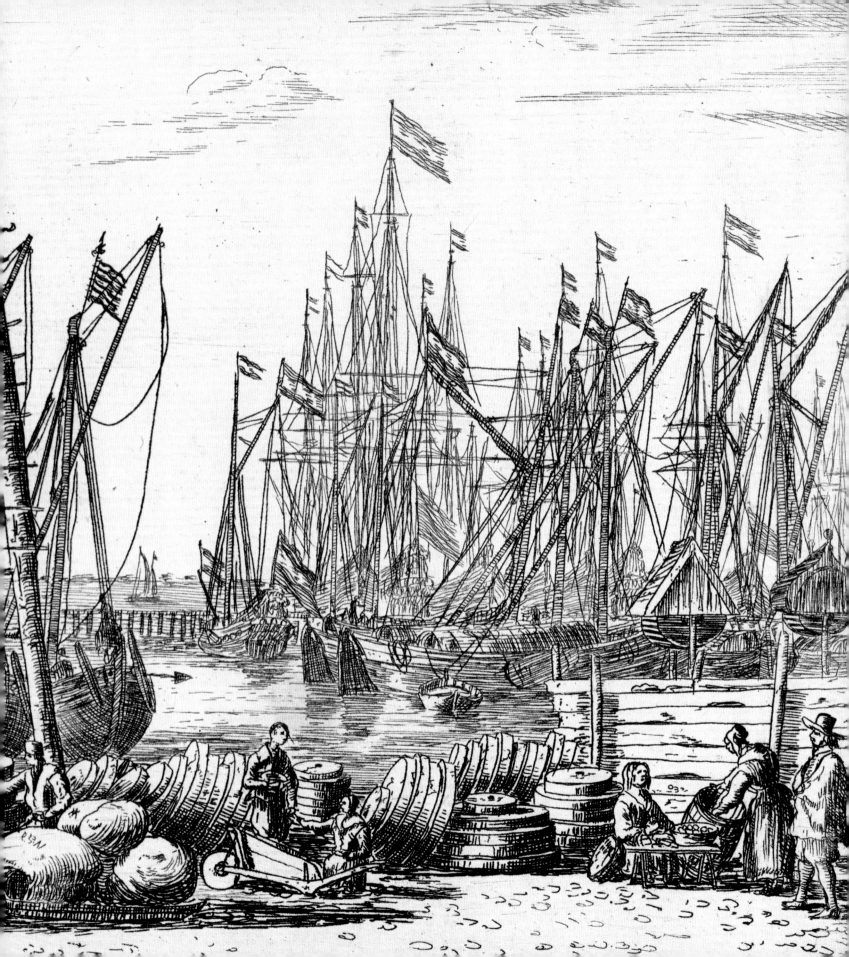

REMBRANDT'S SHELL

What place on earth could one choose where all the commodities and all the curiosities one could wish for were as easy to find as in this city?" So wrote the exiled French mathematician René Descartes from Amsterdam to essayist Jean-Louis Guez de Balzac in 1631.[1] By this time, Amsterdam had reinvented itself from a medieval fishing village into one of the world's busiest port cities, a major trading hub for the Dutch East and West India Companies that imported goods and raw materials from Asia, West Africa, and the Americas (fig. 39). The flourishing market for curios enabled collectors such as Rembrandt to browse an unparalleled variety of imported treasures without venturing outside the city limits.

Non-Western paper attracted his attention. Starting in the late 1640s he began to print etchings on handmade papers from Japan exclusively imported by the East India Company, whose warehouses he included in his view of the Amsterdam skyline (see fig. 83). His etching of a nude bather, for instance, appears with some regularity on golden-toned Japanese paper (fig. 40). And

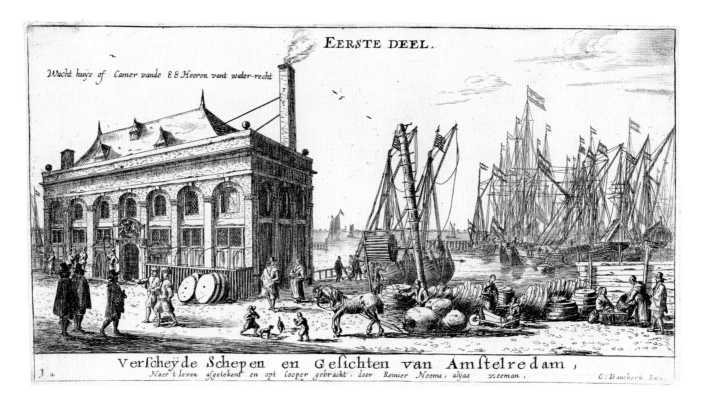

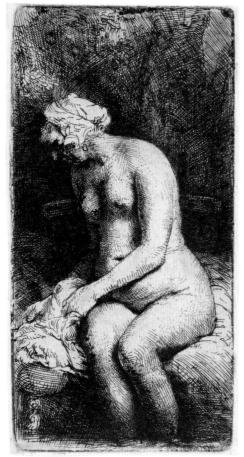

around 1656 Rembrandt started to use these special sheets for a remarkable series of drawings based on contemporary Mughal and Deccani painted miniatures, perhaps from his own collection; his inventory dating from that year lists "an album of curious miniature drawings as well as various wood and copper prints of all sorts of costumes" that may have contained such works.[2] The subject of one of these delicate pen drawings (fig. 41) has been identified as Muhammad Adil Shah, the ruler

FIG. 39 (*above*). Reinier Nooms, called Zeeman, *View of the Port of Amsterdam with the Office of the Water Authority*, title page of *Eerste Deal* (part 1) of the series *Various Ships and Views of Amsterdam*, ca. 1652–1654. Etching with drypoint, 13.1 × 24 cm (5 3/16 × 9 7/16 in.).

FIG. 40 (*left*). Rembrandt van Rijn, *Woman Bathing Her Feet at a Brook*, 1658. Etching on Japanese paper, 16.2 × 8.1 cm (6 3/8 × 3 3/16 in.).

of Bijapur from 1627 until his death in 1656, although the original miniature painting has not been found.[3] Here, as in his other studies of Indian miniatures, Rembrandt seems to have been especially interested in exotic costume accessories, such as the sultan's turban, that might prove useful in his biblical compositions. Also, the distinctive seating arrangement of the special guests in his etching of *Abraham Entertaining the Angels* (fig. 42) is suggestive of a particular Mughal miniature that captured his imagination, his drawn copy of which is in the British Museum.[4]

FIG. 41 (*below left*). Rembrandt van Rijn, *A Medallion Portrait of Muhammad Adil Shah of Bijapur*, ca. 1656–1661. Pen and brown ink on Japanese paper, 9.7 × 7.6 cm (3¹³⁄₁₆ × 3 in.).

FIG. 42 (*below right*). Rembrandt van Rijn, *Abraham Entertaining the Angels*, 1656. Etching and drypoint, 16 × 13.2 cm (6⁵⁄₁₆ × 5³⁄₁₆ in.).

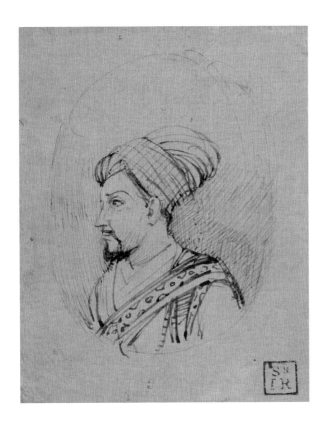

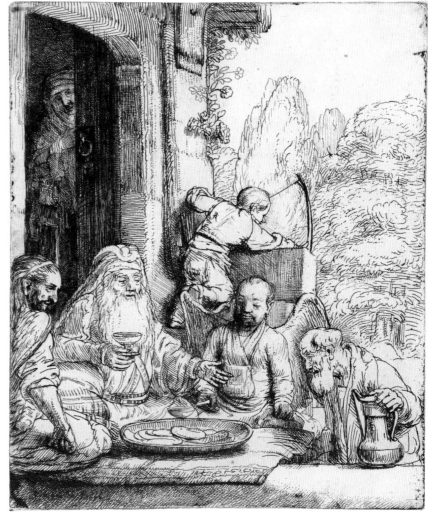

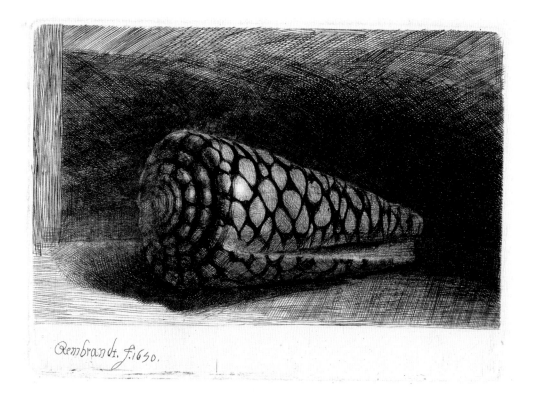

Rembrandt was equally captivated by natural wonders imported from faraway lands. In March 1637 he spent the unheard-of sum of eleven guilders to acquire at auction a single conch for his cabinet of curiosities,[5] and his inventory includes "a great quantity of shells, coral branches, casts from life and many other curios."[6] Visual evidence within his oeuvre is limited to a single etching of a tropical seashell dated 1650 (fig. 43). A rarity among rarities, it is his only etched still life—a genre that held virtually no interest for him as a painter—and survives in relatively few impressions. At roughly ten by thirteen centimeters, it is precious in scale and thus true to the size of the specimen it represents, a marbled cone (*Conus marmoreus*) from the Indo-Pacific region. The shell's geometric black-and-white pattern must have seemed particularly suited to etching, and Rembrandt

lavished such care in recording its appearance that it later passed for a
scientific illustration. But he neglected here, as elsewhere, to account for
the reversal of the printing process, so that the shell's spiral form swirls
unnaturally counterclockwise.[7]

 In the print's first state, the shell and its shadow were isolated against a blank
background, much like the series of thirty-eight etched shells that Bohemian
artist Wenceslaus Hollar produced in Antwerp during the 1640s (fig. 44). There
is no contemporary documentation of these etchings, but Hollar likely under-
took them as a commission by a wealthy collector, possibly his steady patron,
the Earl of Arundel. He printed very few impressions, and it is unlikely that
Rembrandt would have known them. Five of Hollar's shells and a first state
of Rembrandt's *Conus marmoreus* were later copied and united in the English

FIG. 44. Wenceslaus Hollar, *Shell:
Major Harp (Harpa major)*, from a series
of shells, ca. 1646. Etching, 9.3 × 14.1 cm
(3¹¹⁄₁₆ × 5⁹⁄₁₆ in.).

FIG. 45. Jacques Linard, *Still Life of Exotic Shells on a Boîte de Copeaux*, 1621/1624. Oil on panel, 38.1 × 51.8 cm (15 × 20⅜ in.).

naturalist Martin Lister's *Historiae Conchyliorum* (London, 1685–1692), the first comprehensive taxonomy of shells.[8]

Still lifes composed of shells became a specialty among a small group of Dutch and Flemish artists, while in France the genre was taken up by the talented painter Jacques Linard. His ravishing oil of exotic shells (fig. 45) depicts sixteen identifiable specimens, including examples of *Hippopus hippopus* (horse's hoof clam), *Bradybaena similaris* (Asian trampsnail), *Conus textile* (cloth of gold cone), *Mitra papalis* (papal mitre), *Argonauta nodosa* (paper nautilus), *Architectonicidae* (sundial shell), *Conus ammiralis* (admiral cone), and *Spondylus pictorum* (painted thorny oyster). Linard juxtaposes the shells' natural splendor with a humble man-made receptacle, a plain bentwood pantry or chip box (*boîte de copeaux*) faintly incised with his signature. "Conchylomania"—the collecting craze for shells—meant that the combined value of the specimens shown in Linard's painting could have been exponentially greater than that of the painting itself.

While pictures of shells, flowers, fruit, and fish (fig. 46) all became established sub-genres of still life, Hollar's celebrated etchings of fur muffs remain in a class of their own (fig. 47). His eight still lifes of muffs are his own idiosyncratic design and have been subjected to diverse interpretations as eccentric fashion prints, fetishized talismans, and virtuosic vehicles for showcasing his technical prowess and the descriptive power of etching. Most still lifes were encoded with an underlying moral, and luxurious fur goods—as well as tropical seashells—could have been seen as emblems of *vanitas*, empty pursuits of earthly pleasures that have no value in the next world (the term is derived from Ecclesiastes 1:2: *Vanitas vanitatum Omnia vanitas*: Vanity of vanities; all is vanity). Further, like the human skulls that are frequently components of such images, pelts and shells might reasonably be viewed as *memento mori* (reminders of mortality).

These interrelated themes of *vanitas* and *memento mori* became especially pervasive leitmotifs in baroque still lifes. Theodor Matham's engraved *vanitas*

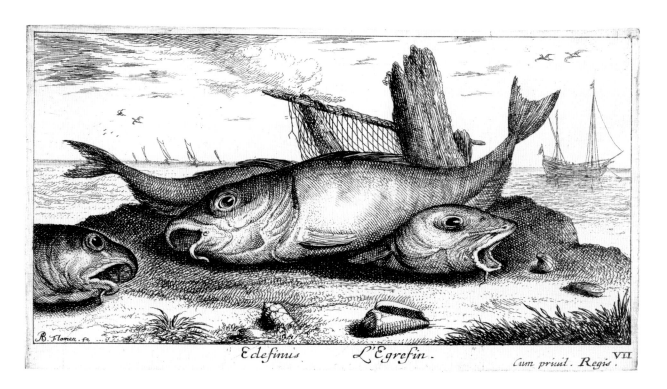

Edefinis *L'Egrefin.* *Cum priuil. Regis.* VII

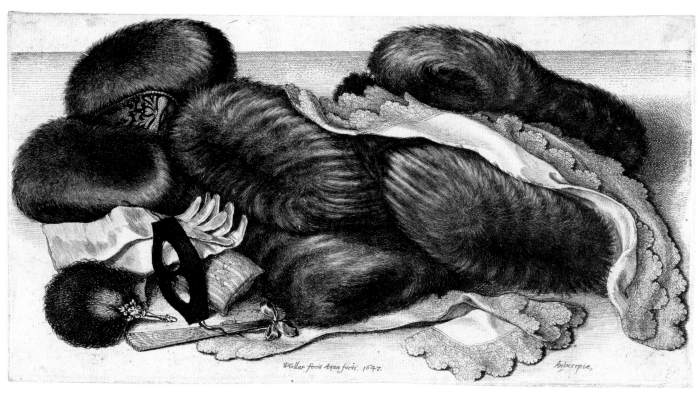

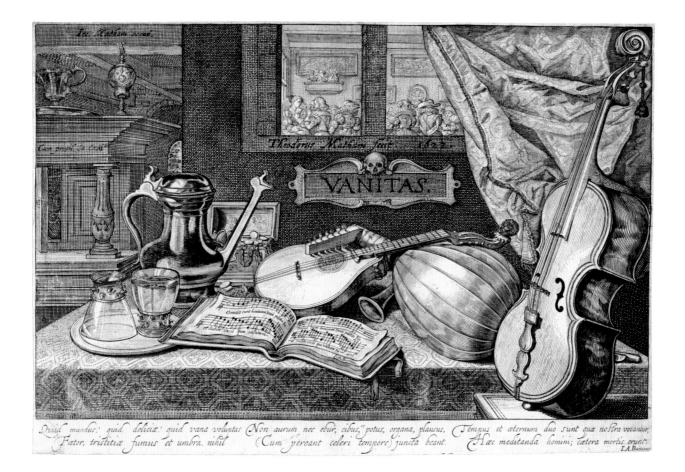

still life of musical instruments (fig. 48) takes full advantage of the print medium's capacity for combining word and image to proselytize. Latin verses in the lower margin credited to Joan Albert Ban (Bannius), a Haarlem-based Roman Catholic priest and amateur composer, cast a pall over the party in the next room:

> What is the world, what pleasure, what vain self-indulgence?
>> Filth, sadness, smoke and shadow. Nothing,
> Neither gold nor ivory, food nor drink, musical instruments nor applause
>> Together bring happiness (for they are lost to us as time slips swiftly by).
> Time and eternity are the two things that are called our own,
>> One should ponder on this; the rest will fall prey to death.[9]

FIG. 46 (*facing top*). Albert Flamen, *Edefinus, L'Egrefin* (*The Haddock*), from *Poissons de mer, troisième partie* (*Salt Water Fish, Part III*), ca. 1660. Etching, 9.8 × 17.5 cm (3⅞ × 6⅞ in.).

FIG. 47 (*facing bottom*). Wenceslaus Hollar, *A Group of Muffs*, 1647. Etching, 11 × 20.4 cm (4⁵⁄₁₆ × 8¹⁄₁₆ in.).

FIG. 48 (*above*). Theodor Matham, *Vanitas*, 1622. Engraving, 22.9 × 33 cm (9 × 13 in.).

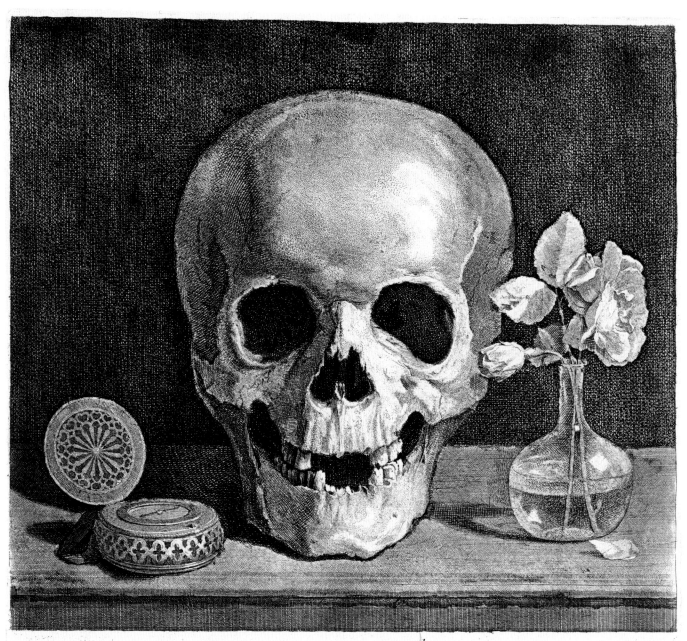

Quid terra cinisque superbis.
Hora fugit, marcescit Honor, Mors, imminet atra.

P. Champaigne Pin. A Paris, chez Basan. Morin scul. Cum Priuil. Re.

FIG. 49. Jean Morin after Philippe de
Champaigne, *Still Life with Skull, Pocket
Watch, and Roses*, 1640–1650. Etching and
engraving, 32.2 × 31.8 cm (12¹¹⁄₁₆ × 12½ in.).

Jean Morin's *Still Life with Skull, Pocket Watch, and Roses*, after a lost painting by Philippe de Champaigne (fig. 49), is even more to the point: time flies, honor fades, and dark death threatens all. The Grim Reaper himself appears in the act of aiming his fatal arrow at a falconer in Andries Jacobsz. Stock's frontispiece to a print series of animal skeletons (fig. 50). The Latin inscription notes, "Death does not care for form or species—or strength—and is reluctant to spare anyone more years, killing all and sundry."

Melancholy sentiments about the fragility and transience of existence were frequently associated with the insect world. Flemish artist Jacob Hoefnagel was the first to survey this realm in print form in his book of fifty-two engravings published when he was just seventeen years old. Its lengthy title translated from Latin reads: *Archetypes and studies by Joris Hoefnagel, my father, are presented, engraved in copper under the guidance of his genius, and freely communicated in friendship to all lovers of the Muses by his son Jacob.* Both father and son were well educated and fluent in the biblical and classical texts that are quoted throughout. Many of the religious texts center on God's intelligent design, while the secular quotations affirm the brevity of life. A vividly rendered wall brown butterfly (*Lasiommata megera*) dominates a typical plate (fig. 51), with an inscription above quoting Psalm 77:12 ("I will meditate on all of your works and consider all of your mighty deeds") and an excerpt below from Martial's twenty-first epigram ("Not everyone has critical acumen"). A fat field mouse occupies the center of

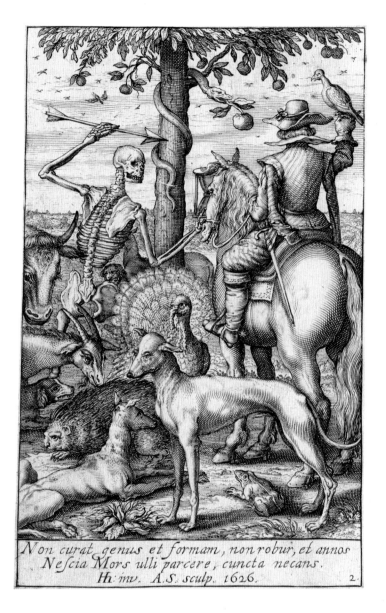

FIG. 50. Andries Jacobsz. Stock after Hendrick Hondius the Elder, *Death with Falconer and Animals*, title page to *Memento Mori* (a series of animal skeletons), 1626. Engraving, 15.3 × 9.6 cm (6 × 3¾ in.).

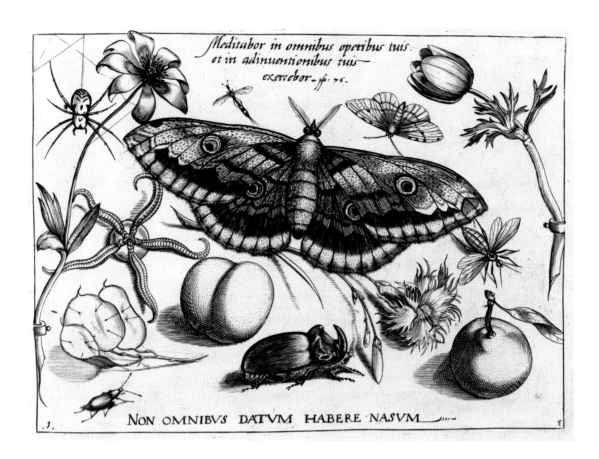

FIG. 51 (*above*). Jacob Hoefnagel after
Joris Hoefnagel, *Meditabor in omnibus
operibus tuis . . .* (*I will meditate on all of
your works . . .*), plate 1 in part 3 of the
book *Archetypa studiaque patris Georgil
Hoefnagelil* (*Archetypes and Studies
by Joris Hoefnagel*), 1592. Engraving,
15.7 × 20.9 cm (6³⁄₁₆ × 8¼ in.).

FIG. 52 (*right*). Jacob Hoefnagel after
Joris Hoefnagel, *Virum Improbum vel
Mures Mordeant* (*Even a mouse will
fasten its teeth in a rascal*), plate 3
in part 1 of the book *Archetypa
studiaque patris Georgil Hoefnagelil*
(*Archetypes and Studies by Joris
Hoefnagel*), 1592. Engraving,
15.5 × 21.2 cm (6⅛ × 8⅜ in.).

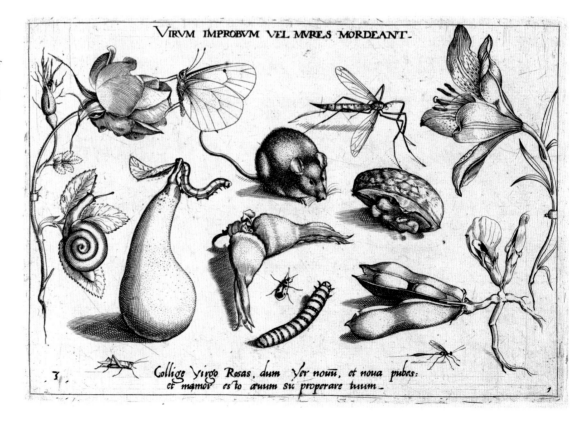

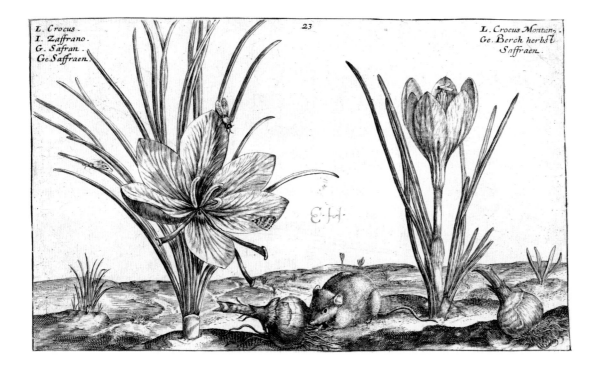

L. Crocus.
I. Zaffrano.
G. Safran.
Ge. Saffraen.

23

L. Crocus Montan.
Ge. Berch herbst
Saffraen.

another image (fig. 52) that offers, above, a proverb from the *Adagia* of Erasmus of Rotterdam ("Even a mouse will fasten its teeth in a rascal") and, below, one of the most famous poems attributed to both Virgil and Ausonius ("Gather, girl, the roses, while spring is new and your youth is fresh, and be mindful how your life rushes by"). Hoefnagel's *Archetypes and Studies* was a sensation. It was reprinted into the eighteenth century and became a popular sourcebook for generations of later artists.

In the realm of botanical prints, the Dutch engraver Crispijn de Passe the Younger made his mark with his stunning *Hortus Floridus* (*Garden of Flowers*), a *florilegium* that first appeared between 1614 and 1617 in Latin, Dutch, French, and English editions. Like Hoefnagel, De Passe was a mere teenager at the time of his book's conception. *Garden of Flowers* lacks the emblematic content of Hoefnagel's work and includes only identifications and factual descriptions of its flowers and bulbs, which are divided into four seasons. These the artist studied from life, but some of his plates incorporate insects and other vermin derived from Hoefnagel's *Archetypes and Studies* and other sources (fig. 53).

FIG. 53. Crispijn de Passe the Younger, *Crocus and Crocus Montan* (*Cultivated Saffron and Mountain Saffron*), plate 23 from the Autumn series of the book *Hortus Floridus* (*Garden of Flowers*), 1614. Engraving, 13 × 21.1 cm (5⅛ × 8⁵⁄₁₆ in.).

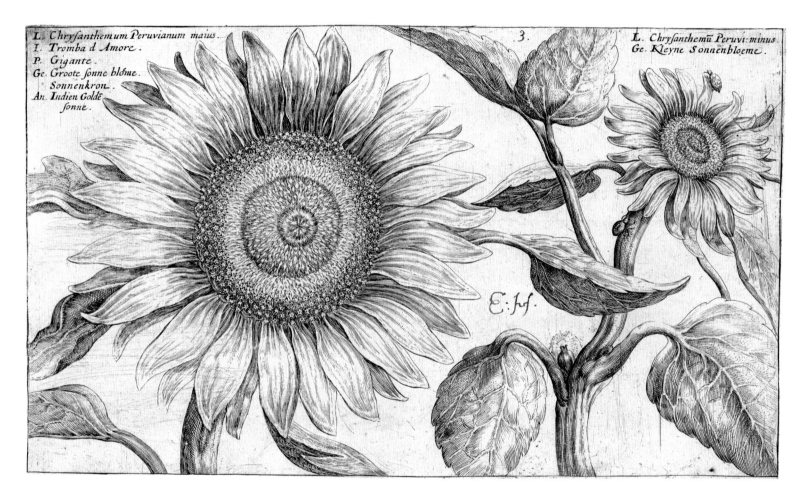

FIG. 54. Crispijn de Passe the Younger,
Chrysanthemum Peruvianum (*The Greater
and Lesser Sunflower*), plate 3 from the
Autumn series of the book *Hortus Floridus*
(*Garden of Flowers*), 1614. Engraving,
13.2 × 21.2 cm (5⅟₁₆ × 8⅜ in.).

Many of the plant species were exotic and expensive imports, such as the Peruvian greater and lesser sunflowers from the autumn garden (fig. 54). In addition, several varieties of tulips appear, foreshadowing the "Tulipomania" that would grip the Dutch nation in the coming decades, when prices for special varieties of rare bulbs rose to unsustainable levels before the market abruptly collapsed in 1637.

To enhance their realism, prints by Hoefnagel and De Passe were frequently hand colored by professional artists and amateurs alike. De Passe actually encouraged owners of the prints to illuminate them by providing step-by-step instructions in his introduction. Appealing to wealthier collectors with a taste for flora and fauna, Jan van Kessel II began at mid-century producing intimately scaled, beautifully detailed, and richly colored natural history paintings on copper that recall Hoefnagel's engravings (fig. 55). Like the works of Hoefnagel, his insect pieces often incorporate fruits, vegetables, nuts, flowers, and even tropical seashells; a comparable work in the Fitzwilliam Museum dated 1661 features five shells, including a *Conus marmoreus*.[10] Johannes Bronkhorst created similarly meticulous insect studies in watercolor. His sheet of lepidopterans (fig. 56), comprising six adults and a caterpillar, is numbered in graphite, suggesting that it was originally accompanied by a descriptive key that enhanced its scientific value.

In 1665, English bibliophiles such as the great diarist Samuel Pepys were treated to very different perspectives on the insect world in the form of two lavishly illustrated books: John Ogilby's *The Fables of Aesop paraphras'd in verse: adorn'd with sculptures and illustrated with annotations* (London: Thomas Roycroft) and Robert Hooke's revolutionary best-seller *Micrographia: or some physiological Descriptions of minute Bodies made by Magnifying Glasses. With Observations and Inquiries thereupon* (London: The Royal Society). The lowly ant, admired by Aesop for its tireless work ethic and by Hooke for its seemingly armored anatomy, is featured in both tomes. Hollar's illustration of the fable *Of the Fly and the Ant* (fig. 58) could equally accompany Hooke's account of the insect, "which was one of many, of a very large kind, that inhabited under

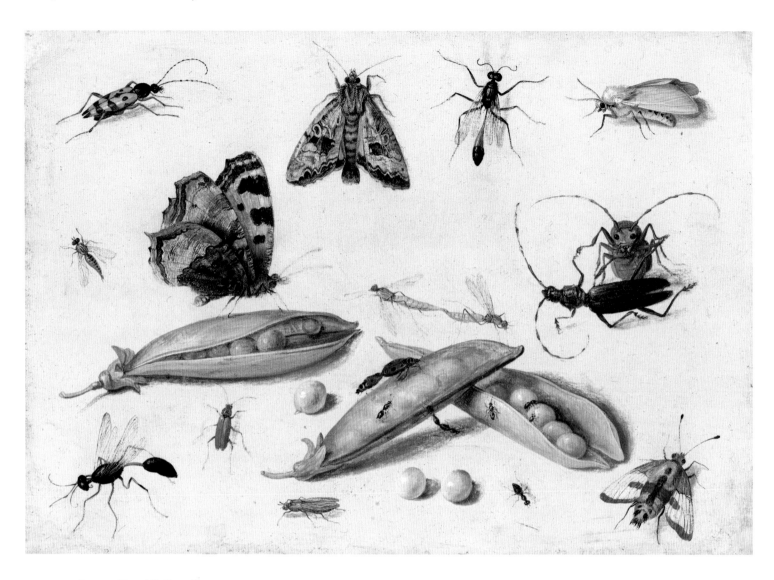

FIG. 55. Jan van Kessel II, *Peapods and Insects*, ca. 1650. Oil on copper, 13.7 × 19.1 cm (5⅜ × 7½ in.).

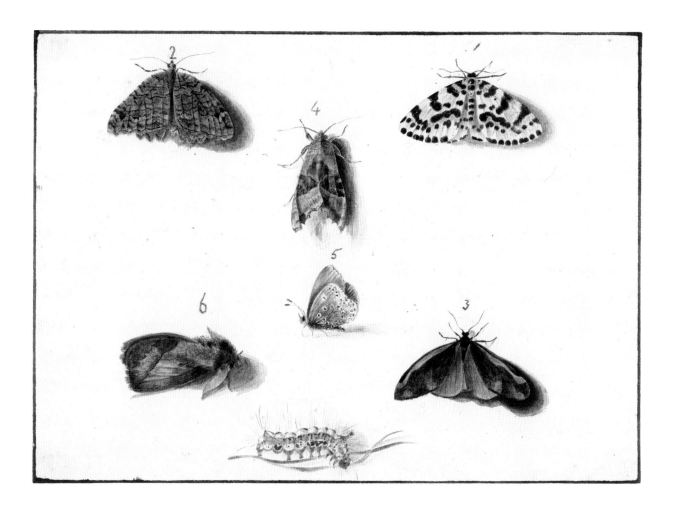

the Roots of a Tree, from whence they would sally out in great parties, and make most grievous havock of the Flowers and Fruits, in the ambient Garden, and return back again very expertly, by the same wayes and paths they went."[11] Hooke's illustration (fig. 57), made with the aid of the newly invented microscope, revealed the ant's anatomy in unprecedented detail. The startling immensity of such insect plates relative to the book's typography and overall scale make turning each page an adventure. On January 21, 1665, Pepys procured one of the first copies of *Micrographia* and pored over it until two o'clock in the morning, proclaiming it "the most ingenious book that ever I read in my life."[12]

FIG. 56. Johannes Bronkhorst, *Study of Lepidopterans (Five Adults and a Caterpillar)*, ca. 1700. Watercolor with gum glaze additions on cream paper, 13.3 × 17.8 cm (5¼ × 7 in.).

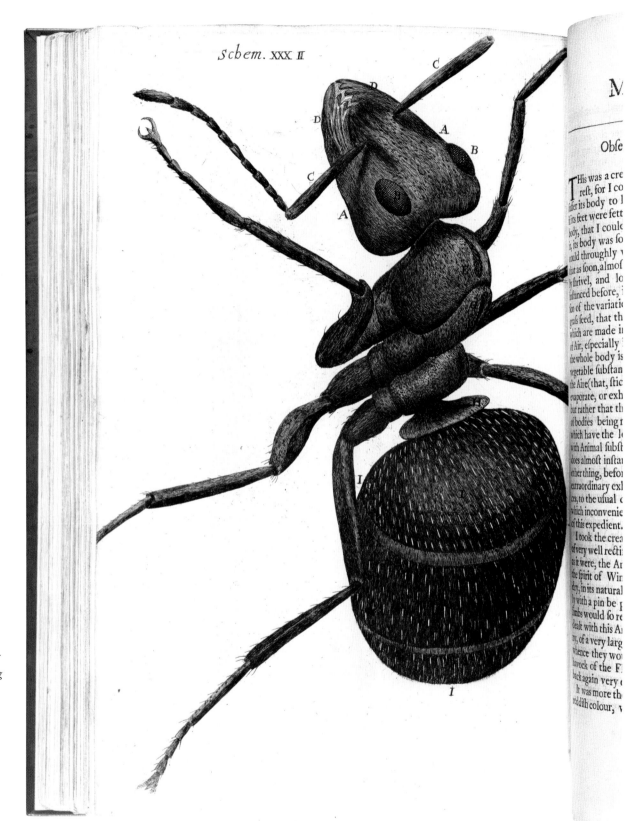

THE FLY AND THE ANT. 33

FIG. 58. Wenceslaus Hollar, illustration for Fable 33, *Of the Fly and the Ant,* opposite page 78 in the book *The Fables of Aesop Paraphras'd in Verse . . .* by John Ogilby, 1665. Etching and engraving, 25.7 × 16.8 cm (10⅛ × 6⅝ in.).

Schem XXXIV

FIG. 59. After Robert Hooke, *Flea*, plate 34, opposite page 210 in the book *Micrographia: or some physiological Descriptions of minute Bodies made by Magnifying Glasses. With Observations and Inquiries thereupon*, 1665. Engraving, 32.3 × 43.5 cm (12¹¹⁄₁₆ × 17⅛ in.).

The same Dutch trading vessels that brought rare shells, flower bulbs, and the wondrous products of exotic cultures to European consumers also facilitated the transmission of deadly infectious diseases. During the 1660s, major outbreaks of bubonic plague swept through the United Provinces and England, wiping out whole communities. Rembrandt lost his companion, Hendrickje, and his adult son, Titus, during epidemics in Amsterdam. The "Great Plague" struck London in 1665–1666, taking up to eight thousand lives per week. Cats and dogs, thought to be responsible for its spread, were rounded up and slaughtered en masse, but that only worsened the situation by enabling the rat population to surge. In *Micrographia* Hooke unknowingly focused his lens on the true culprit in the spread of the pandemic, a tiny parasite carried by the rodents reproduced in a magnificent foldout engraving (fig. 59). Of the killer flea he wrote with admiration, "the strength and beauty of this small creature, had it no other relation at all to man, would deserve a description."

NOTES

1. Fernand Braudel, *Civilization and Capitalism, 15th–18th Century: The Perspective of the World*, trans. Siân Reynolds (New York: HarperCollins, 1984), 30, quoting René Descartes, *Oeuvres*, ed. Charles Adam and Paul Tannery (Paris: Librairie Philosophique J. Vrin, 1969), vol. 1, *Correspondance*, 204.

2. Walter L. Strauss and Marjon van der Meulen, eds., *The Rembrandt Documents* (New York: Abaris Books, 1979), 369, document 1656/12, fol. 34, no. 203.

3. Joachim K. Bautze, *Interaction of Cultures: Indian and Western Painting, 1780–1910. The Ehrenfeld Collection*, exh. cat. (Alexandria, Virginia: Art Services International, 1998), 74–75.

4. British Museum accession number 1895-9-15-1275; see Martin Royalton-Kisch, *Drawings by Rembrandt and His Circle in the British Museum*, exh. cat. (London: British Museum Press, 1992), 141–144.

5. Paul Crenshaw, *Rembrandt's Bankruptcy: The Artist, His Patrons, and the Art Market in Seventeenth-Century Netherlands* (New York: Cambridge University Press, 2006), 93–94.

6. Strauss and van der Meulen, *The Rembrandt Documents*, 367, document 1656/12, fol. 33v, no. 179.

7. Other Rembrandt etchings in which his failure to account for the reversal of the printed image leads to similar discrepancies include *Self-Portrait with Saskia* (fig. 1), in which he appears to draw with his left hand; *View of Amsterdam from the Kadijk* (fig. 83), in which the skyline is backwards; *The Raising of Lazarus* of circa 1632 (fig. 96) and 1642 (fig. 97), in which Christ is blessing with his left hand; and *The Annunciation to the Shepherds* of 1634 (fig. 119), in which the angel gestures with the wrong hand. This phenomenon was the subject of an exhibition at the Rijksmuseum, Amsterdam, "Rembrandt Reflected," December 16, 2009–March 21, 2010.

8. It appears as figure 787. See Karin Leonhard, "Shell Collecting. 17th-Century Conchology, Curiosity Cabinets and Still Life Painting," in *Early Modern Zoology: The Construction of Animals in Science, Literature, and the Visual Arts*, ed. Karl A.E. Enenkel and Paul J. Smith, Intersections, vol. 7 (Leiden, Netherlands: Koninklijke Brill NV, 2007), vol. 1, 198–203.

9. Translation in Eddy de Jongh and Ger Luijten, eds., *Mirror of Everyday Life: Genreprints in the Netherlands, 1550–1700*, exh. cat., trans. Michael Hoyle (Amsterdam: Rijksmuseum with Snoeck-Ducaju and Zoon, 1997), 181.

10. The accession number of this work is 224. I am grateful to Nadia Baadj for calling my attention to the Fitzwilliam painting.

11. Robert Hooke, *Micrographia: or some physiological Descriptions of minute Bodies made by Magnifying Glasses. With Observations and Inquiries thereupon* (London: The Royal Society, 1665), 203.

12. Samuel Pepys, *The Diary of Samuel Pepys 1665*, ed. Henry B. Wheatley (Teddington, UK: The Echo Library, 2006), 13.

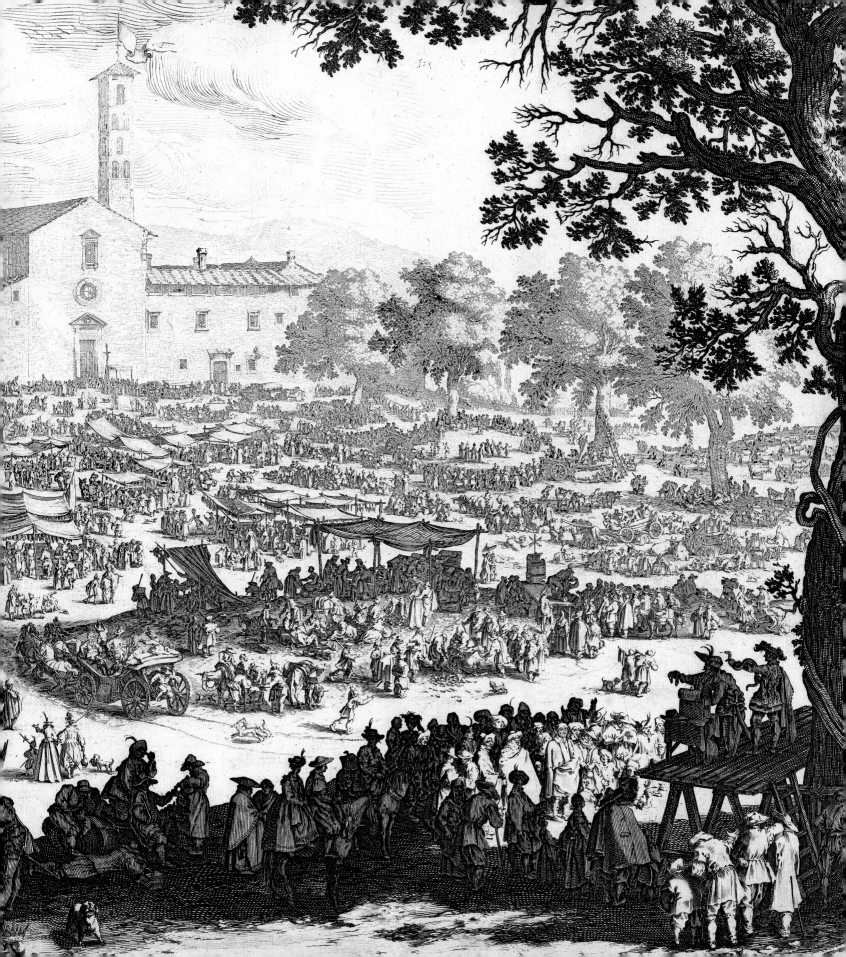

"ALL THE WORLD'S A STAGE ..."

Jacques Callot's etchings of *The Fair at Impruneta* (first version in 1620 and second in 1622; fig. 60) stand out as among the greatest virtuoso performances by any printmaker of any age. One scholar estimated that the composition contains 1,138 human figures, 137 dogs, 67 donkeys, and 45 horses, the majority executed on a miniscule scale.[1] To populate the scene, Callot filled his sketchbooks with chalk drawings of people in a variety of poses, some from multiple angles, similar to those on the small sheet illustrated in fig. 61. Dedicated to Callot's patron, Cosimo II de Medici, the Grand Duke of Tuscany, the print represents the festival in honor of Saint Luke that took place annually at Impruneta, a small Tuscan village outside Florence. The image was so popular that Callot etched a second, duplicate version after the death of Cosimo and the artist's return to his native town of Nancy in 1622. Beneath the tree at the right of the image two entertainers appear on an elevated stage, but their performance pales in comparison to the panoramic vista before them, a vast sea of humanity representing every age and class, methodically organized into numerous distinct groups. Indeed, Callot's crowd-control skills were second to none.

FACING Jacques Callot, *L'Impruneta* (*The Fair at Impruneta*), 1622, detail of fig. 60.

65

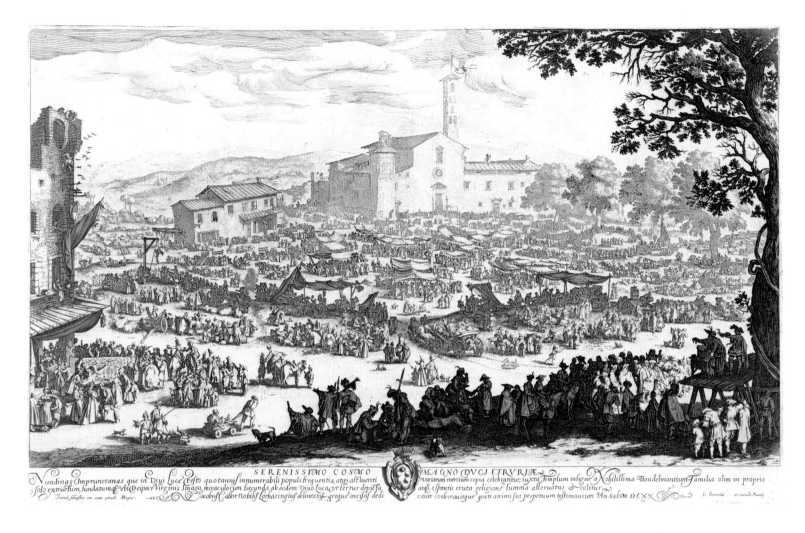

SERENISSIMO COSMO MAGNO DVCI ETRVRIÆ

Nundinas Imprunetanas que in Diui Lucæ Festo quotannis innumerabili populi frequentia, atq affluenti variarum mercium copia celebrantur, iuxta Templum insigne a Nobilissima Bondelmontium Familia olim in proprio solo extructum, fundatumq Vbi Deiparæ Virginis Imago, miraculorum fæcunda, ab eodem Diuo Luca, vt fertur, depicta, arq, e spineris eruta religione summa asseruatur & colitur, cauit consecrauitque grati animi sui perpetuum testimonium An. Salu: MDCXX

Israel siluestre ex: cum priuil: Regis. Jacobus Callot Nobilis Lothazingius delineauit, gregue incisas dedi Se florentie. et excudit Nancy

FIG. 60 (*above*). Jacques Callot, *L'Impruneta*
(*The Fair at Impruneta*), 1622. Etching,
42.3 × 66.9 cm (16⅝ × 26⁵⁄₁₆ in.).

FIG. 61 (*left*). Jacques Callot, *Two Studies
of a Standing Man*, ca. 1621. Red chalk,
9.1 × 11.5 cm (3⁹⁄₁₆ × 4½ in.).

Callot's *Fair at Impruneta* calls to mind the famous opening monologue in Act II, Scene VII of William Shakespeare's comedy *As You Like It* (1598–1600), when Jaques, a character with a pessimistic outlook, steps forward to observe, "All the world's a stage, And all the men and women merely players: They have their exits and their entrances; And one man in his time plays many parts." He goes on to enumerate the seven ages of man that lead inexorably from an infant "mewling and puking in the nurse's arms" to a "second childishness, and mere oblivion, Sans teeth, sans eyes, sans taste, sans everything."[2] Shakespeare's notion that everyone going about his or her daily routine is essentially playing a role on the world stage, combined with his enumeration of stereotypical character types based on age, bears relevance to the visual arts of the seventeenth century. Theatricality in the broadest sense is one of the hallmarks of mannerist and baroque art, not simply in the telling of tales drawn from mythology or religion but also in the portrayal of contemporary events and scenes of daily life.

Hendrick Goltzius's flair for the dramatic is evident in his engraving of a graceful and elegantly costumed standard-bearer who appears light on his feet even while supporting an enormous silk flag (fig. 62). The very composition of this print is suggestive of a stage set, with the main figure seemingly elevated in the shallow foreground and the exaggerated form of the standard functioning like a curtain, fluttering aside in the wind to unveil the distant landscape. A similar structure characterizes Callot's etchings of commedia dell'arte players who perform on a raised, shallow mountebank stage set up in the open air (fig. 63). This pictorial formula was long lasting and lent a heroic quality even to the Flemish artist David

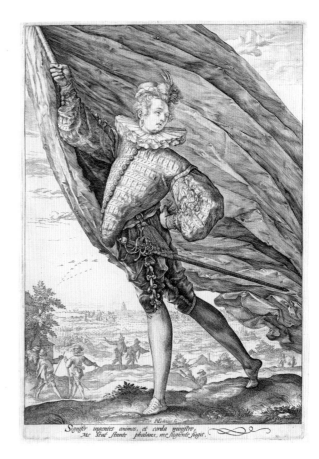

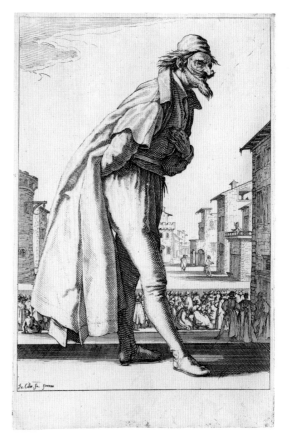

FIG. 62 (*top right*). Hendrick Goltzius, *The Standard Bearer*, 1587. Engraving, 28.6 × 19.6 cm (11¼ × 7¹¹⁄₁₆ in.).

FIG. 63 (*right*). Jacques Callot, *Pantalone*, from a set of three actors, ca. 1618–1620. Etching and engraving, 24.2 × 15.3 cm (9½ × 6 in.).

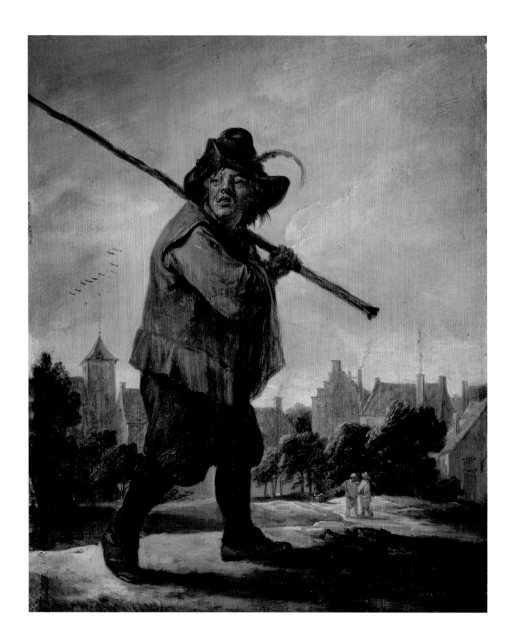

FIG. 64. David Teniers II, *Peasant Walking*, ca. 1670. Oil on panel, 26 × 20.5 cm (10¼ × 8¹/₁₆ in.).

Teniers II's characteristically stubby peasants ambling at the edge of town (fig. 64) in his paintings from much later in the century.

A fascinating Dutch painter-printmaker who traveled in France and was strongly influenced by Callot, Pieter Jansz Quast specialized in peasant imagery with a dual emphasis on beggars and theatrical figures. His etching of an apparently disabled mendicant with a cloth sack on the end of his walking stick, a debilitated hand bent downward, and a peg leg (fig. 65) is one of a large number

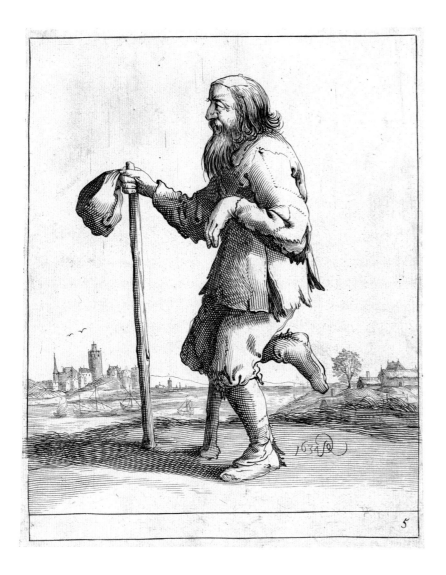

of representations of individuals with bent-knee prostheses attached to non-amputated limbs by artists ranging from Bosch to Rembrandt.[3] While this man may have suffered from a disorder that required the use of a wooden leg, such conditions were looked upon with suspicion as potentially exploitative attempts to attract sympathy. The rampant problem of able-bodied beggars feigning illness was described in a little book by an unknown author called *Liber Vagatorum* (Book of Vagabonds) that appeared in numerous editions and languages

FIG. 65. Pieter Jansz Quast, *Beggar Standing on One Foot, Second on Crutches*, no. 5 from a series of twenty-six beggars and peasants, 1634. Etching and engraving, 21 × 16.3 cm (8¼ × 6⁷⁄₁₆ in.).

FIG. 66. Pieter Jansz Quast, *A Jester*, 1640. Black chalk on vellum, 19.6 × 14.9 cm (7¹¹⁄₁₆ × 5⅞ in.).

from the early sixteenth to the late seventeenth century. It warned that, among other tricks of the vagabond's trade, "many a [beggar] ties a leg up or besmears an arm with salves, or walks on crutches, and all the while as little ails him as other men."[4]

Quast also made a series of black-chalk drawings of comic performers with masklike faces and grotesquely exaggerated features that are reminiscent of Callot's commedia dell'arte subjects (fig. 66). In villages throughout the Low Countries, the annual or biannual kermis was a carnival-like celebration lasting up to three weeks that filled the streets with traveling peddlers, craftsmen, and other entertainers. The sixteenth-century painter Pieter Bruegel the

Elder (ca. 1525–1569) was so associated with kermis imagery that his name continued to be invoked on seventeenth-century prints designed by his innumerable followers, such as Hendrick Hondius the Elder's engraving of jaunty carnival fools dancing outside an inn (fig. 67), which includes Bruegel's initials as inventor, perhaps in a form of false advertising.

As any stage director will attest, a fine line separates the choreography of dancers and fighters, and the same is true of their pictorial representations. Jacques Bellange, who preceded Callot as court artist in the autonomous duchy of Lorraine, is responsible for an unflinching depiction of street violence in his etching of a blind hurdy-gurdy player attacking a man on his pilgrimage to Santiago de Compostela (fig. 68).[5] The shallow, stagelike setting is crowded by the two ungainly actors locked in their eternal struggle; a dog jumping into the melee underscores its animalistic intensity. The audience for Bellange's print expanded well beyond his remote hometown of Nancy when this plate and several others of his entered the stock of Jean Leblond I, a major Parisian publisher who printed a large edition after the artist's death. The composition was also pirated by the Swiss etcher Matthäus Merian, whose copy was published in Strasbourg by the Netherlandish émigré Jacob van der Heyden.[6] Bellange's violent scene proved broad in appeal, freely crossing borders without explanation or translation. A street mugging is much the same everywhere.

FIG. 67. Hendrick Hondius the Elder in the manner of Pieter Bruegel the Elder, *Two Fools of the Carnival*, 1642. Engraving, 12.8 × 15.7 cm (5¹⁄₁₆ × 6³⁄₁₆ in.).

FIG. 68 (*left*). Jacques Bellange, *Hurdy-Gurdy Player Attacking a Pilgrim*, 1610–1616. Etching, drypoint, and engraving, 31.3 × 21.3 cm (12 5/16 × 8 3/8 in.).

FIG. 69 (*facing*). Cornelis Bloemaert II after Adriaen van de Venne, *All-arm All-arm* (*Brawl Between Beggars*), ca. 1635. Engraving, 26.2 × 19.7 cm (10 5/16 × 7 3/4 in.).

All-arm All-arm.

In the second quarter of the century, the Dutch painter and poet Adriaen van de Venne concentrated on similarly indelicate images of peasant life, focusing like Quast on the true outcasts of society, the physically disabled and destitute. Cornelis Bloemaert II's engraving *All-arm All-arm* reproduces a typical grisaille panel painting by Van de Venne of the early 1630s. It is a raucous scene of violence between two scruffy peasants, with a fallen peg-legged man and a walking stick flying off into the background (fig. 69).[7] Analogous scenes occur in Van de Venne's epic comic poem of 1635, *Tafereel van de Belacchende Werelt* (*Picture of the Laughable World*), set during The Hague's kermis. Although the stakes may be low, the aggression is no less fierce. The print's curious title, which recurs with some frequency in Van de Venne's oeuvre, derives from the legend "Al-arm!" inscribed on a tablet in his original oil (private collection). While "alarm" has the same meaning in English, the Dutch word *arm* also

FIG. 70. Rembrandt van Rijn, *Beggar Seated on a Bank*, 1630. Etching, 11.8 × 7 cm (4⅝ × 2¾ in.).

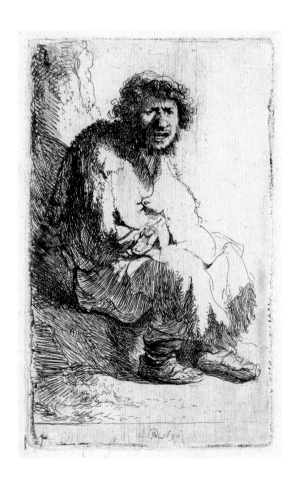

signifies "poor," which produces a double entendre ("alarm"/"entirely poor"). To Van de Venne and his sophisticated audience, a beggars' brawl like the one shown here and at the end of *Picture of the Laughable World* was an object for moral condemnation and sheer amusement rather than pity.

Rembrandt tapped into the market for images of vagrants and other less fortunate members of society with a number of diminutive etchings inspired, in part, by a popular print series of mendicants by Callot. Rembrandt's *Beggar Seated on a Bank* of 1630 (fig. 70) has garnered special attention because of its model, the artist himself. Bearded elderly men with crutches and canes appear with some frequency in his figure drawings (see fig. 32) and etchings (fig. 71) of beggar types. His copperplate of *A Peasant in a High Cap, Standing Leaning on a Stick* of 1639 (fig. 72) is one of the few original plates to survive without having been reworked or rebitten.[8] All of these works occupy a gray area in terms of our understanding of the artist's motivations and intentions. Are they meant to incite fear, disgust, amusement, or sympathy? Rembrandt's later etching of *Beggars Receiving Alms at the Door of a House* from 1648 (fig. 73) appears more

FIG. 71 (*above left*). Rembrandt van Rijn, *A Peasant in a High Cap, Standing Leaning on a Stick*, 1639. Etching, 7.8 × 4.5 cm (3¹⁄₁₆ × 1¾ in.).

FIG. 72 (*above right*). Rembrandt van Rijn, *A Peasant in a High Cap, Standing Leaning on a Stick*, 1639. Copper etching plate, 8.5 × 4.5 × .15 cm (3⅜ × 1¾ × ¹⁄₁₆ in.).

straightforward in its compassionate treatment of the subject: a simple act of charity distilled into the moment when a homeowner drops a coin into the outstretched hand of a poor mother standing on his doorstep, surrounded by her unfortunate family.

Among Rembrandt's contemporaries, Haarlem-based Adriaen van Ostade was one of the most proficient and prolific—as a painter, draftsman, and

FIG. 73. Rembrandt van Rijn, *Beggars Receiving Alms at the Door of a House*, 1648. Etching, engraving, and drypoint, 16.5 × 12.9 cm (6½ × 5⅟₁₆ in.).

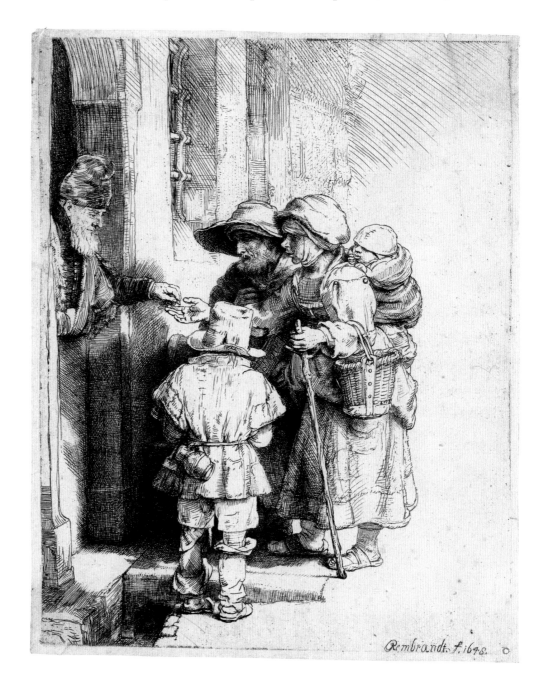

etcher—in the genre of peasant life. His earliest works accentuate the more uncouth aspects of country living, with an emphasis on debauchery and violence, but by the late 1640s he settled into a more sanguine view. His picturesque etching of a hardworking family in the rustic interior of their barnlike home is a marvel of anthropological detail (fig. 74). A later print known as *Village Romance* (fig. 75) depicts an amorous country couple as seen through the top

FIG. 74. Adriaen van Ostade, *The Family*, 1647. Etching, 17.3 × 15.4 cm (6¹³⁄₁₆ × 6¹⁄₁₆ in.).

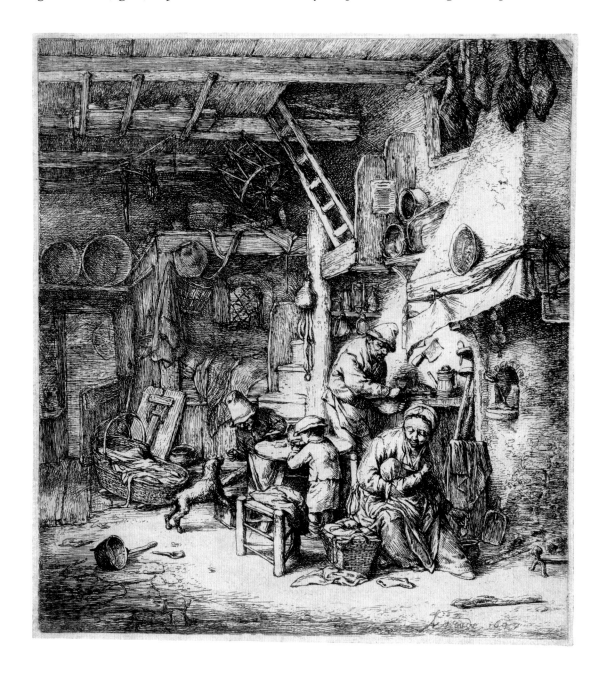

FIG. 75 (*above left*). Adriaen van Ostade, *Village Romance*, ca. 1652. Etching, 15.7 × 12.4 cm (6¾₆ × 4⅞ in.).

FIG. 76 (*above right*). After Adriaen van de Venne, *Couple Carrying Their Belongings on a Stretcher*, folio 17 (recto) in the section Vrouwe (Wife) of the book *Hovwelyck* (*Marriage*) by Jacob Cats, 1625. Engraving, 13.7 × 13.8 cm (5¾₆ × 5⅜ in.).

of a Dutch door, a framing convention popularized by Rembrandt's pupil Gerrit Dou. The woman leans into the light in a vain attempt to pull away from her partner in the shadows, their tender embrace suggesting playfulness or perhaps an allegory of touch rather than a sermon against wanton lust.[9] In Ostade's etching of *Rhetoricians at a Window* (*The Singers*) (see fig. 125), the mullioned window frame serves in effect as a proscenium arch for a performance or competition of the kind traditionally staged at a peasant kermis.

The Dutch interior was generally considered women's domain. The influential moralist poet Jacob Cats (1577–1660) wrote an illustrated guide to married life directed at female readers entitled *Hovwelyck* (*Marriage*) (The Hague, 1625),

which stated, "In short, many a house is truly built / By women's stout leadership and industry alone; / Yes, and many a man is great in his profession, / Thanks not to his own brains, but to a noble wife."[10] One of the many amusing plates designed by Van de Venne depicts a married couple transporting a chest that is about to spill its contents because the wife uses only one hand to support her end of the stretcher (fig. 76). Women quietly engaged in their domestic tasks became popular subjects among such genre painters as Nicolaes Maes and Pieter de Hooch but were first taken up by one of the few female engravers of the seventeenth century, the Amsterdam-based Geertruydt Roghman (fig. 77). Her highly original cooking scene faces her subject away from the viewer and keeps anecdotal detail to a minimum, including just enough to indicate that she is making pancakes.[11]

FIG. 77. Geertruydt Roghman, *Woman Cooking*, from a set of five domestic occupations, ca. 1648–1650. Engraving, 20.9 × 16.7 cm (8¼ × 6⁹⁄₁₆ in.).

FIG. 78. Rembrandt van Rijn, *Sleeping Puppy*, ca. 1640. Etching and drypoint, 3.9 × 8.3 cm (1⁹⁄₁₆ × 3¼ in.).

Domesticated animals like the begging dog in Ostade's etching appear with great frequency in Dutch genre scenes of home and family. On one very rare occasion, Rembrandt etched a sleeping puppy huddled all alone in the corner of a tiny plate (fig. 78). Cornelis Visscher's popular engraving known as *The Large Cat* (1657), which dates from the end of his brief but productive career, is undoubtedly the most famous animal print of the seventeenth century (fig. 79). His dozing feline appears to be taking a break from its rat-catching duties, while one of its mortal adversaries emerges to investigate the potentially perilous situation. Judging by the considerable number of Dutch artists who chose to specialize in this genre, collectors' appetites for paintings as well as sets of prints devoted to livestock seem to have been virtually limitless. Celebrating the booming Dutch cattle and dairy industries, a host of talented engravers such as Reinier van Persyn (who reproduced designs by Jacob Gerritsz. Cuyp) (fig. 80) and etchers such as Adriaen van de Velde (fig. 81) saturated this equally booming niche in the print market.

NOTES

1. These numbers, recited frequently in the literature on Callot and misattributed to Lieure, appeared in Jules Lieure, *Jacques Callot: Catalogue raisonné de l'oeuvre gravé* (Paris: Editions de la Gazette des Beaux-Arts, 1927), vol. 2, 14; and Jules Lieure, *Jacques Callot: La vie artistique, première partie, appendice* (Paris: Editions de la Gazette des Beaux-Arts, 1929), vol. 2, 28. Lieure had not made the count himself but was quoting the German art historian Gottfried Kinkel's enumeration of the figures in an enlarged painted copy by David Teniers the Younger in the Bayerische

FIG. 79. Cornelis Visscher, *The Large Cat*, 1657.
Engraving, 14.4 × 18.6 cm (5¹¹⁄₁₆ × 7⁵⁄₁₆ in.).

FIG. 80. Reinier van Persyn after Jacob Gerritsz. Cuyp, *A Standing Ox*, plate 3 from the series *Diversa Animalia Quadrupedia* (*Various Four-Legged Animals*), 1641. Engraving, 13.1 × 19.7 cm (5³⁄₁₆ × 7¾ in.).

Staatsgemäldesammlungen–Alte Pinakothek, Munich. Teniers based his painting on Salomon Savery's reversed copy of Callot's first Impruneta plate.

2. William Shakespeare, *As You Like It*, Act II, Scene VII, quoted from *The Oxford Shakespeare: The Complete Works of William Shakespeare*, ed. W. J. Craig (London: Oxford University Press, 1914); www.bartleby.com/70/2027.html.

3. J. J. ten Kate, F.G.I. Jennekens, and J.M.E. Vos-Niël, "Rembrandt's 'Beggar with a Wooden Leg' and Other Comparable Prints," *The Journal of Bone and Joint Surgery* 91-B, no. 2 (February 2009): 278–282.

4. *The Book of Vagabonds and Beggars: with a vocabulary of their language*, trans. John Camden Hotten (London: The Author, 1860), 13–14.

5. See the illuminating discussions of this print in Sue Welsh Reed, *French Prints from the Age of the Musketeers*, exh. cat. (Boston: Museum of Fine Arts, 1998), 65; and Antony Griffiths and Craig Hartley, *Jacques Bellange, c. 1575–1616: Printmaker of Lorraine*, exh. cat. (London: The British Museum Press, 1997), 113–118.

6. Griffiths and Hartley, *Jacques Bellange*, 33–34.

7. This imagery is discussed in Mariët Westermann, "Bodily Infirmity as Social Disease:

The Art of Adriaen van de Venne," in *In Sickness and in Health: Disease as Metaphor in Art and Popular Wisdom*, ed. Laurinda S. Dixon (Newark: University of Delaware Press, 2004), 45–61. See also Laurens J. Bol, *Adriaen Pietersz. Van de Venne: Painter and Draughtsman*, trans. Jennifer M. Killian and Marjorie E. Wieseman (Doornspijk, Netherlands: Davaco Publishers, 1989), 77–84.

8. Erik Hinterding, "The History of Rembrandt's Copperplates, with a Catalogue of Those That Survive," *Simiolus* 22, no. 4 (1993–1994): 298.

9. See Peter van der Coelen et al., *Everyday Life in Holland's Golden Age: The Complete Etchings of Adriaen van Ostade*, exh. cat. (Amsterdam: Museum Het Rembrandthuis, Rembrandt Information Centre, 1988), 104–105.

10. Translated in David R. Smith, "Rembrandt's Early Double Portraits and the Dutch Conversation Piece," *The Art Bulletin* 64, no. 2 (June 1982): 275n55.

11. See Martha Moffitt Peacock, "Geertruydt Roghman and the Female Perspective in 17th-Century Dutch Genre Imagery," *Woman's Art Journal* 14, no. 2 (Fall/Winter 1993–1994): 3–10; and Mariët Westermann, *Art and Home: Dutch Interiors in the Age of Rembrandt*, exh. cat. (Zwolle, Netherlands: Waanders Publishers, 2001), 21, 192–193.

FIG. 81. Adriaen van de Velde, *Cow Resting*, from a series of various animals, 1657. Etching, 10.9 × 13.2 cm (4⁵⁄₁₆ × 5³⁄₁₆ in.).

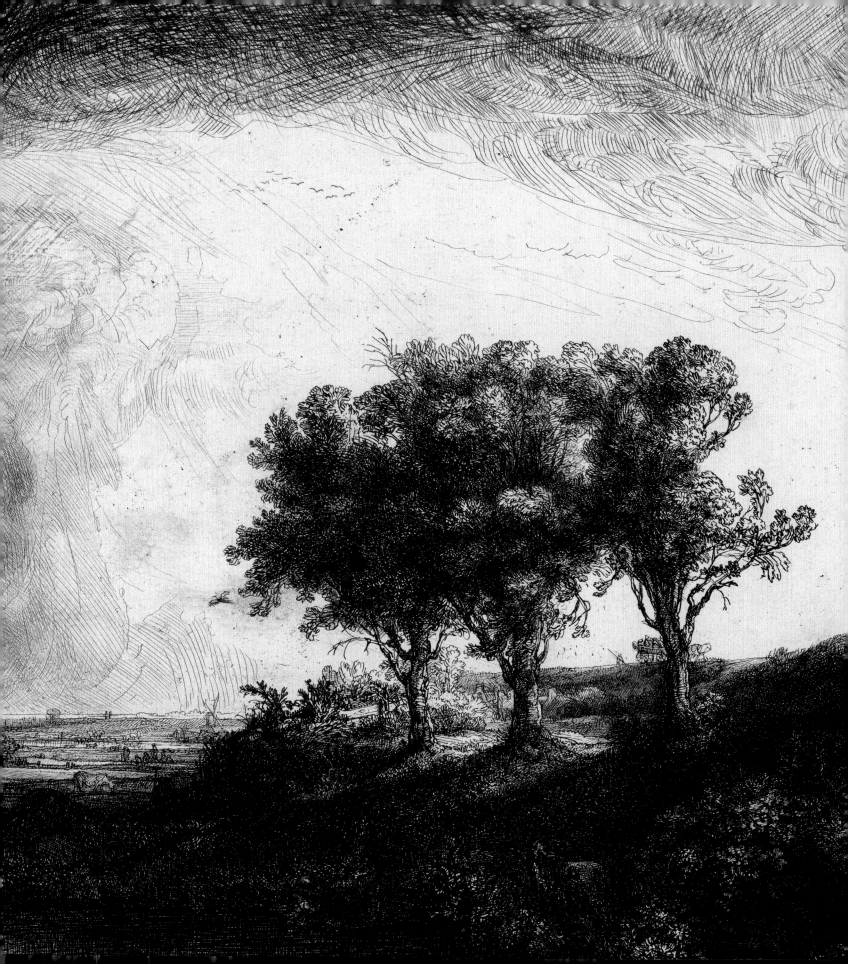

THE ART OF NATURE,
THE NATURE OF LANDSCAPE

Young painters, who have sat crouched, absorbed in art through constant
work, [so] that you, always eager to learn more, have become half blind,
your senses dulled almost to insensibility and numbness, stop, for this time
you have pulled the plow long enough; lay down your work for awhile. . . .
And come, let us go very early, with the opening of the [town] gate, pass
the time together in easing our spirits, and go look at the beauty that is
to be seen outdoors, where the billed musicians [birds] trill in the wild.
There we shall see many prospects that will serve us all to create a
landscape on canvas or hard Norwegian oaken planks. Come, you will—
I promise—be satisfied with the excursion.

—Karel van Mander, *The Foundation of the Noble Art of Painting*, 1604[1]

Rembrandt's century witnessed profound innovations in the
genre of landscape as artists gradually emerged from their
studios to let nature be their guide. With its flat terrain,
the Dutch Republic would seem an unlikely place for naturalism to prevail,
but by the time Rembrandt took up landscape as a painter in the 1630s and as
an etcher in the 1640s, a down-to-earth approach to the indigenous scenery
was well on its way to becoming one of the primary artistic innovations of the
Golden Age. At the same time in Italy, Claude Lorrain elevated the status of
landscape by seamlessly combining natural and imagined elements into views
of the Roman countryside that were both unprecedented and unequaled in
their lyricism.

FACING Rembrandt van Rijn,
The Landscape with the Three Trees,
1643, detail of fig. 85.

Debuit inde senex qui nunc Acheronticus esse,
Ecce amat et capiti florea serta parat.

Ast ego mutato quia amor me perculit arcu,
Deficio, injiciunt et mihi fata manum,

Parce puer, Mors signa tenens victricia parce,
Fac ego amem, subeat fac Acheronta senex.

FIG. 82. Jan Sadeler I after Pieter Stevens, *Landscape with a Couple Threatened by Death and Cupid*, 1599. Engraving, 21.8 × 27.1 cm (8⁹⁄₁₆ × 10¹¹⁄₁₆ in.).

Published just before the dawn of the century, Jan Sadeler I's *Landscape with a Couple Threatened by Death and Cupid* (fig. 82) was a product of the thriving artists' colony at Prague under Holy Roman Emperor Rudolf II. The engraving is based on a pen-and-ink drawing by the official court painter Pieter Stevens,[2] while the Latin inscription, taken from Andrea Alciato's popular *Emblemata* (Book of Emblems), relates the tragic consequences of Death and Cupid accidentally swapping arrows: "Thus, an old man who should now be in

Acheron lo and behold falls in love and prepares floral garlands for his head," explains his doomed companion, "and, because Love has struck me with the wrong arrow, I am dying and the fates lay their hand upon me." The figures also derive from a recent edition of Alciato's *Emblemata*. Here the forest functions as a stage set, an artful construction of intertwined trees, a riverside path, and rustic buildings—components that appear in at least two other drawings by Stevens. The wooded backdrop is an extension of the fantastic narrative that it contains, a work of fiction rather than fact.

Dating from circa 1640, Rembrandt's *View of Amsterdam from the Kadijk* (fig. 83), one of his first etched landscapes, represents an entirely new approach. A full three-quarters of the composition consists of pristine negative space, a sky without a wisp of clouds, setting sun, or bird in flight. In proportion to

FIG. 83. Rembrandt van Rijn, *View of Amsterdam from the Kadijk*, ca. 1640. Etching, 10.7 × 15.4 cm (4³⁄₁₆ × 6¹⁄₁₆ in.).

FIG. 84. Schelte Adamsz. Bolswert after Peter Paul Rubens, *Landscape*, from a set of small landscapes, ca. 1638. Engraving, 31.6 × 48.7 cm (12⁷⁄₁₆ × 19³⁄₁₆ in.).

the plate's overall size, this blank expanse of paper would have been novel, if not unprecedented. The pictorial structure is entirely lacking in traditional framing devices, and the extraordinarily low placement of the horizon emphasizes the flatness of the Dutch landscape, its most distinctive feature. The lower register seems at first glance to offer a faithful transcription of the view from the embankment lining the northeastern edge of Amsterdam. The skyline is the primary subject, featuring (from left to right) such legible monuments as the medieval Haringpakkerstoren (Herring Packers' Tower), the Westerkerk (West Church), the Oude Kerk (Old Church), the Montelbaanstoren (Montelbaans Tower, the tallest

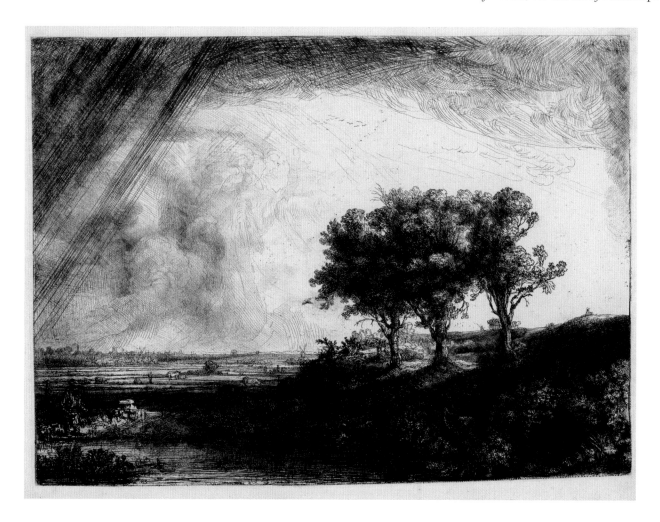

structure in the image), the giant warehouses of the East India Company, a large windmill on the Rijzenhoofd, and the Zuiderkerk (South Church).[3] The sequence of landmarks is correct, but, characteristically, Rembrandt chose not to account for the reversal of the image when printed, creating a discrepancy that would have been immediately obvious to those familiar with the city.

Dating from a few years later, Rembrandt's spectacular *Landscape with the Three Trees* (fig. 85) is somewhat more traditional in conception, harkening back to Peter Paul Rubens's melodramatic late landscapes as engraved by Schelte Adamsz. Bolswert (fig. 84). Although a variety of figures populate the

FIG. 85. Rembrandt van Rijn, *The Landscape with the Three Trees*, 1643. Etching, drypoint, and engraving, 21.3 × 27.8 cm (8⅜ × 10¹⁵⁄₁₆ in.).

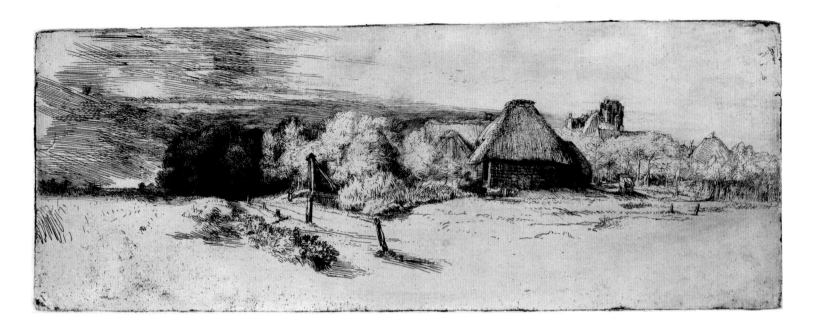

FIG. 86. Rembrandt van Rijn, *Landscape with Trees, Farm Buildings, and a Tower,* ca. 1650–1651. Etching and drypoint, 12 × 32.2 cm (4¾ × 12¹¹⁄₁₆ in.).

view, including a couple of lovers camouflaged in the bushes, they are entirely upstaged by the meteorological drama. As in *View of Amsterdam from the Kadijk,* the majority of the composition is taken up by the sky, which here features billowing clouds and rain showers. The heavens brighten immediately behind three closely connected trees that serve as the etching's main protagonists. Despite the vast scholarship devoted to this print, it remains one of Rembrandt's most fundamentally elusive creations. Its traditional title, like that of so many of his iconic works, was assigned by later cataloguers. While persuasive in its naturalism, attempts to pinpoint its actual site—and even the species of its trees—have proven inconclusive. And while the three trees are potentially rich symbols of both the Holy Trinity and the Three Crosses of Calvary, there is no proof that the artist saw them—or intended them—that way.

Rembrandt's *Landscape with Trees, Farm Buildings, and a Tower* of circa 1650–1651 (fig. 86) belongs to a quieter, humbler strain of Dutch landscapes by artists such as Pieter Molyn (fig. 87) that emphasize vernacular structures found in the

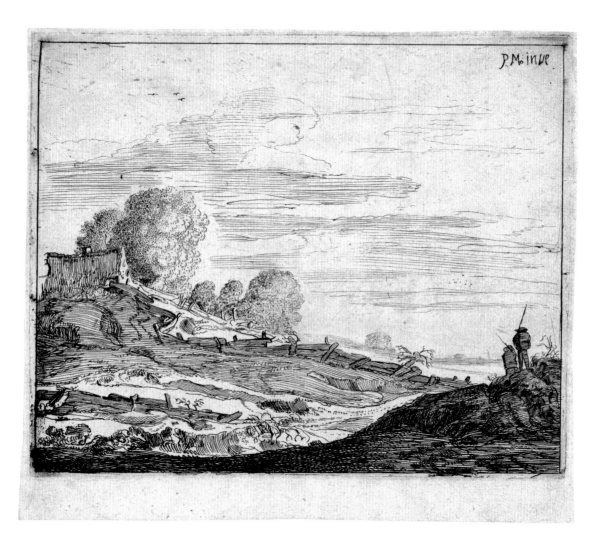

FIG. 87. Attributed to Cornelis van
Kittensteyn after Pieter Molyn,
Landscape with a Cottage on a Hill, from
a set of four landscapes, ca. 1629–1630.
Etching, 12.9 × 15.6 cm (5⅟₁₆ × 6⅛ in.).

countryside. Karel van Mander had advised young painters to observe "bizarre whimsies [such as] herders' huts and peasant hamlets in grottos, hollow trees and on stakes, with walls and roofs," and depict them "not with bright red tiles, but rather with turf of earth, reeds and straw, patches and holes; and plaster [them] whimsically and let moss grow on them."[4] Rembrandt focuses on the thatched farm buildings at the expense of a more upscale country house that is only partially glimpsed in the right background. His placement and handling of this structure reveals his relaxed attitude toward topographical and architectural precision. The house in question belonged to the government official Johannes Uytenbogaert, chief tax collector for the province of Holland, and a longtime friend and patron of Rembrandt. Its tower was topped with a turret and cupola that appear in the first two states of this print but were burnished out in the third and final state shown here, further suppressing its role in the composition.

A balance of topographical precision and artistic impression is achieved 'in the watercolors of Lambert Doomer, an artist long thought to have been a pupil of Rembrandt, but whose exposure to the master was more likely through his etchings, drawings, and paintings. The distinctive salt flats in the Breton fishing town of Le Croisic inspired one of Doomer's most extraordinary quasi-industrial landscapes (fig. 88). His brother Maerten, a wine merchant, had moved from Amsterdam to Nantes in the early 1640s, and Doomer paid him a visit in 1645. At that time he made a number of sketches, including a sheet representing the salt flats.[5] In the 1670s Doomer used his earlier drawings as the basis for a series of watercolors on ruled ledger paper. Of these works, *Salt Flats at Le Croisic* stands out with its combination of geometric raised walkways that make a grid of the evaporation pools, and the subtle washes of ink evoking the mutable light and atmosphere. Rising on the horizon is a slender church spire, most likely that of Saint-Guénolé in the adjacent community of Batz-sur-mer.[6] Between Doomer's visit to the site and his execution of the watercolor thirty years later, the wooden steeple had been destroyed by lightning and was in the process of being rebuilt in stone. Two figures derived

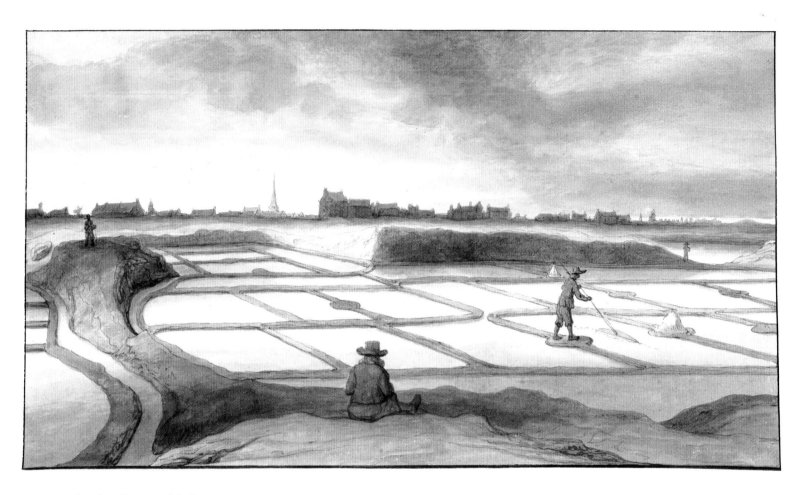

FIG. 88. Lambert Doomer, *Salt Flats at Le Croisic*, ca. 1671–1673. Brown ink and brown and gray washes on ledger paper, 24 × 41 cm (9⁷⁄₁₆ × 16⅛ in.).

from the original sketch serve important roles: in the middle ground a laborer rakes crystals of sea salt into mounds for collection, while a lone man seated on a slope in the foreground functions as a surrogate for the artist, taking in the view. Drained of nostalgia and literary association, Doomer's watercolor documents a developed environment segmented by artificial boundaries, a modern view organized by the rules of agriculture rather than academic principles of composition.

Moving south to Italy, the pastoral countryside around Rome provided abundant source material for seventeenth-century artists. Even painters not generally disposed to pure landscape such as Giovanni Benedetto Castiglione could not resist the rustic allure of the Campagna. Executed with quick calligraphic strokes, his nature study of a scraggly copse (fig. 89) has been dated to circa 1647–1651, when the artist was working in Rome.[7] The pen-and-ink sketch is not connected to a particular painting or etching, but was created as an independent study of the motif. Castiglione's drawing is a lively exercise in selective finish worthy of Rembrandt, with the greatest attention given to a hoary tree stump at the center of the sheet, stooped like an elderly figure.

For Claude Lorrain, the Campagna provided a natural extension of his studio and an infinite wellspring of inspiration. He filled his sketchbooks with studies of individual trees, rocks, streams, and waterfalls, as well as views of the distant mountains. Back in his Roman atelier, he worked to synthesize these disparate motifs into coherent compositions, first on paper (fig. 90) and then on canvas. Representing the intermediate stage of his working process, Claude's pen-and-wash drawing is one of a handful of compositional studies for his large painting *Landscape with Rural Dance*, completed in 1640–1641.[8] The setting is not the Campagna but the coast, with the horizon indicated by a single line and the sun by a simple circle. The dancing figures were added later, after the scenography was complete.

FIG. 89. Giovanni Benedetto Castiglione,
Pastoral Landscape, ca. 1647–1651.
Pen and brown ink, 27.5 × 39.6 cm
(10¹³⁄₁₆ × 15⁹⁄₁₆ in.).

FIG. 90. Claude Lorrain, *Landscape in the Campagna*, 1640–1641. Pen and brown ink and gray wash over black chalk and graphite, 21.9 × 31.6 cm (8⅝ × 12⁷⁄₁₆ in.).

Claude's considerable skills as a draftsman and painter were equaled by his abilities as an etcher. Like Rembrandt, he used the print medium to create original compositions exploring and exploiting the aesthetic possibilities of pure black and white. His etching of a herd passing through a pastoral landscape in stormy weather (fig. 91) represents an artful composition, with the view laid out in a rhythmic series of alternating dark and light registers set off against the repoussoir of the monumental ruin. The columns and architrave—among

FIG. 91. Claude Lorrain,
*The Herd Returning in Stormy
Weather*, ca. 1650–1651. Etching,
15.8 × 21.7 cm (6¼ × 8⁹⁄₁₆ in.).

the artist's favored architectural motifs—serve a formal as well as a thematic function, reminding the viewer that the quotidian activities of the rural inhabitants are timeless and will forever continue in the shadow of the decaying ancient wonders. Unusual is the presence of storm clouds and rain; the majority of Claude's landscapes are set in calm conditions.

Claude would rival Rembrandt in his influence on generations of European artists well into the nineteenth century. The prolific Florentine graphic artist Stefano della Bella, who learned etching from Callot's teacher Remigio Cantagallina, was one of countless followers in Claude's footsteps. His grand etched view of the Arch of Constantine with grazing sheep in the foreground and a portion of the Colosseum in the background (fig. 92) clearly demonstrates his grasp of Claude's classical landscape style with its predominant mood of peace and harmony.

At the same time, della Bella was fluent in a darker type of landscape that overlapped with the genre of contemporary history: the landscape of war. As modern Europe took shape over the course of the long and bloody century, there was much to fight over, including land, trade, and religion. The Thirty Years' War (1618–1648)—which broadly pitted the United Provinces, France, England, and Sweden against the Holy Roman Empire and Spanish Empire—is the backdrop of two extraordinary series of etchings by Callot known as *The Small Miseries of War* (1632) and *The Large Miseries of War* (1633). *The Hanging* (fig. 93), plate eleven of eighteen from the second series, represents the execution of soldiers who engaged in criminal behavior. The work has come to stand as an icon of the senseless violence of war, although Callot's personal point of view on the conflict is unclear. Della Bella's apocalyptic *Death Riding Across a Battlefield* (fig. 94), which dates from the final years of the Thirty Years' War, leaves no doubt as to the artist's perspective. The only victor on this field of battle is Death.

FIG. 92 (*facing*). Stefano della Bella, *The Arch of Constantine*, from the series *Six Large Views of Rome and the Countryside*, 1656. Etching, 32.1 × 27.1 cm (12⅝ × 10¹¹⁄₁₆ in.).

NOTES

1. Karel van Mander, *Den grondt der edel vry schilder-const*, ed. Hessel Miedema, 2 vols. (Utrecht: Haentjens Dekker & Gumbert, 1973), vol. 1, fol. 34–34v, verses 1 and 3, 202–205. I am grateful to Walter Gibson for providing me with his English translation of this passage.

2. Johan Bosch van Rosenthal, catalogue entry on Pieter Stevens's *Wooded River Landscape with a Bridge by a Village* in *In Arte Venustas, Studies on Drawings in Honour of Teréz Gerszi: Presented on Her Eightieth Birthday* (Budapest: Szépmüvészeti Múzeum, 2007), 71–72.

3. Christopher White, *Rembrandt as an Etcher: A Study of the Artist at Work*, 2nd ed. (New Haven and London: Yale University Press, 1999), 216.

4. Van Mander, *Den grondt der edel vry schilder-const*, ed. Miedema, vol. 1, fol. 35, verse 31, and fol. 37, verse 32, 212–215. English translation by Walter Gibson.

5. Wolfgang Schulz, *Lambert Doomer: Sämtliche Zeichnungen* (Berlin and New York: Walter de Gruyter, 1974), 59, no. 92 (collection of the Kunsthalle, Hamburg). See also Stijn Alsteens and Hans Buijs, *Paysages de France dessinés par Lambert Doomer et les artistes hollandais et flamands des XVIe et XVIIe siècles*, exh. cat. (Paris: Fondation Custodia, 2008), 104–109.

FIG. 93. Jacques Callot, *La Pendaison* (*The Hanging*), plate 11 in the series *Les Grandes Misères de la Guerre* (*The Large Miseries of War*), 1633. Etching, 8.8 × 18.9 cm (3⁷⁄₁₆ × 7⁷⁄₁₆ in.).

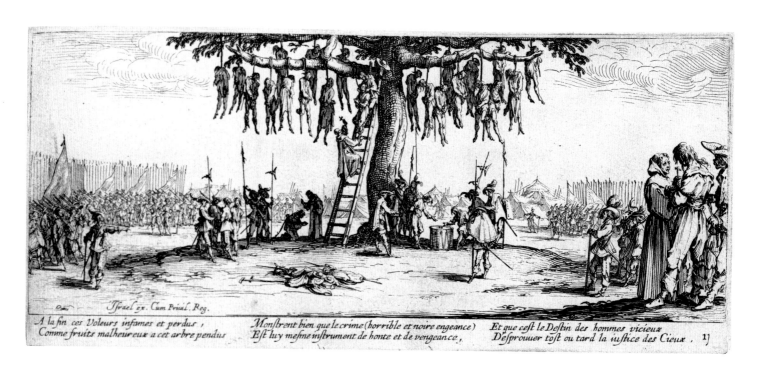

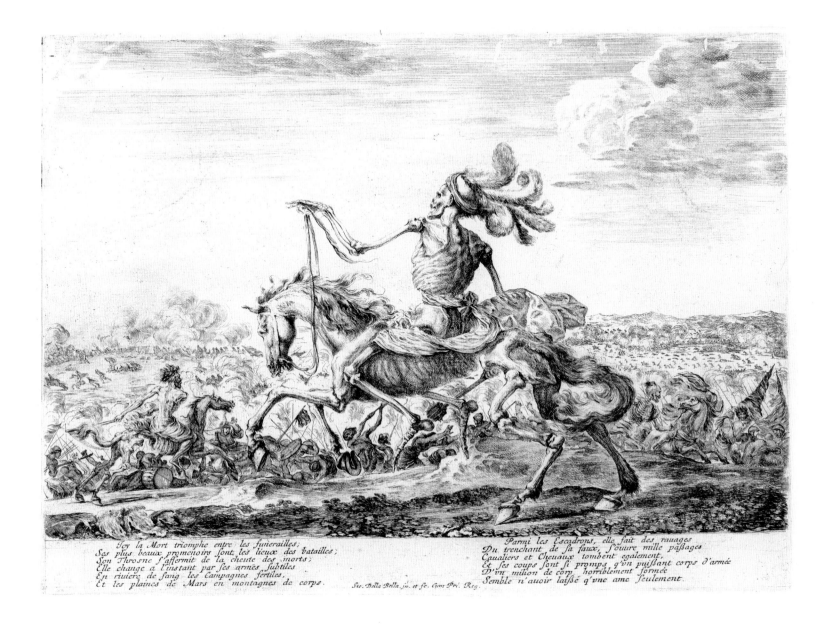

Icy la Mort triomphe entre les funerailles;
Ses plus beaux promenoirs sont les lieux des batailles;
Son Throsne s'affermit de la cheute des morts;
Elle change à l'instant par ses armes subtiles
En riviere de sang les Campagnes fertiles,
Et les plaines de Mars en montagnes de corps.

Parmi les Escadrons, elle fait des rauages
Du trenchant de sa faux, s'ouure mille passages
Caualiers et Cheuaux tombent egalement,
Et ses coups sont si promps, q'vn puissant corps d'armée
D'vn million de cors, horriblement formée
Semble n'auoir laissé q'vne ame seulement.

Ste. Della Bella in. et sc. Cum Pri. Reg.

6. Victor Adolfe Malte-Brun, *La France illustrée, géographie—histoire—administration—statistique* (Paris: J. Rouff, 1881), vol. 2, 27.

7. Ann Percy, "A Castiglione 'Album,'" *Master Drawings* 6, no. 2 (August 1968): 147, no. 5; and Ann Percy, *Giovanni Benedetto Castiglione: Master Draughtsman of the Italian Baroque*, exh. cat. (Philadelphia: Philadelphia Museum of Art, 1971), 76, no. 28.

8. See Marcel Röthlisberger, *Claude Lorrain: The Paintings* (New Haven: Yale University Press, 1961), vol. 1, 189–190, LV 53. The painting is illustrated in vol. 2, fig. 122, as in the collection of the Duke of Bedford, Woburn Abbey.

FIG. 94. Stefano della Bella, *Death Riding Across a Battlefield*, ca. 1646–1647. Etching and engraving, 22.2 × 30.1 cm (8¾ × 11⅞ in.).

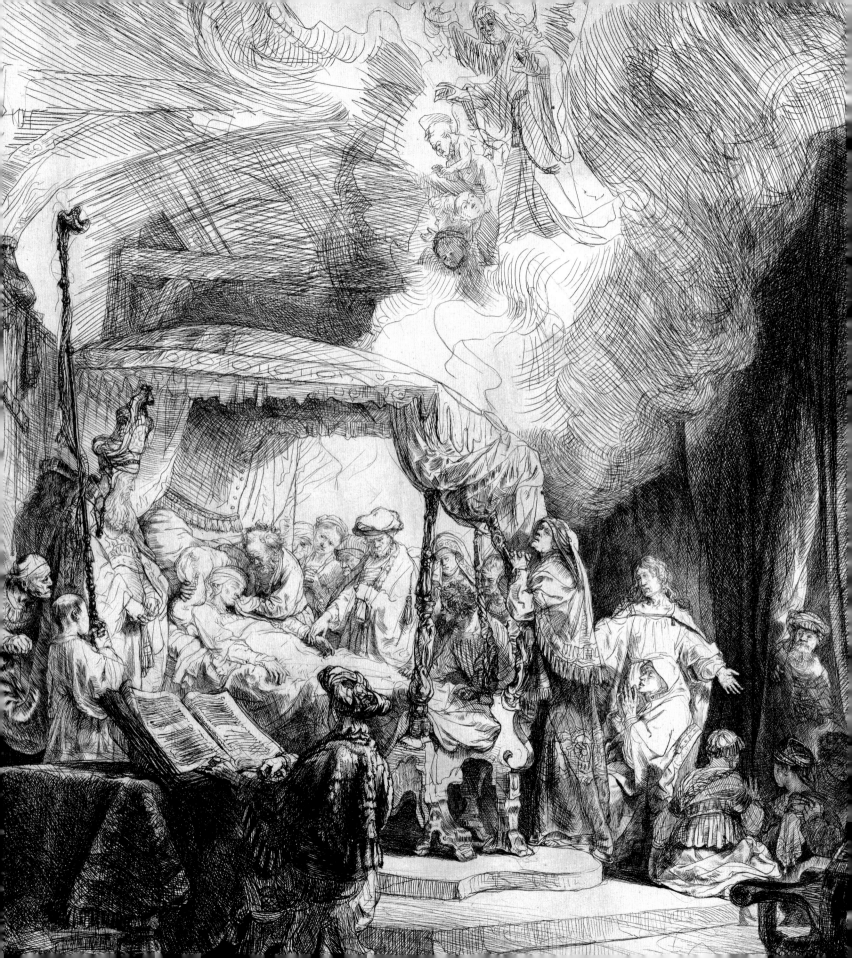

FROM WORD TO IMAGE

Rembrandt and History

A man of few recorded words, Rembrandt was a master storyteller in pictures. Determined from the beginning to avoid being confined to a lesser niche of painting faces or flowers, he instead sought to join his teacher Pieter Lastman on the art world's main stage, the realm of the history painter. There he found himself in a lively discourse with artists of the past, present, and future. In addition to depicting historic and current events, history painters in Rembrandt's century concocted elaborate allegories and spun narratives drawn from classical mythology and religion. Mastery of this genre required, in effect, mastery of all genres, as any history painting may include portrait likenesses, bodies at rest and in motion, animals (domestic and exotic), still life, architecture, and landscape, all working together to tell a coherent story. Packing these components into the small scale of a monochromatic print required another specialized set of skills that Rembrandt also mastered. Despite the prohibition against religious images in places of worship by the Dutch Calvinist Church, biblical subjects played an important role among Rembrandt's earliest paintings and

103

FACING Rembrandt van Rijn, *The Death of the Virgin*, 1639, detail of fig. 107.

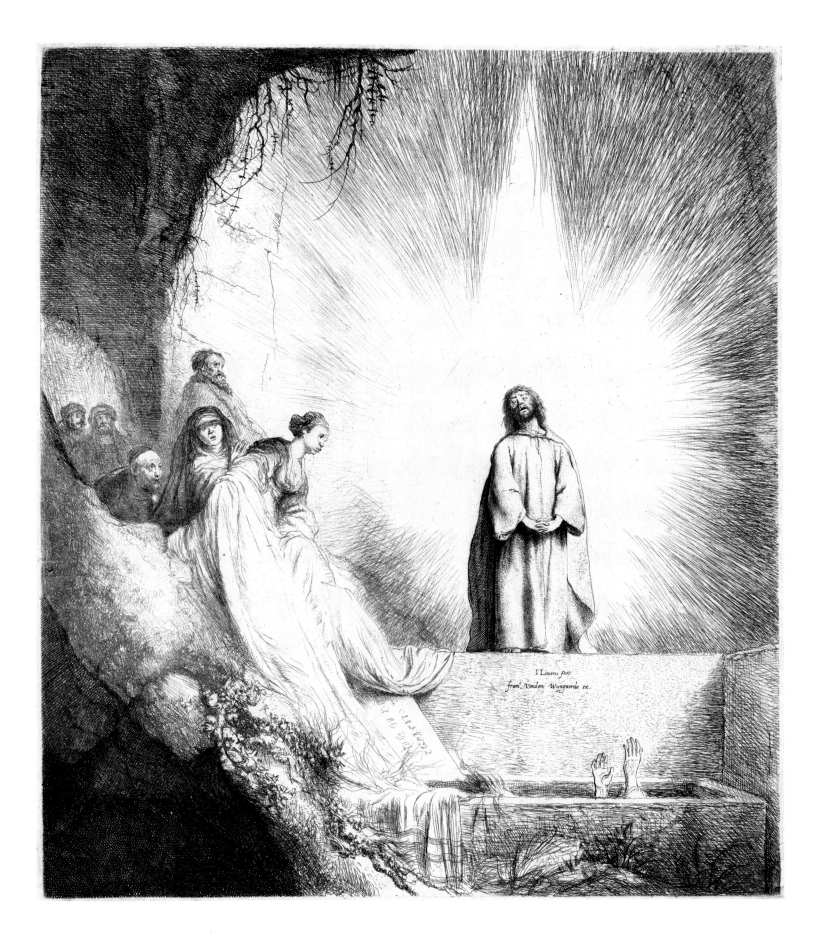

J Liuens fecit
fran. Vanden Wyngaerde ex.

etchings. These works were meant for private collectors, including such illustrious patrons as the historian Petrus Scriverius, Constantijn Huygens, and the stadtholder Frederik Hendrik of Orange.

Working near each other in Leiden, the young Rembrandt and Jan Lievens each treated the New Testament subject of the raising of Lazarus, portraying the miraculous moment when Christ commands the recently deceased brother of Martha and Mary Magdalene to rise from the grave. Lievens's painting (Brighton Museum and Art Gallery) and his etching (fig. 95) based on the painting are dated 1630–1631; Rembrandt's painting (Los Angeles County Museum of Art) and its associated etching (fig. 96) from the same period are undated, complicating attempts to sort out the relationship and chronology of these works. Lievens's etching is relatively faithful to his canvas, other than reversing its composition and tonality, while Rembrandt's print offers a decidedly different approach that shifts the perspective to a dynamic side view—as if from the wings of a stage rather than the front row—and alters the frame from a rectangle to an arch. In Rembrandt's hands, etching would never serve a strictly reproductive role; instead, it would offer an autonomous medium

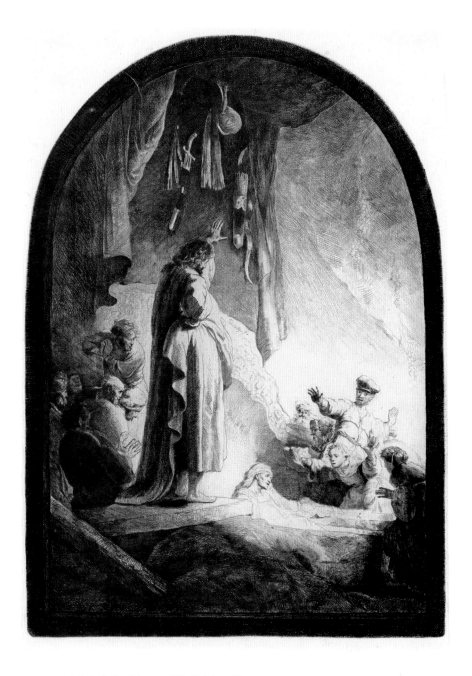

FIG. 95 (*facing*). Jan Lievens, *The Raising of Lazarus*, 1630–1631. Etching, 35.9 × 31.2 cm (14⅛ × 12⁵⁄₁₆ in.).

FIG. 96 (*above*). Rembrandt van Rijn, *The Raising of Lazarus* (The Larger Plate), ca. 1632. Etching and engraving, 36.3 × 25.4 cm (14⁵⁄₁₆ × 10¹⁄₁₆ in.).

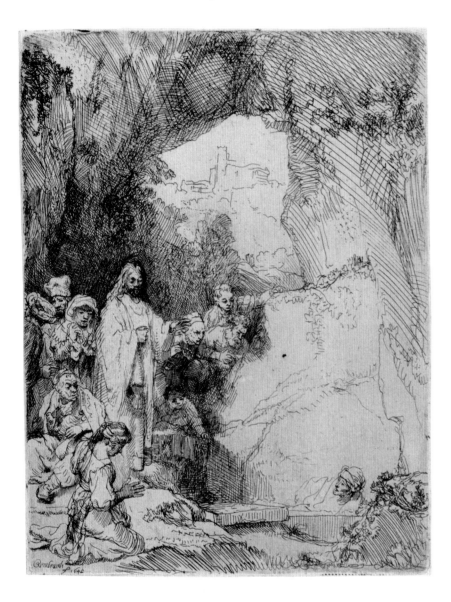

FIG. 97. Rembrandt van Rijn,
The Raising of Lazarus (The Small Plate),
1642. Etching, 15 × 11.1 cm (5⅞ × 4⅜ in.).

for original artistic expression with its own vocabulary and syntax.

In contrast to his earlier plate, Rembrandt's return to the subject in an etching created a decade later (fig. 97) is an exercise in restraint. Executed on a much smaller scale, it tones down the histrionic gestures and tempers the illumination, setting the miraculous event in the light of day. In addition, Rembrandt's graphic language has undergone a radical shift from controlled to expressive use of line. When Giovanni Benedetto Castiglione etched a nocturnal *Raising of Lazarus* around 1647–1651 (fig. 98), during a period when he was particularly responsive to Rembrandt's etchings, he seems to have been inspired by the more dramatic chiaroscuro of the earlier print.

Ultimately, the theatrical lighting effects of Rembrandt, Lievens, and Castiglione might be traced to a common source: Michelangelo Merisi da Caravaggio (1571–1610), who cast a long and broad shadow indeed. The self-taught radical painter jolted the art world with his spotlit naturalism in a series of striking canvases begun in the 1590s in Rome and subsequently continued in Naples and Sicily. Compared with the idealized progeny of the academic tradition, such as Guercino's delicately featured characterization of the youngest apostle in *Saint John the Evangelist Meditating the Gospel* (fig. 99), Caravaggio's sacred figures look as if they just walked in off the street—or, more precisely, out of some dark alley in a bad Roman neighborhood—and his harsh chiaroscuro makes them

<small>FIG. 98.</small> Giovanni Benedetto Castiglione,
The Raising of Lazarus, ca. 1647–1651.
Etching, 22.3 × 31.7 cm (8¾ × 12½ in.).

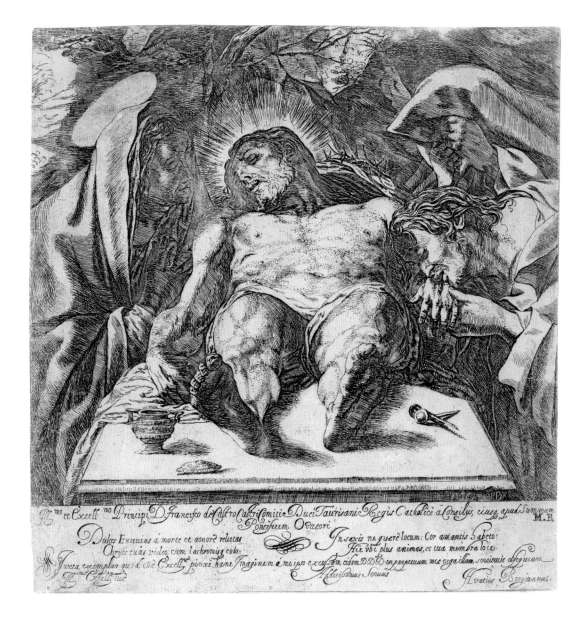

appear startlingly real. His influence quickly spread to Spain, France, and the Netherlands, where he had a particular following in Utrecht. A print such as Orazio Borgianni's *Lamentation* (fig. 100), while clearly indebted in its foreshortened composition to the famous precedent of Andrea Mantegna's *Lamentation* of circa 1480 (Pinacoteca di Brera, Milan), presents the stone-cold cadaver of Christ in a harsh light that reflects the artist's exposure to Caravaggio. In Naples, Jusepe de Ribera painted and etched (fig. 101) a Caravaggesque bacchanal that revels in the naturalistic repulsiveness of the drunken Silenus's flaccid

FIG. 99 (*facing*). Guercino (Giovanni Francesco Barbieri), *Saint John the Evangelist Meditating the Gospel*, ca. 1645–1650. Pen and brown ink, 21.8 × 19.9 cm (8⁹⁄₁₆ × 7¹³⁄₁₆ in.).

FIG. 100 (*above*). Orazio Borgianni, *The Lamentation*, 1615. Etching, 23.4 × 21.6 cm (9³⁄₁₆ × 8½ in.).

body. Surely at home in their company would be Rembrandt's *Diana at the Bath* of circa 1631 (fig. 102), in which a classical goddess is portrayed as a middle-aged Dutch woman with a sagging belly, wrinkled skin, and cellulite. That kind of unidealized figure inspired poet Andries Pels to write of Rembrandt in 1681:

> When he painted a nude woman, as sometimes occurred,
> No Greek Venus did he choose, oh no, upon my word
> His model was a laundress from a hut or a turf treader,
> His error he explained away as following Dame Nature,
> And all else as idle decoration. Drooping breasts,
> Misshapen hands, marks left on flesh all pinched and pressed

FIG. 101. Jusepe de Ribera, *Drunken Silenus*, 1628. Etching, 26.6 × 33.8 cm (10½ × 13⅝ in.).

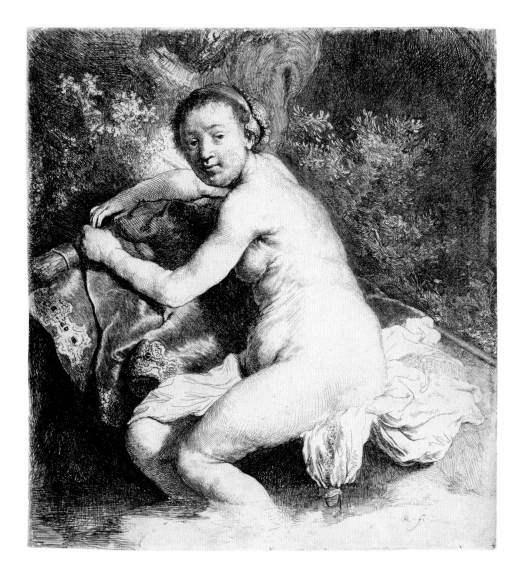

By tightly laced-up corsets, garter bands that legs constrain,

It all must be depicted or risk nature's high disdain;

His, at least, which brooked no rules, nor did he yet believe

In molding human limbs into proportions bound to please,

Correct perspective, rules of art, he did not utilize,

Preferring simply to depict whatever filled his eyes.[1]

Notable in his absence from this representation is Actaeon, the Theban huntsman who, in Ovid's telling of the myth, stumbled on the bathing Diana and as punishment was changed into a stag and killed by his own dogs. But the

ill-fated voyeur is not entirely missing, for Rembrandt effectively places the viewer in his role. In this way, the moralizing aspect of the story as a warning against lustful temptation is made personal.

In his treatment of certain historical subjects, Rembrandt turned to his growing print collection for inspiration. One of the first clear instances of his reliance on a printed prototype is his etching *The Return of the Prodigal Son* of 1636 (fig. 103), which he closely patterned after a sixteenth-century woodcut

of the same subject designed by the Dutch painter-printmaker Maerten van Heemskerck.[2] Specific features of the setting may be traced to Heemskerck's print, such as the arched opening onto a distant view of the killing of the fatted calf (a slightly later part of the story), but Rembrandt's poignant portrayal of the father's embrace of his penitent son is all his own.

When Ferdinand Bol, Rembrandt's student, created a lively pen-and-brush drawing of the same subject a few years later (fig. 104), he in turn closely

FIG. 104. Ferdinand Bol, *The Return of the Prodigal Son*, ca. 1640. Pen and brown ink, brush and brown wash, 14.2 × 18 cm (5⁹⁄₁₆ × 7¹⁄₁₆ in.).

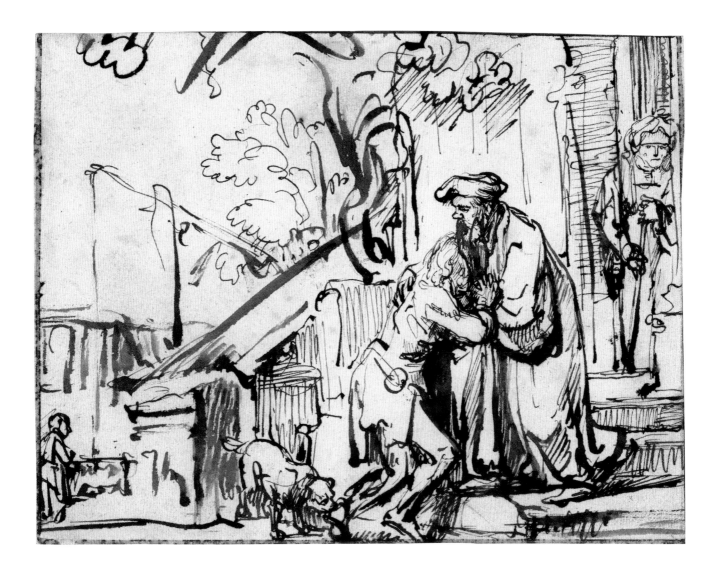

modeled his staging of the story on his master's printed prototype. As in Rembrandt's version, Bol's narrative focuses on the pivotal moment of embrace and forgiveness. The fatted calf appears in the lower left corner of the sheet and a small dog has been added, symbolizing loyalty and sniffing at the heels of the prodigal. Another drawing modeled on a Rembrandt prototype, *The Fall of Man* (fig. 105), is attributed to Constantijn Daniel van Renesse, an amateur who studied with the master around 1650. Satan peers at the ashamed Adam and Eve from behind the Tree of Knowledge just as Death stalks young couples in northern Renaissance prints. The three figures relate closely to a sheet in the collection of the Morgan Library, New York, but are rearranged. Corrections to the placement of Eve's arms are thought to be by the hand of Rembrandt himself.[3]

Rembrandt's richly detailed etching of *The Death of the Virgin* of 1639 (fig. 107), his most ambitious history print to that date, borrows freely from several print sources, most notably works by Albrecht Dürer. In February 1638 Rembrandt had acquired at auction a large quantity of Dürer's prints, including multiple sets of *The Life of the Virgin* woodcuts.[4] Dürer's stagings of *The Birth of the Virgin* (fig. 106) and *The Death of the Virgin* seem to have particularly informed Rembrandt's composition.

Rembrandt went on in 1653 to create two prints representing religious subjects that, for their landscape settings, incorporate or reference inventions of other artists whose work he evidently admired. *The Flight into Egypt* (fig. 108) provides one of the most fascinating examples of artistic appropriation in his oeuvre. Much of the landscape is the work of Hercules Segers, a fabled Dutch painter-printmaker who died around 1638. Rembrandt owned a number of Segers's paintings and at some point acquired his original copperplate dating from circa 1620 that depicted Tobias and the Angel (Segers had, in turn, appropriated his figures from Hendrik Goudt's 1613 engraving of *Tobias, with the Angel, Dragging the Fish* after Adam Elsheimer; see fig. 116). Perhaps as an experiment, he proceeded to burnish out Segers's figures, replacing them with the Holy Family but leaving portions of the angel's wings visible in the tree line at

FIG. 105 (*facing*). Constantijn Daniel van Renesse, *The Fall of Man*, ca. 1650. Pen and brown ink, brown and gray washes, and opaque watercolor over red and black chalks, 21.2 × 16 cm (8⅜ × 6⁵⁄₁₆ in.).

FIG. 106 (*right*).
Albrecht Dürer, *The Birth of the Virgin,* from the series *The Life of the Virgin,* 1503–1505. Woodcut, 29.3 × 20.8 cm (11⁹⁄₁₆ × 8³⁄₁₆ in.).

FIG. 107 (*facing*).
Rembrandt van Rijn, *The Death of the Virgin,* 1639. Etching and drypoint, 40.9 × 31.4 cm (16¹⁄₈ × 12³⁄₈ in.).

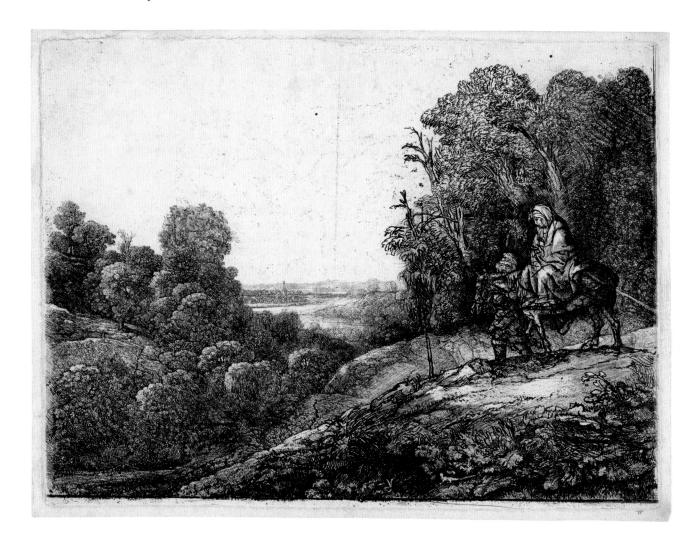

FIG. 108. Rembrandt van Rijn, *The Flight into Egypt* (altered from Hercules Segers), 1653. Etching, engraving, and drypoint, 21.3 × 28.3 cm (8⅜ × 11⅛ in.).

the upper right. In Rembrandt's *Saint Jerome Reading in an Italian Landscape* (fig. 109), an etching that maintains a perfect balance of finished and unfinished passages, the hilly backdrop with a group of buildings recalls the graphic work of the sixteenth-century Venetian artist Domenico Campagnola (fig. 110).

The following year Rembrandt produced a series of six modestly scaled etchings representing scenes from the childhood of Christ that successfully combine the spiritual and the mundane. His etching *Christ Returning from the Temple with His Parents* (fig. 111), a rarely represented subject, could almost be mistaken

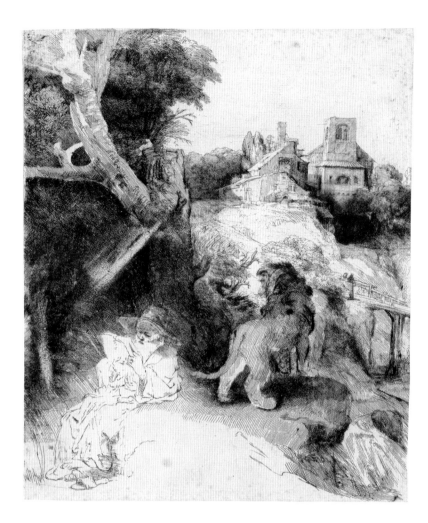

FIG. 109 (*left*). Rembrandt van Rijn,
Saint Jerome Reading in an Italian Landscape,
ca. 1653. Etching, engraving, and drypoint,
25.6 × 20.9 cm (10¹/₁₆ × 8¼ in.).

FIG. 110 (*below*). Domenico Campagnola,
Hilly Landscape with Woman and Donkey,
ca. 1550–1564. Pen and brown ink,
24.6 × 38.3 cm (9¹¹/₁₆ × 15¹/₁₆ in.).

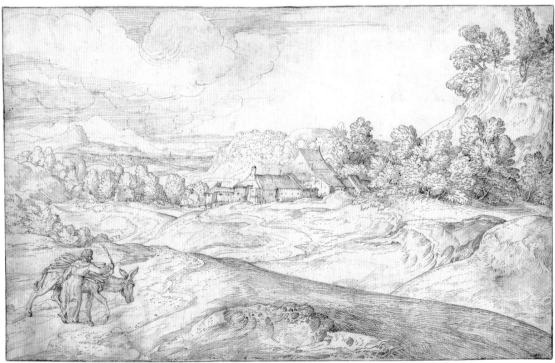

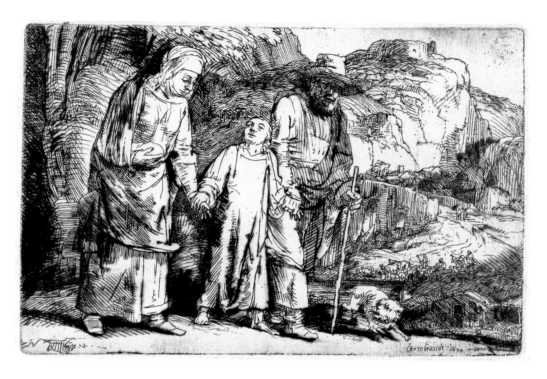

FIG. 111. Rembrandt van Rijn, *Christ Returning from the Temple with His Parents*, 1654. Etching and drypoint, 9.5 × 14.6 cm (3¾ × 5¾ in.).

for a depiction of a simple family outing. Having found their missing twelve-year-old son disputing scriptures with the priests and scholars in the temple, Christ's parents walk him home from Jerusalem, tightly clutching his hands. It is an accessible moment in the life of Christ expressed in touching human terms.

During this same decade Rembrandt formulated an unidealized, ethnically accurate portrayal of Jesus Christ that was one of his most iconoclastic innovations.

He sought and found the face of Jesus in the Jewish quarter of Amsterdam, casting an anonymous young Sephardic Jew in this special role in a series of portrait studies.[5] Within his printed oeuvre, Rembrandt's etching of *Christ Preaching* of the mid-1650s (fig. 112) is one of his more ambitious and original contributions to Christian iconography. No longer a colossus, as he was in the first version of *The Raising of Lazarus*, or fair-haired as in the second version, the barefoot Christ is not even the tallest figure in this gathering. Nor is anything overtly miraculous happening: Christ preaches, the faithful listen, and a bored little boy in the foreground draws with his finger in the dirt.

NOTES

1. Eric Jan Sluijter, *Rembrandt and the Female Nude*, Amsterdam Studies in the Dutch Golden Age (Amsterdam: Amsterdam University Press, 2006), 196 (translation credited to Diane Webb).

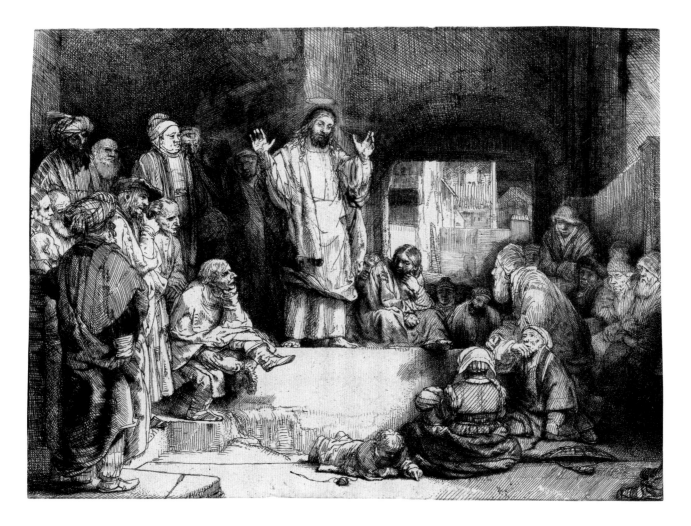

FIG. 112. Rembrandt van Rijn, *Christ Preaching*, ca. 1654–1657. Etching, engraving, and drypoint, 15.3 × 20.7 cm (6 × 8⅛ in.).

2. Christopher White, *Rembrandt as an Etcher: A Study of the Artist at Work*, 2nd ed. (New Haven and London: Yale University Press, 1999), 36–37.

3. The Achenbach and Morgan Library drawings are discussed together in Winslow Ames, "A Rembrandt Composition Remodeled," *The Art Quarterly* 17, no. 1 (Spring 1954): 60–62. See also Holm Bevers, Lee Hendrix, William W. Robinson, and Peter Schatborn, *Drawings by Rembrandt and His Pupils: Telling the Difference,* exh. cat. (Los Angeles: The J. Paul Getty Museum, 2009), 182–195.

4. Walter L. Strauss and Marjorn van der Meulen, eds., *The Rembrandt Documents* (New York: Abaris Books, 1979), 150, document 1638/2, Rembrandt's purchases at the sale of Gommer Spranger's collection.

5. These works formed the core of the 2011–2012 exhibition *Rembrandt and the Face of Jesus* held at the Philadelphia Museum of Art, Musée du Louvre, and Detroit Institute of Arts; *Rembrandt and the Face of Jesus*, ed. Lloyd DeWitt, exh. cat. (Philadelphia: Philadelphia Museum of Art, 2011).

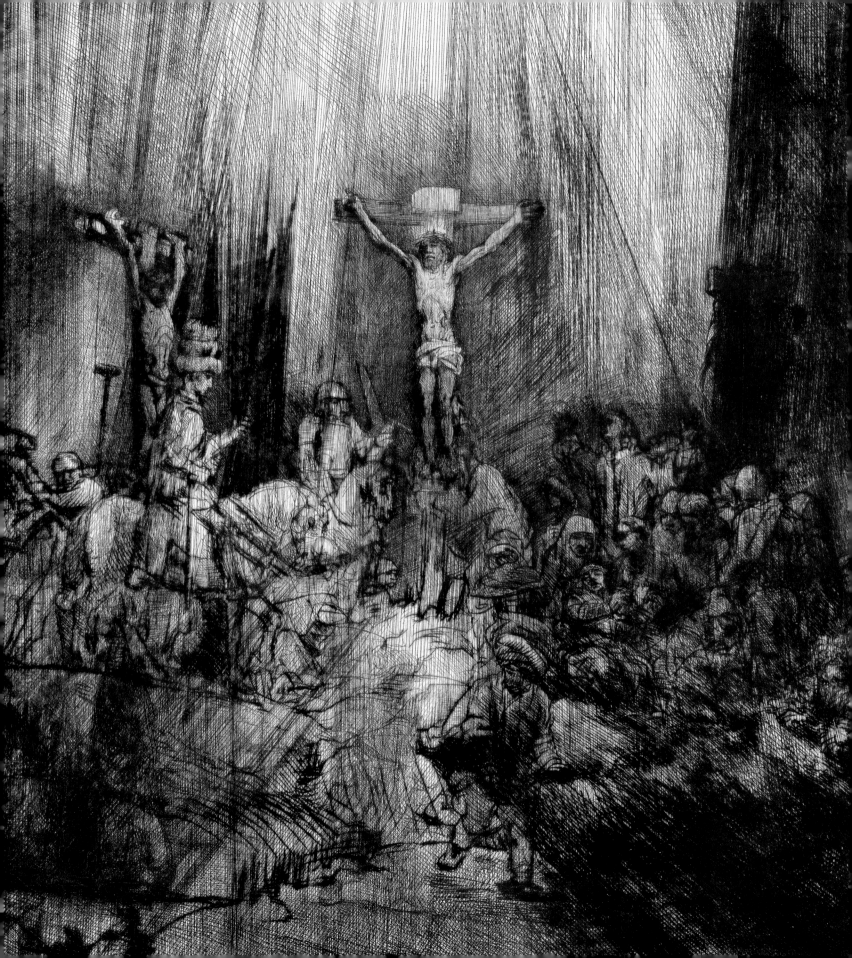

ART OF DARKNESS

Most seventeenth-century prints are binary in nature. Their visual drama derives in part from the interaction of liquid ink and absorptive paper (or, occasionally, vellum). More striking yet, the graphic interplay of black and white—the blackness of the ink and the whiteness of the paper—defines the aesthetic of the majority of printed images. These two forces may work together in harmony, but the balance of power can shift. As a mature printmaker, Rembrandt never shied away from extremes, even within a single etching. He frequently juxtaposed fully developed areas of a composition against summarily sketched or open expanses of unmarked paper; compare, for instance, the foreground and background of his enigmatic etching of a scholar startled by a blinding apparition of light in his darkened study (fig. 113). Rembrandt was also particularly drawn to stories of physical blindness such as the apocryphal tale of Tobit, whom the artist last depicted stumbling sightlessly toward his door in an etching of 1651 (fig. 114).[1] Willing to take his darkest etchings to places where few painters or printmakers had gone before, Rembrandt pushed the art of darkness to the very edge of perception.

FACING Rembrandt van Rijn, *Christ Crucified Between Two Thieves* (*The Three Crosses*), 1653, detail of fig. 121.

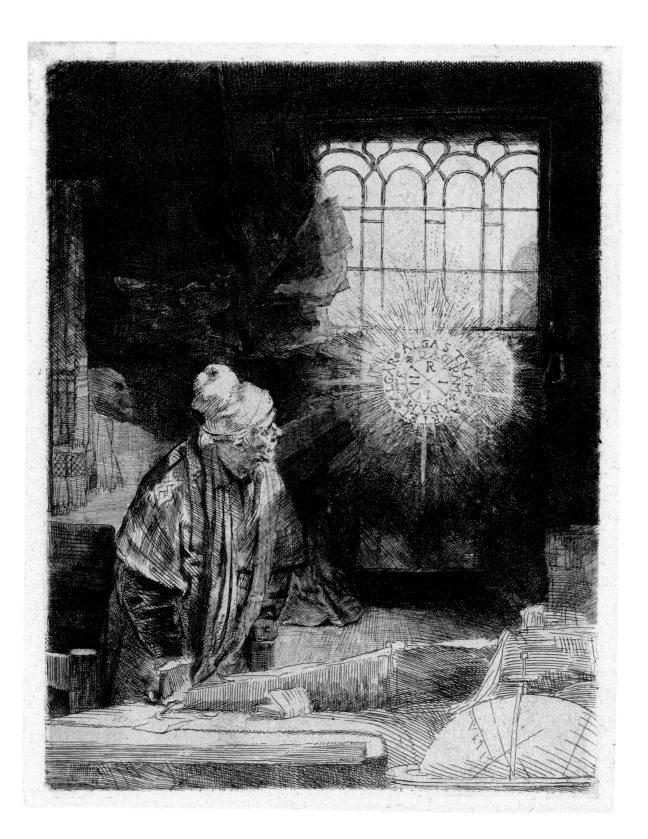

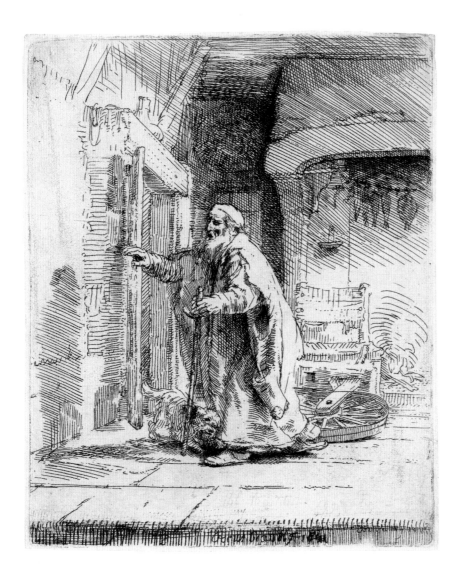

The aesthetic possibilities of extreme darkness were explored at the turn of the seventeenth century in the nocturnal paintings of Adam Elsheimer and the prints of Hendrik Goudt. Elsheimer was a German artist active in Rome who specialized in the mysterious effects of moonlit landscapes and dark interiors faintly illuminated by the flicker of candlelight. Goudt, a Dutch painter-printmaker, worked closely with Elsheimer starting around 1604. They lived

FIG. 113 (*facing*). Rembrandt van Rijn, *A Scholar in His Study* (*Faust*), ca. 1652. Etching, drypoint, and engraving, 21.1 × 16 cm (8⁵⁄₁₆ × 6⁵⁄₁₆ in.).

FIG. 114 (*above*). Rembrandt van Rijn, *The Blindness of Tobit* (The Larger Plate), 1651. Etching and drypoint, 15.7 × 12.6 cm (6³⁄₁₆ × 4¹⁵⁄₁₆ in.).

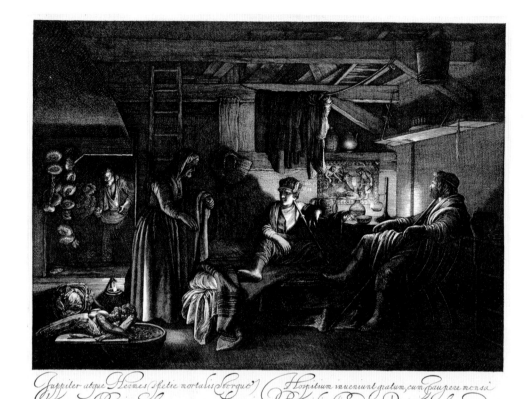

FIG. 115 (*above*). Hendrik Goudt after Adam Elsheimer, *Jupiter and Mercury in the House of Philemon and Baucis*, 1612. Engraving, 21.7 × 22.4 cm (8⁹⁄₁₆ × 8¹³⁄₁₆ in.).

FIG. 116 (*facing*). Hendrik Goudt after Adam Elsheimer, *Tobias, with the Angel, Dragging the Fish* (The Large Tobias), 1613. Engraving, 25.4 × 27.2 cm (10 × 10¹¹⁄₁₆ in.).

together for a period of time, and out of their brief, not clearly defined affiliation (artist and . . . pupil? patron? dealer?) came a total of seven reproductive engravings, two produced in Rome and the other five in Utrecht, where Goudt settled after Elsheimer's death in 1610 (figs. 115, 116). In prints such as *Jupiter and Mercury in the House of Philemon and Baucis* (fig. 115)—which provided Rembrandt with the model for Christ (Jupiter) in his painting of *The Supper at Emmaus* now in the Jacquemart-André Museum, Paris—Goudt achieved his intense blacks by a rigorous, even obsessive, technique in which he so densely engraved his networks of lines that they blended into areas of continuous tone. Goudt's skill with the burin extended into the specialized realm of calligraphy, which he executed with panache in the inscription fields of his prints.

TOBIAS caei sequitur cum iussa parentis, Nam Gonium comitemque auersoremque malorum
Commeruit magni numinis auxilium: Nactus, lustrato perfruitur thalamo.

HGoudt Palat. Comes, et Aur. Mil. Eques.

A° 1613

FIG. 117. Jan van de Velde II after Willem Buytewech, *The White Cow*, 1622. Etching and engraving, 16.9 × 22.4 cm (6⅝ × 8¹³⁄₁₆ in.).

One of the first to take up Goudt's style and technique was Jan van de Velde II, an immensely talented landscapist who had trained with his father, a noted calligrapher, and the engraver Jacob Matham, Goltzius's star pupil and stepson. In Van de Velde's print known as *The White Cow*, 1622 (fig. 117), a farmer and his wife head off to market beautifully silhouetted against the radiance of an unseen sunrise. His sensitive treatment of the sky, distant landscape, and foreground vegetation is patterned closely after the setting of Goudt's *Tobias, with the Angel, Dragging the Fish* (fig. 116). Van de Velde's *Sorceress* of 1626 (fig. 118) is a Boschian spectacle of witchcraft in which a curiously young and beautiful sorceress summons a group of grotesque creatures in the black of night.

Rembrandt followed closely in the footsteps of Goudt and Van de Velde in his first great "dark-manner" etching, *The Annunciation to the Shepherds* of 1634

Quantum malorum clausa nullo limite
Cogit libido, quamque dulci Carmine

Puriſsimas mortalium mentes rapit
Furias in omnes: sed cito quam fallimur.

Vitam brevem breve gaudium Mors occupat;
Momentulum quod videt aeternum dolet.

G. van Schagen Excudit. I.A.B.

FIG. 118. Jan van de Velde II, *The Sorceress*, 1626. Etching and engraving, 21.3 × 28.6 cm (8⅜ × 11¼ in.).

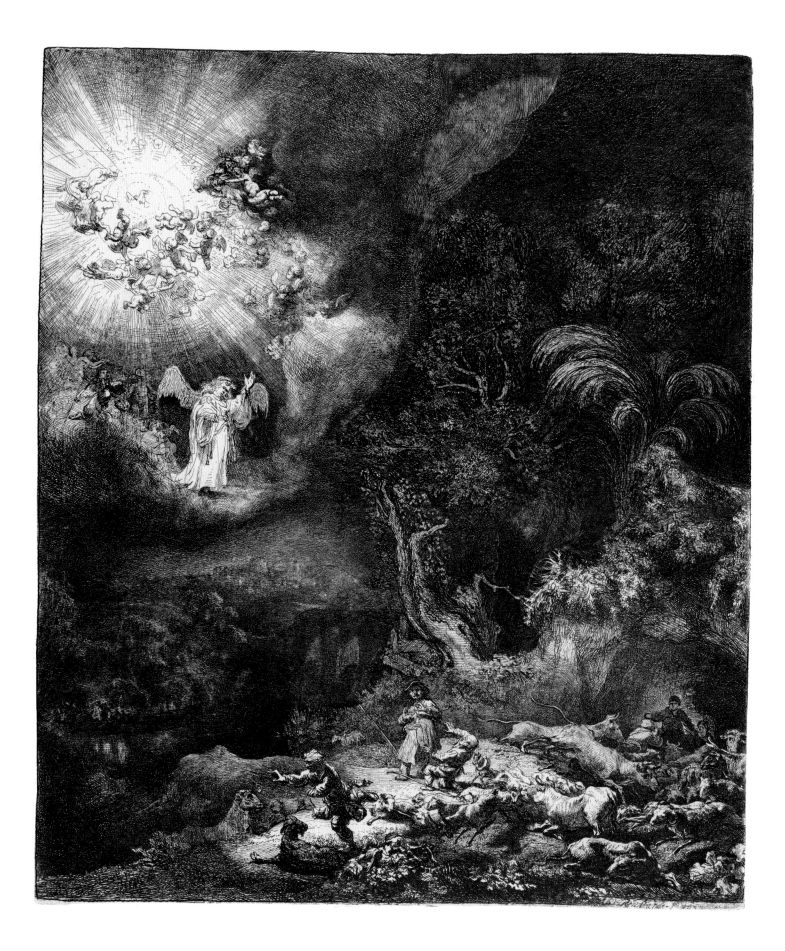

(fig. 119). Above a deep and mysterious nocturnal landscape, a blazing vision of heavenly light accompanies an angel who has come to announce Jesus's birth. The pyrotechnics inadvertently frighten the shepherds and their animals, scattering them in all directions. Rembrandt used a variety of techniques to achieve the subtle tones and textures of this print, including etched lines, engraving, drypoint, and acid applied directly to his copper plate to corrode its surface, thereby achieving tone without line. He went on to explore the depths of blackness in a series of increasingly dramatic etchings carried out in the 1650s. In *The Flight into Egypt: A Night Piece* (fig. 120), a small print of 1651, Joseph's lantern is the only source of light and the only patch of paper left visible. In each successive state, Rembrandt intensified his crosshatching to the point where the Holy Family and their donkey are barely discernible.

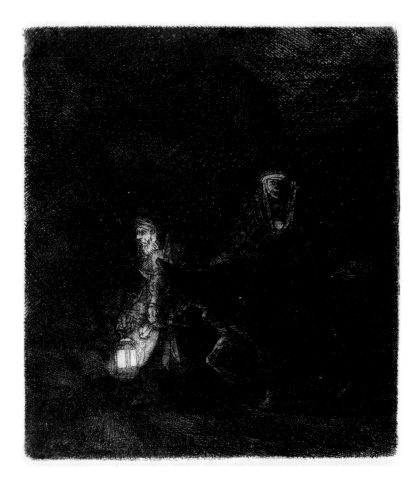

FIG. 119 (*facing*). Rembrandt van Rijn, *The Annunciation to the Shepherds*, 1634. Etching, engraving, and drypoint, 26.2 × 21.9 cm (10⁵⁄₁₆ × 8⅝ in.).

FIG. 120 (*left*). Rembrandt van Rijn, *The Flight into Egypt: A Night Piece*, 1651. Etching and drypoint, 12.8 × 11 cm (5 × 4⅜ in.).

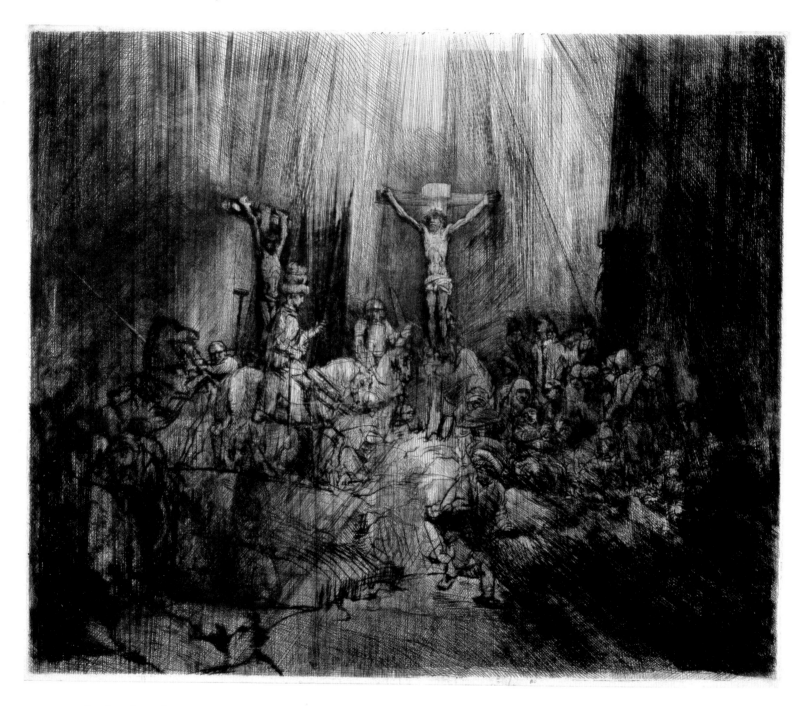

FIG. 121. Rembrandt van Rijn,
Christ Crucified Between Two Thieves
(*The Three Crosses*), 1653. Drypoint,
38.5 × 45.3 cm (15³⁄₁₆ × 17¹³⁄₁₆ in.).

Christ Crucified Between Two Thieves (*The Three Crosses*) (fig. 121) is one of Rembrandt's most powerful artistic statements in black and white. Conceived on the scale of a small painting, it corresponds to a passage in the Gospel of Saint Luke (23:44–48): "It was now about noon and darkness came over the whole land until three in the afternoon, while the sun's light failed; and the curtain of the temple was torn in two. Then Jesus, crying with a loud voice, said, 'Father, into your hands I commend my spirit.' Having said this, he breathed his last." A standard biblical subject among painters and printmakers, the death of Christ on the cross had never been depicted with such graphic intensity or raw expressive force. The plate is entirely executed with drypoint, that is, gouged into the copper with a sharp point rather than etched through a wax ground. Rembrandt conceives the culmination of Christ's suffering as a battle of dark versus light in which countless rays of shadow rain down like inky projectiles from the sky, a curtain of despair falling inexorably on the chaos below. *The Three Crosses* is a tour de force of draftsmanship and printmaking in which emotion eclipses intelligibility.

Rembrandt followed this print with the smaller but no less powerful *Descent from the Cross by Torchlight* (fig. 122), one of four etchings of scenes from the life of Christ he created in a similar format in 1654, perhaps with a series in mind. It is a peculiar composition centered on the right leg of a man struggling to support the lifeless body of Christ as it is lowered from the cross. Illuminated by the torch in the upper left corner, the brightest part of the nocturnal scene is the winding sheet and the legs of Christ, whose right foot is still nailed to

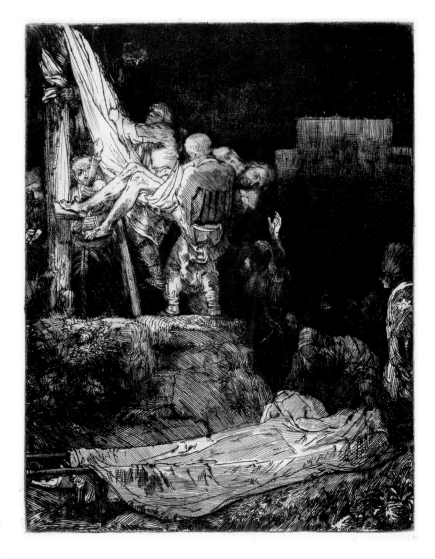

FIG. 122. Rembrandt van Rijn, *The Descent from the Cross by Torchlight*, 1654. Etching and drypoint, 21 × 16.2 cm (8¼ × 6⅜ in.).

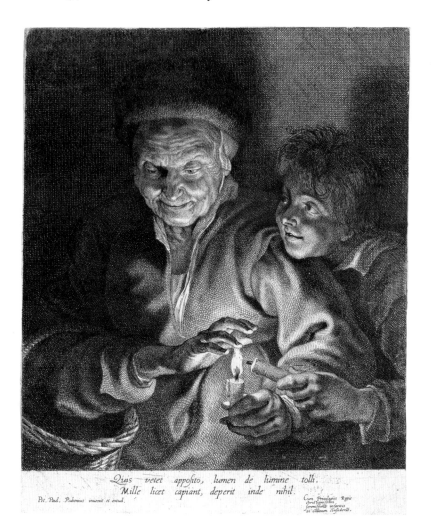

Qius vetet appofito, lumen de lumine tolli.
Mille licet capiant, deperit inde nihil.

Pet. Paul. Rubenus invenit et excud.

Cum Privilegiis Regis
chriftianiffimi
ferenifsifsimæ vel sanctæ
et celsium Confæderat.

the cross. In the lower foreground Joseph of
Arimathea, partially obscured in shadow, lays
out a linen shroud to receive the body. The dra-
matic chiaroscuro is softened by the many subtle
areas of velvety drypoint burr—the tiny bits of
copper that form a ridge along the incised lines
and catch ink—and retroussage, the use of a
muslin to coax ink out of the etched and incised
lines. Works like this one helped establish an
alternate set of criteria for print connoisseurs,
for whom the aesthetic of the blur would come
to be prized over the sharp line. In graphic
terms, Rembrandt's dark-manner etchings
marked the ultimate triumph of the irrational
over the rational.

Not all tenebrist images are concerned with
the religious spectacle or the supernatural; a long
tradition of candlelit genre scenes runs through
much of the seventeenth century, as well. One
of the first such pictures to be carried out in the
Netherlands was Rubens's small painting from
circa 1616–1617 of *An Old Woman and a Boy with
Candles* (Mauritshuis, The Hague), which reflects
his exposure to the art of Caravaggio during the eight years he spent in Italy.
Although he never sold the panel, he circulated it in the form of a reproduc-
tive print that he published during the 1620s (fig. 123) with a Latin inscription
quoting Ovid's *Art of Love*: "Who would forbid light to be taken from another
light presented? Even if thousands do so, nothing is lost from it."[2] The flame is
unseen, but the warmth of its glow as transmitted through paper and flesh
is the true subject of a mid-century painting of a singing youth (fig. 124) by a

s. v. Oftade fecit et excud.

follower of Georges de La Tour (1593–1652), who specialized in similar dramatic effects. Adriaen van Ostade combines two Golden Age conventions of mise-en-scène—candlelight and the figure emerging from an open window—in his etching of a group of *rederijkers* (rhetoricians) reciting poetry of circa 1668 (fig. 125). Ostade's construction of this image and its lighting impart an uncanny illusion of three-dimensionality, as both the man holding the candle and the orator seem to project from the dark shadows of their guild house into the viewer's space. His treatment of this subject mirrors several oils by the Leiden painter Jan Steen, who lived in Ostade's hometown of Haarlem during the 1660s, but the uncertainties of dating the print and the related paintings muddles the question of priority.[3]

The Dutch artist Godfried Schalcken merged the candlelight genre with portraiture and transported it to the burgeoning art market of London. There in 1694 he painted a nocturnal self-portrait in which he holds a candle in his bare hand, and commissioned a reproduction in mezzotint by the leading British printmaker

FIG. 125 (*above*). Adriaen van Ostade, *Rhetoricians at a Window (The Singers)*, ca. 1668. Etching, 24 × 19.1 cm (9⁷⁄₁₆ × 7½ in.).

FIG. 126 (*facing*). John Smith after Godfried Schalcken, *Self-Portrait of Godfried Schalcken*, ca. 1694. Mezzotint, 34.2 × 25.1 cm (13⁷⁄₁₆ × 9⁷⁄₈ in.).

and publisher, John Smith (fig. 126; see also Smith's portrait of Grinling Gibbons, fig. 24). The development of mezzotint engraving marked a culmination, of sorts, of a larger international movement toward tonal printmaking in which Rembrandt was a key figure.[4] In the distinctive process of mezzotint, a special serrated tool (a rocker) is used to systematically roughen a copper plate, creating a surface that, if inked, would print uniformly black. The artist then scrapes

Godfridus Schalcken

Hanc suam Effigiem pinxit Londini 1694

I. Smith fec: & exc:

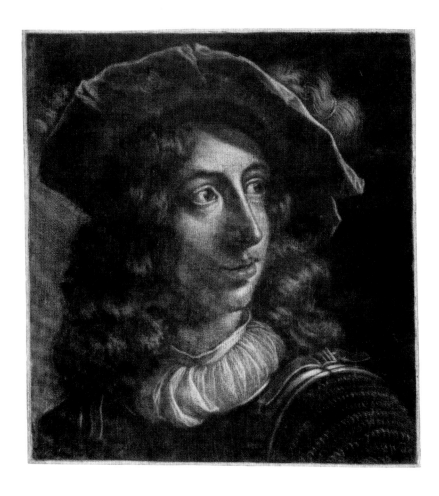

FIG. 127 (*above*). Prince Rupert of the Rhine after Pietro della Vecchia, *"The Little Lansquenet"* or *Standard-Bearer*, ca. 1660. Mezzotint, 18.3 × 16.4 cm (7³⁄₁₆ × 6⁷⁄₁₆ in.).

FIG. 128 (*facing*). Wallerant Vaillant, *Self-Portrait*, 1660–1675. Mezzotint, image: 25.9 × 18.9 cm (10³⁄₁₆ × 7⅜ in.).

the design using various burnishing tools, flattening the raised burrs left by the rocker and working, in effect, from dark to light.

While sophisticated centers of reproductive engraving and print publishing had long been established in continental Europe, England had consistently lagged behind. With the exception of the output of several talented emigrants, including Lucas Vorsterman and Wenceslaus Hollar, its print production during the seventeenth century consisted primarily of engraved maps and book illustrations. Mezzotint, meanwhile, had originated in Germany and the Low Countries—where it was perfected early on by the likes of the amateur Prince Rupert, Count Palatine of the Rhine (fig. 127), and Wallerant Vaillant (fig. 128),

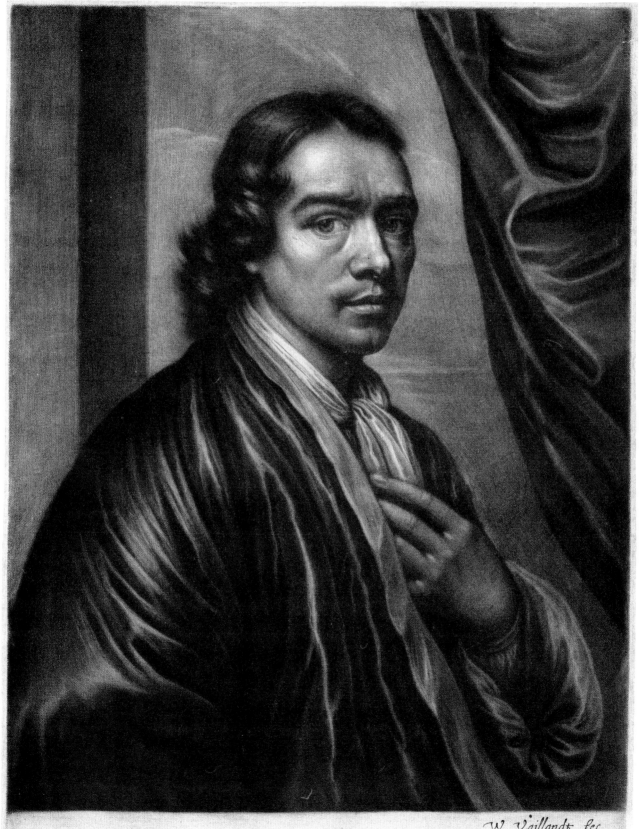

W. Vaillandt fec.

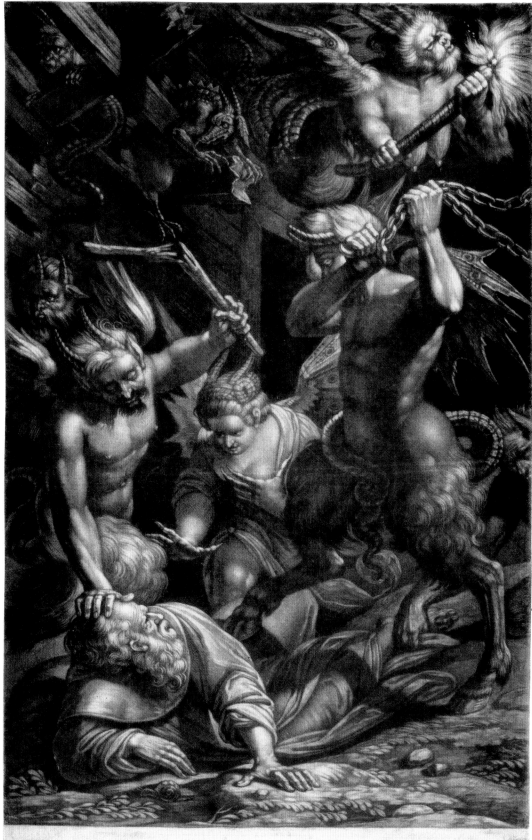

a Dutch painter active mainly in Amsterdam—but the process was slow to cross the North Sea.[5] It arrived during the 1670s when several of the most successful Dutch mezzotint engravers came to England, including Abraham Blooteling, who reproduced a late sixteenth-century drawing by Camillo Procaccini in the renowned collection of Peter Lely (now in the British Museum, London) during his stay (fig. 129). By the beginning of the next decade, the "secret" of the technique was out, and it was quickly taken up by native English artists, including a quirky figure named Robert Robinson, many of whose plates later entered the stock of Smith. The versatile Robinson painted everything from Dutch-inspired still lifes to theatrical sets and decorative interior schemes. As a printmaker he also worked in a variety of genres, including portraiture, still life, and architectural *capricci* inspired by Claude Lorrain that may reflect his work for the Restoration stage. He also depicted mythological subjects in works such as *Leda and the Swan* (fig. 130), in which he plagiarized the central figure from an unknown continental engraving after Lambert Sustris's painting *Venus and Cupid* (Louvre, Paris). In the hungry print market, copying was rampant, and a number of Robinson's mezzotints were soon pirated by his Dutch contemporaries.

Gérard de Lairesse (1640/41–1711), a prominent Dutch history painter who sat for a well-known portrait by Rembrandt (Metropolitan Museum of Art, New York), suffered the worst fate that could befall a visual artist: by the age of fifty, he was fully blind. He then took up writing about art. In his most important treatise, *The Art of Painting* (Amsterdam, 1707), he said about the mezzotint:

> It is a great pity, that both this beautiful art and the artist have so bad a name, as if the one were witchcraft, and the other a magician, though nothing but mere works of art. I long to hear what name the Italians will give it. The French and English, agreeable to the Dutch, call it—the former, *l'Art noire* [actually, *manière noire*]—and the latter the black art. An improper and

FIG. 129 (*facing*). Abraham Blooteling after Camillo Procaccini, *The Temptation of Saint Anthony*, ca. 1675. Mezzotint, 37.9 × 23.4 cm (14¹⁵⁄₁₆ × 9³⁄₁₆ in.).

FIG. 130. Robert Robinson after
Lambert Sustris, *Leda and the Swan*,
ca. 1685. Mezzotint, 22.4 × 28.6 cm
(8¹³⁄₁₆ × 11¼ in.).

unnatural name, unless they mean first, that the artist works the light out of the black ground; and in the next place, to distinguish it from etching and engraving.[6]

De Lairesse did not foresee that in the new century the art of the mezzotint, whose pictorial origins were deeply rooted in the diverse works of Caravaggio, Goudt, and Rembrandt, would be rechristened the "English manner." The Dutch Golden Age had long since come to a close.

NOTES

1. See Simon Schama, *Rembrandt's Eyes* (New York: Alfred A. Knopf, 1999), 425–429.

2. Ovid, *The Art of Love*, trans. Henry T. Riley (New York: Stravon Publishers, 1949), 90. The print is discussed in Eddy de Jongh and Ger Luijten, *Mirror of Everyday Life: Genreprints in the Netherlands, 1550–1700*, trans. Michael Hoyle, exh. cat. (Amsterdam: Rijksmuseum with Snoeck-Ducaju and Zoon, 1997), 209–212, no. 40.

3. See H. Perry Chapman, Wouter Th. Kloek, and Arthur K. Wheelock, Jr., *Jan Steen: Painter and Storyteller*, exh. cat. (Washington, DC: National Gallery of Art, 1996), 56–58, 176–179; also Albert Heppner, "The Popular Theatre of the *Rederijkers* in the Work of Jan Steen and His Contemporaries," *Journal of the Warburg and Courtauld Institutes* 3, nos. 1/2 (October 1939–January 1940): 28–31.

4. See Clifford Ackley's classic essay on this subject, "Printmaking in the Age of Rembrandt: The Quest for Printed Tone," in *Printmaking in the Age of Rembrandt*, exh. cat. (Boston: Museum of Fine Arts, 1981), xix–xxvi.

5. Gerdien Wuestman, "The Mezzotint in Holland: 'easily learned, neat, and convenient,'" *Simiolus* 23, no. 1 (1995): 63–89.

6. Gérard de Lairesse, *A Treatise on the Art of Painting, in All Its Branches*, trans. William Marshall Craig (London: E. Orme, 1817), 272.

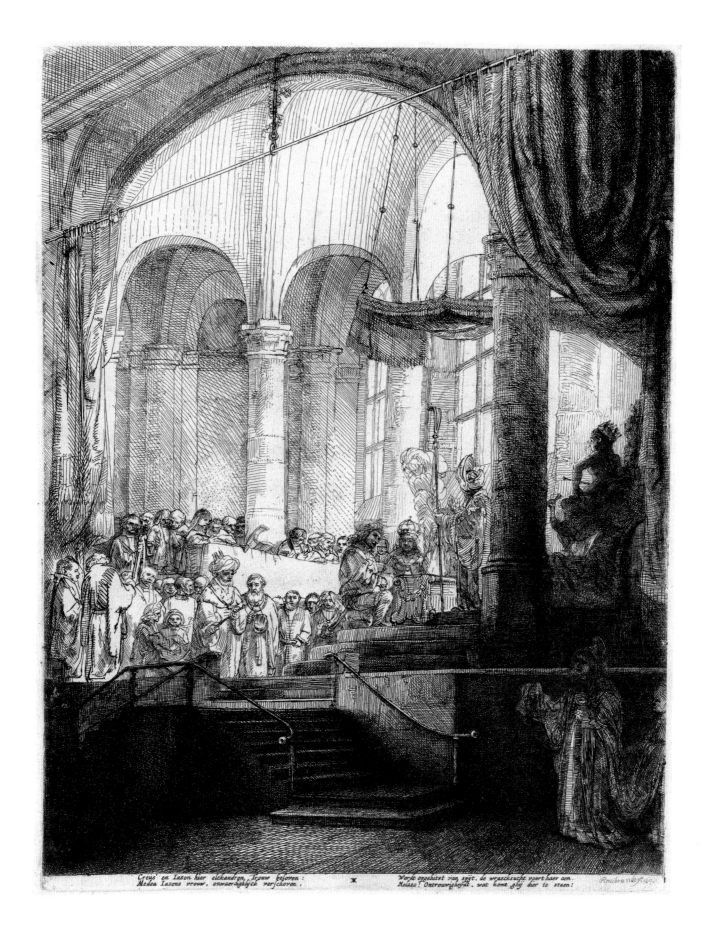

Creus' en Iason hier elckandren, Trouw beloven: Werdt opgehitst van spijt, de wraecksucht voert haer aen.
Medea Iasons vrouw, onwaerdghlijck verschoven, ❋ Helaes! Ontrouwigheyt, wat komt ghy dier te staen!

Rembrandt f. 1648

Acknowledgments

This exhibition is a tribute to the many generous collectors who have enriched the Achenbach's old-master holdings, including Bruno and Sadie Adriani, Michael G. Berolzheimer, Timothy and Margaret Brown, Dr. Ludwig A. Emge, Victor and Lorraine Honig, Julius Landauer, Mr. and Mrs. Herman Phleger, Mrs. Edgar Sinton, Mr. and Mrs. Marcus Sopher, Lucie Stern, and Mr. and Mrs. Harry Weinstein. We would also like to recognize the members of the Achenbach Graphic Arts Council for their longtime dedication to supporting acquisitions of works on paper for the Museums' collection. We are furthermore especially grateful to the distinguished private collectors who have allowed us to enlarge the scope of the exhibition, including Frank Bayley, Phoebe Cowles and Robert Girard, Marie and George Hecksher, and Malcolm and Karen Whyte.

The talented staff of the Fine Arts Museums of San Francisco contributed to the realization of this project in countless ways. Colleen Terry, curatorial assistant in the Achenbach, coordinated the myriad details of its production with her remarkable organizational skills and cataloguing expertise. The Museums'

FACING Rembrandt van Rijn, *Medea* or *The Marriage of Jason and Creusa*, 1648. Etching with drypoint, 24 × 17.9 cm (9⁷⁄₁₆ × 7¹⁄₁₆ in.).

145

paper conservation laboratory, headed by Debra Evans with Victoria Binder, did an outstanding job of treating many of these precious works of art to make them suitable for display. Also putting in many long hours on the herculean task of matting and framing the show was our gifted technician Mark Garrett. In the Publications Department, Leslie Dutcher skillfully directed the production of this catalogue. Thanks are also due to Nadia Alaee, Jorge Bachmann, Karin Breuer, Krista Brugnara, Therese Chen, Louise Chu, Julian Cox, Randy Dodson, Elise Effmann, Elizabeth Etienne, Robert Futernick, Susan Grinols, Craig Harris, Robert Haycock, Danica Hodge, Don Larsen, Karen Levine, Joseph McDonald, Lucy Medrich, Dan Meza, Natasa Morovic, Lynn Federle Orr, Juliana Pennington, Leni Velasquez, Bill White, and the entire marketing, development, design, and installation teams. We also add a special note acknowledging our deceased director John E. Buchanan, Jr., who green-lighted this project along with the previous exhibition catalogues *Japanesque* and *Impressionist Paris*, all highlighting the Achenbach's distinctive holdings.

Beyond the Museums we extend our thanks to Nadia Baadj, Thomas Beischer, Esther Bell, Timothy Brown, Nancy Evans, Walter Gibson, Joseph Goldyne, Sarah Hammond, Brian Isobe, Andrew Joron, Valerie Krall, Melody Lacina, Heidi Linsmayer, Gregory Rubenstein, Christine Taylor, Yvonne Tsang, Jack Vanderryn, LeRoy Wilsted, and Elizabeth Wyckoff. Finally, the author dedicates this publication to the memory of Rafael Fernandez (1927–1999), who introduced him to the etchings of Rembrandt.

Suggested Further Reading

REMBRANDT

Ackley, Clifford S., et al. *Rembrandt's Journey: Painter, Draftsman, Etcher*, exh. cat. Boston: MFA Publications, 2003.

Benesch, Otto. *The Drawings of Rembrandt*. Enlarged and edited by Eva Benesch. 6 vols. London: Phaidon Press, 1973.

Bruyn, Josua, and Ernst van de Wetering, et al. *A Corpus of Rembrandt Paintings*. 5 vols. The Hague: Nijhoff Press, 1982–1989; Dordrecht: Springer Verlag, 2005–2011.

DeWitt, Lloyd, ed. *Rembrandt and the Face of Jesus*, exh. cat. Philadelphia: Philadelphia Museum of Art, 2011.

Dickey, Stephanie S. *Rembrandt: Portraits in Print*. Studies in the Art of the Low Countries, vol. 9. Amsterdam: John Benjamins, 2004.

Hinterding, Erik. *Rembrandt as an Etcher*. Translated by Michael Hoyle. 3 vols. Studies in Prints and Printmaking, vol. 6. Ouderkerk aan den IJssel, Netherlands: Sound and Vision Publishers, 2006.

Hinterding, Erik, Ger Luijten, and Martin Royalton-Kisch. *Rembrandt the Printmaker*, exh. cat. Zwolle, Netherlands: Waanders Publishers; Amsterdam: Rijksmuseum, 2000.

Schwartz, Gary. *Rembrandt: His Life, His Paintings*. London: Phaidon Press, 1985.

Slive, Seymour. *Rembrandt Drawings*. Los Angeles: The J. Paul Getty Museum, 2009.

Strauss, Walter L., and Marjon van der Meulen, eds. *The Rembrandt Documents*. New York: Abaris Books, 1979.

White, Christopher. *Rembrandt as an Etcher: A Study of the Artist at Work*. 2nd edition. New Haven and London: Yale University Press, 1999.

White, Christopher, and Karel G. Boon. *Rembrandt's Etchings*. 2 vols. Amsterdam: A.L. van Gendt, 1969.

REMBRANDT'S CENTURY

Ackley, Clifford S. *Printmaking in the Age of Rembrandt*, exh. cat. Boston: Museum of Fine Arts, 1981.

Alpers, Svetlana. *The Art of Describing: Dutch Art in the Seventeenth Century*. Chicago: University of Chicago Press, 1983.

Bevers, Holm, Lee Hendrix, William W. Robinson, and Peter Schatborn. *Drawings by Rembrandt and His Pupils: Telling the Difference*, exh. cat. Los Angeles: The J. Paul Getty Museum, 2009.

Coelen, Peter van der. *Everyday Life in Holland's Golden Age: The Complete Etchings of Adriaen van Ostade*. Amsterdam: Museum Het Rembrandthuis, Rembrandt Information Centre, 1998.

Freedberg, David. *Dutch Landscape Prints of the Seventeenth Century*. London: The British Museum, 1980.

Gibson, Walter S. *Pleasant Places: The Rustic Landscape from Bruegel to Ruisdael*. Berkeley, Los Angeles, and London: University of California Press, 2000.

Griffiths, Antony. *The Print in Stuart Britain, 1603–1689*, exh. cat. London: British Museum Press, 1998.

de Jongh, Eddy, and Ger Luijten, eds. *Mirror of Everyday Life: Genreprints in the Netherlands, 1550–1700*, exh. cat. Translated by Michael Hoyle. Amsterdam: Rijksmuseum with Snoeck-Ducaju and Zoon, 1997.

Luijten, Ger, et al., eds. *Dawn of the Golden Age: Northern Netherlandish Art, 1580–1620*, exh. cat. Zwolle, Netherlands: Waanders Publishers; Amsterdam: Rijksmuseum, 1993.

Orenstein, Nadine M. *Hendrick Hondius and the Business of Prints in Seventeenth-Century Holland*. Studies in Prints and Printmaking, vol. 1. Rotterdam: Sound and Vision Interactive, 1996.

Reed, Sue Welsh. *French Prints from the Age of the Musketeers*, exh. cat. Boston: Museum of Fine Arts, 1998.

Reed, Sue Welsh, and Richard Wallace. *Italian Etchers of the Renaissance and Baroque*, exh. cat. Boston: Museum of Fine Arts, 1989.

Riggs, Timothy, and Larry Silver. *Graven Images: The Rise of Professional Printmaking in Antwerp and Haarlem, 1540–1640*, exh. cat. Evanston, Illinois: Mary and Leigh Block Gallery, Northwestern University, 1993.

Schama, Simon. *The Embarrassment of Riches: An Interpretation of Dutch Culture in the Golden Age*. New York: Vintage Books, 1997.

Westermann, Mariët. *A Worldly Art: The Dutch Republic, 1585–1718*. New Haven: Yale University Press, 1996.

FINE ARTS MUSEUMS OF SAN FRANCISCO PUBLICATIONS

Hattis, Phyllis. *Four Centuries of French Drawings in the Fine Arts Museums of San Francisco*. San Francisco: Fine Arts Museums of San Francisco, 1977.

Johnson, Robert Flynn, Karin Breuer, and Joseph R. Goldyne. *Treasures of the Achenbach Foundation for Graphic Arts*, exh. cat. San Francisco: Fine Arts Museums of San Francisco, 1995.

Johnson, Robert Flynn, and Joseph R. Goldyne. *Master Drawings from the Achenbach Foundation for Graphic Arts*, exh. cat. San Francisco: Fine Arts Museums of San Francisco, 1985.

List of Illustrations

Unless denoted with an asterisk, all works are part of the collections of the Fine Arts Museums of San Francisco. Height precedes width in all measurements. Measurements for etchings and engravings are of the plate mark, unless otherwise indicated. Measurements for woodcuts are of the image size. Measurements for drawings and paintings are of the sheet, canvas, or panel, unless otherwise noted. Catalogues raisonnés are cited, along with state information, following the medium description when applicable. Watermarks are listed for Rembrandt prints only, following Erik Hinterding's classification.

The Temptation of Saint Anthony, ca. 1675
Published by Abraham Blooteling
Mezzotint, Hollstein 219 ii/iii
37.9 × 23.4 cm (14¹⁵/₁₆ × 9³/₁₆ in.)
Ex coll.: Unidentified French collector,
May 6, 1868; R.W.P. de Vries, Amsterdam,
October 1924; Moore S. Achenbach, San
Francisco, May 27, 1949
Achenbach Foundation for Graphic Arts,
1963.30.11965
[Fig. 129]

FERDINAND BOL
Dutch, 1616–1680
The Return of the Prodigal Son, ca. 1640
Pen and brown ink, brush and brown wash
14.2 × 18 cm (5⁹/₁₆ × 7¹/₁₆ in.)
Ex coll.: Dr. Carl Robert Rudolf, London (Lugt
2811b); Sotheby Mak van Waay sale, Amster-
dam, April 18, 1977, lot 105, as Samuel von
Hoogstratten; David Tunick, Inc., New York
Museum purchase, Elizabeth Ebert and
Arthur W. Barney Fund, 1977.2.6
[Fig. 104]

Bearded Old Man with Beret, ca. 1642
Gray wash with black chalk and incised
transfer lines on ivory paper
12.7 × 10.4 cm (5 × 4⅛ in.)
Ex coll.: Sir Charles Greville (Lugt 549); Earl
of Warwick (his sale, Sotheby's, June 17, 1936,
lot 128); J. Theodor Cremer (his sale, Sotheby
Mak van Waay, Amsterdam, November 17,
1980, lot 62); Richard Day Ltd., London
Museum purchase, William H. Noble Bequest
Fund, 1980.2.46
[Fig. 35]

SCHELTE ADAMSZ. BOLSWERT
Dutch, active in Flanders, ca. 1586–1659
After Peter Paul Rubens (Flemish, 1577–1640)
Landscape, from a set of small landscapes,
ca. 1638
Published by Gillis Hendricx
Engraving, Hollstein 305–325 iv/v
31.6 × 48.7 cm (12⁷/₁₆ × 19¹/₁₆ in.), cropped within
plate mark
Ex coll.: Joseph Mallord William Turner,
London (Lugt 1498); Dr. and Mrs. Earl Bubar,
Los Angeles, California
Gift of Dr. and Mrs. Earl Bubar, 1983.1.159
[Fig. 84]

ORAZIO BORGIANNI
Italian, 1578–1616
The Lamentation, 1615
Etching, Bartsch 2 (321)
23.4 × 21.6 cm (9³/₁₆ × 8½ in.)
Ex coll.: Joannes Michiel Rysbrack, London
(Lugt 1912); R. E. Lewis, Belvedere, California,
October 30, 1975; Mr. and Mrs. Marcus Sopher,
Berkeley, California
Mr. and Mrs. Marcus Sopher Collection,
1985.1.405
[Fig. 100]

ABRAHAM BOSSE
French, ca. 1604–1676
The Intaglio Printers, 1642
Etching, Blum 205
26 × 32.7 cm (10¼ × 12⅞ in.)
Ex coll.: Alfred Morrison, London and Fonthill
(Lugt 151)
★California State Library long loan
[Fig. 15]

The Engraver and the Etcher, 1643
Etching, Blum 356
25.9 × 32.3 cm (10³/₁₆ × 12¹¹/₁₆ in.), cropped within
plate mark
Ex coll.: Alfred Morrison, London and Fonthill
(Lugt 151)
★California State Library long loan
[Fig. 14]

JOHANNES BRONKHORST
Dutch, 1648–1727
*Study of Lepidopterans (Five Adults and a
Caterpillar)*, ca. 1700
Watercolor with gum glaze additions on
cream paper
13.3 × 17.8 cm (5¼ × 7 in.)
Ex coll.: Morton Morris & Co., London
Museum purchase, Achenbach Foundation for
Graphic Arts Endowment Fund, 1984.2.45
[Fig. 56]

JACQUES CALLOT
French, 1592–1635
Pantalone, from a set of three actors,
ca. 1618–1620
Etching and engraving, Lieure 288 i/ii
24.2 × 15.3 cm (9½ × 6 in.)
Ex coll.: Pierre Mariette II, Paris, 1664 (Lugt

1788); Dr. Ludwig A. Emge, San Francisco
Gift of Dr. Ludwig A. Emge, 1971.17.97
[Fig. 63]

Two Studies of a Standing Man, ca. 1621
Red chalk
9.1 × 11.5 cm (3⁹/₁₆ × 4½ in.)
Ex coll.: Sir Joshua Reynolds, London (Lugt
2364); Nathaniel Hone, London (Lugt 2793);
H. Shickman Gallery, New York; Christian
Humann, New York; Sven Bruntjen,
Woodside, California
Museum purchase, Achenbach Foundation
for Graphic Arts Endowment Fund,
1982.2.56
[Fig. 61]

L'Impruneta (The Fair at Impruneta), 1622
Published by Israel Silvestre
Etching, Lieure 478 ii/ii
42.3 × 66.9 cm (16⅝ × 26⁵/₁₆ in.), cropped within
plate mark
Ex coll.: Dr. Ludwig A. Emge, San Francisco
Gift of Dr. Ludwig A. Emge, 1971.17.686
[Fig. 60]

La Pendaison (The Hanging), plate 11 in
the series *Les Grandes Misères de la Guerre
(The Large Miseries of War)*, 1633
Published by Israel Silvestre
Etching, Lieure 1349 ii/iii
8.8 × 18.9 cm (3⁷/₁₆ × 7⁷/₁₆ in.)
Ex coll.: Vera Frances Salomons, Broomhill,
Tunbridge Wells; Herta Weinstein,
Berkeley, California
Gift of Herta Weinstein in memory of
Harry Weinstein, 2005.175.11
[Fig. 93]

DOMENICO CAMPAGNOLA
Italian, 1500–1564
Hilly Landscape with Woman and Donkey,
ca. 1550–1564
Pen and brown ink
24.6 × 38.3 cm (9¹¹/₁₆ × 15¹/₁₆ in.)
Ex coll.: Aldo Caselli, 1968; Esther S. and Mal-
colm W. Bick, Longmeadow, Massachusetts;
Sotheby's, London, July 2, 1984, lot 14
Museum purchase, Achenbach Foundation
for Graphic Arts Endowment Fund,
1984.2.39
[Fig. 110]

TRADITIONALLY ATTRIBUTED
TO THE CANDLELIGHT MASTER
(MASTER JACOMO?)
A Youth Singing, 1650
Oil on canvas
67.3 × 49.5 cm (26½ × 19½ in.)
Ex coll.: Heinigke collection, New York;
Arnold Seligman, Rey & Co., Inc., New
York, until 1946; California Palace of the
Legion of Honor as Georges de La Tour
Museum purchase, Gift of Archer M. Hunting-
ton in memory of Collis Potter Huntington,
1946.2
[Fig. 124]

GIOVANNI BENEDETTO CASTIGLIONE
Italian, 1609–1664
Recto: *Pastoral Landscape*; Verso: *Sheet of Figure,
Animal and Landscape Studies,* ca. 1647–1651
Recto and verso: pen and brown ink
27.5 × 39.6 cm (10¹³⁄₁₆ × 15⅝ in.)
Ex coll.: Joseph Green Cogswell, Cambridge,
Massachusetts; Mortimer Leo Schiff, New
York (Lugt 1889–1890; suppl. 1889); Moore
S. Achenbach, San Francisco, October 20, 1952
Achenbach Foundation for Graphic Arts,
1963.24.115r–v
[Fig. 89]

The Raising of Lazarus, ca. 1647–1651
Etching, Bartsch 6
22.3 × 31.7 cm (8¾ × 12½ in.), cropped within
plate mark
Ex coll.: Mr. and Mrs. Marcus Sopher,
Berkeley, California
Mr. and Mrs. Marcus Sopher Collection,
2000.156.7
[Fig. 98]

*The Genius of Giovanni Benedetto
Castiglione,* 1648
Published by Giovanni Giacomo de'Rossi
Etching, Bartsch 23
36.7 × 24.7 cm (14⁷⁄₁₆ × 9¾ in.), cropped within
plate mark
Ex coll.: Moore S. Achenbach, San Francisco,
February 15, 1937
Achenbach Foundation for Graphic Arts,
1963.30.36575
[Fig. 16]

Profile of a Bearded Man in a Turban, from a set
of small oriental heads, ca. 1650

Etching, Bartsch 40 i/ii
10.9 × 8.2 cm (4�5⁄₁₆ × 3¼ in.)
*Loan from the Mr. and Mrs. Marcus
Sopher Collection
[Fig. 36]

CLAUDE LORRAIN
French, active in Italy, ca. 1604–1682
Recto: *Landscape in the Campagna*; Verso:
Landscape with Figures, 1640–1641
Recto: pen and brown ink and gray wash over
black chalk and graphite; verso: black chalk,
Roethlisberger 400
21.9 × 31.6 cm (8⅝ × 12⁷⁄₁₆ in.)
Ex coll.: Album: Prince Odescalchi, Rome;
Wildenstein Album, sold to Norton Simon;
Thomas Agnew & Sons, London; and Gene
Thaw, New York, at which point the album
was dismembered; this sheet to private
collection, Geneva; sold to the museum
by Jean Pierre Selz, Paris
Museum purchase, Roscoe and Margaret
Oakes Income Fund, 1997.144a–b
[Fig. 90]

The Herd Returning in Stormy Weather,
ca. 1650–1651
Etching, Mannocci 40 iiB/iiC
15.8 × 21.7 cm (6¼ × 8⁹⁄₁₆ in.), cropped within
plate mark
Ex coll.: Mr. and Mrs. Marcus Sopher,
Berkeley, California
Mr. and Mrs. Marcus Sopher Collection,
2000.212.2
[Fig. 91]

LAMBERT DOOMER
Dutch, 1624–1700
Salt Flats at Le Croisic, ca. 1671–1673
Brown ink and brown and gray washes on
ledger paper, Schulz 92A
24 × 41 cm (9⁷⁄₁₆ × 16⅛ in.)
Ex coll.: Jeronimus Tonneman (1687–1750),
Amsterdam; left to his mother, Maria
Tonneman, née Van Breusegom (died in 1752),
Amsterdam; her sale, October 21, 1754, and
following days, p. 85, lot S-12 ("Zoutpan by
Nantes"); to Hendrik de Leth, Amsterdam;
D. Smith; sold Amsterdam, July 13, 1761,
G-457; Bernard Houthakker Gallery, Amster-
dam; Sotheby Mak van Waay auction house,
Amsterdam (sale, January 15, 1974, and follow-

ing days, no. 1126d, repr.); R. M. Light and Co.,
Boston, 1975, to Joseph and Deborah Goldyne,
San Francisco
Museum purchase, Achenbach Foundation
for Graphic Arts Endowment Fund and gift
of the Graphic Arts Council, 2012.8
[Fig. 88]

ALBRECHT DÜRER
German, 1471–1528
The Birth of the Virgin, from the series *The Life
of the Virgin,* 1503–1505
Woodcut, Bartsch 280 (before text)
29.3 × 20.8 cm (11⁹⁄₁₆ × 8³⁄₁₆ in.)
Ex coll.: Bruno and Sadie Adriani,
Carmel, California
Bruno and Sadie Adriani Collection, 1961.46.4
[Fig. 106]

GÉRARD EDELINCK
Flemish, active in France, 1640–1707
After Philippe de Champaigne (French,
1602–1674)
Self-Portrait of Philippe de Champaigne, 1676
Etching and engraving, IFF 74 ii/ii
39.6 × 33.5 cm (15⁹⁄₁₆ × 13³⁄₁₆ in.)
Ex coll.: Robert Balmanno, London (Lugt 213)
to G. Cooke, 1824; Moore S. Achenbach,
San Francisco, January 1, 1934
Achenbach Foundation for Graphic Arts,
1963.30.30124
[Fig. 18]

ALBERT FLAMEN
Flemish, ca. 1620–after 1693
Edefinus, L'Egrefin (The Haddock), from *Poissons
de mer, troisième partie (Salt Water Fish, Part III),*
ca. 1660
Etching, Bartsch 31 ii/ii
9.8 × 17.5 cm (3⅞ × 6⅞ in.), cropped within
plate mark
Ex coll.: Moore S. Achenbach, San Francisco,
probably October 22, 1936
Achenbach Foundation for Graphic Arts,
1963.30.31468
[Fig. 46]

ATTRIBUTED TO SIMON FRISIUS
Dutch, ca. 1575–1628
Michiel van Mierevelt, from *Pictorum aliquot
celebrium praecipuae Germaniae Inferioris effigies*

Hieronymus de Bran, ca. 1634–1643
Black chalk
14.4 × 13.4 cm (5¹¹⁄₁₆ × 5¼ in.)
Ex coll.: Jonathan Richardson Sr., London
(Lugt 2183); Christie's London, December 12,
1985, lot 172 (ill.); Kate Ganz, London
Museum purchase, Achenbach Foundation for
Graphic Arts Endowment Fund, 1986.2.40
[Fig. 33]

JACQUES LINARD
French, ca. 1600–1645
*Still Life of Exotic Shells on a Boîte de
Copeaux*, 1621/1624
Oil on panel
38.1 × 51.8 cm (15 × 20⅜ in.)
Ex coll.: Gallery Wildenauer, Berlin;
Gallery Speelman, London
*The Phoebe Cowles and Robert
Girard Collection
[Fig. 45]

THEODOR MATHAM
Dutch, ca. 1605–1676
Vanitas, 1622
Published by Jacob Matham
Engraving, Hollstein 36
22.9 × 33 cm (9 × 13 in.)
Ex coll.: Moore S. Achenbach, San Francisco,
April 5, 1956
Achenbach Foundation for Graphic Arts,
1963.30.13265
[Fig. 48]

JEAN MORIN
French, ca. 1605–1650
After Philippe de Champaigne (French,
1602–1674)
Still Life with Skull, Pocket Watch, and Roses,
1640–1650
Published by Pierre-François Basan
Etching and engraving, Mazel 040 ii/ii
32.2 × 31.8 cm (12¹¹⁄₁₆ × 12½ in.)
Ex coll.: R. E. Lewis & Daughter,
Belvedere, California
Museum purchase, Achenbach Foundation for
Graphic Arts Endowment Fund, 1994.13
[Fig. 49]

REINIER NOOMS, CALLED ZEEMAN
Dutch, ca. 1623–1664
View of the Port of Amsterdam with the Office of

the Water Authority, title page of *Eerste Deal*
(part 1) of the series *Various Ships and Views
of Amsterdam*, ca. 1652–1654
Etching with drypoint, Hollstein (Zeeman)
29 iii/vi
13.1 × 24 cm (5³⁄₁₆ × 9⁷⁄₁₆ in.)
Ex coll.: Moore S. Achenbach, San Francisco,
March 17, 1944
Achenbach Foundation for Graphic Arts,
1963.30.11398
[Fig. 39]

ADRIAEN VAN OSTADE
Dutch, 1610–1685
The Family, 1647
Etching, Godefroy 46 i/vii
17.3 × 15.4 cm (6¹³⁄₁₆ × 6¹⁄₁₆ in.)
Ex coll.: E. Brupbacher-Bourgeois (not in
Lugt); Timothy and Margaret Brown,
San Francisco
Gift of Timothy and Margaret Brown, 2011.35.8
[Fig. 74]

Village Romance, ca. 1652
Etching, Godefroy 11 vii/xii
15.7 × 12.4 cm (6³⁄₁₆ × 4⅞ in.), cropped within
plate mark
Ex coll.: Walter Francis, Duke of Buccleuch,
London and Dalkeith (Lugt 402); Dr. Edgar F.
Platzer (not in Lugt); Timothy and Margaret
Brown, San Francisco
Gift of Timothy and Margaret Brown, 2011.35.3
[Fig. 75]

Rhetoricians at a Window (The Singers), ca. 1668
Etching, Godefroy 19 iv/vii
24 × 19.1 cm (9⁷⁄₁₆ × 7½ in.)
Ex coll.: Timothy and Margaret Brown,
San Francisco
Gift of Timothy and Margaret Brown, 2011.35.5
[Fig. 125]

CRISPIJN DE PASSE THE YOUNGER
Dutch, ca. 1594–1670
*Chrysanthemum Peruvianum (The Greater and
Lesser Sunflower)*, plate 3 from the Autumn
series of the book *Hortus Floridus (Garden of
Flowers)* (Utrecht: Officina Calcographica Cr.
Passaei, 1614)
Engraving, Hollstein 171
13.2 × 21.2 cm (5³⁄₁₆ × 8⅜ in.), cropped within
plate mark

Ex coll.: Edmond Harris(on?); Bernard
Quaritch, London, May 27, 1886; Wheldon &
Wesley, London; Moore S. Achenbach, San
Francisco, May 15, 1943
Achenbach Foundation for Graphic Arts,
1963.30.38761.66
[Fig. 54]

*Crocus and Crocus Montan (Cultivated Saffron and
Mountain Saffron)*, plate 23 from the Autumn
series of the book *Hortus Floridus (Garden of
Flowers)* (Utrecht: Officina Calcographica Cr.
Passaei, 1614)
Engraving, Hollstein 171
13 × 21.1 cm (5⅛ × 8³⁄₁₆ in.), cropped within
plate mark
Ex coll.: Edmond Harris(on?); Bernard
Quaritch, London, May 27, 1886; Wheldon &
Wesley, London; Moore S. Achenbach,
San Francisco, May 15, 1943
Achenbach Foundation for Graphic Arts,
1963.30.38761.86
[Fig. 53]

REINIER VAN PERSYN
Dutch, ca. 1614–1668
After Jacob Gerritsz. Cuyp (Dutch, 1594–1652)
A Standing Ox, plate 3 from the series *Diversa
Animalia Quadrupedia (Various Four-Legged
Animals)*, 1641
Published by Claes Jansz. Visscher
Engraving, Hollstein 13
13.1 × 19.7 cm (5³⁄₁₆ × 7¾ in.)
Ex coll.: Moore S. Achenbach, San Francisco,
December 18, 1951
Achenbach Foundation for Graphic Arts,
1963.30.10060
[Fig. 80]

ATTRIBUTED TO PAULUS PONTIUS
Flemish, 1603–1658
After Peter Paul Rubens (Flemish, 1577–1640)
An Old Woman and a Boy with Candles, 1620s
Published by Peter Paul Rubens
Etching and engraving, Hollstein 48 ii/ii
24.2 × 19.3 cm (9½ × 7⅝ in.), cropped within
plate mark
Ex coll.: Moore S. Achenbach, San Francisco,
May 29, 1947
Achenbach Foundation for Graphic Arts,
1963.30.11499
[Fig. 123]

PIETER JANSZ QUAST
Dutch, ca. 1605–1647
Beggar Standing on One Foot, Second on Crutches,
no. 5 from a series of twenty-six beggars and
peasants, 1634
Etching and engraving, Hollstein 12
21 × 16.3 cm (8¼ × 6⁷⁄₁₆ in.), cropped within
plate mark
Ex coll.: Moore S. Achenbach, San Francisco,
February 16, 1954
Achenbach Foundation for Graphic Arts,
1963.30.29718
[Fig. 65]

A Jester, 1640
Black chalk on vellum
19.6 × 14.9 cm (7¹¹⁄₁₆ × 5⅞ in.)
Ex coll.: Sotheby Mak van Waay, Amsterdam,
November 16, 1981, lot 12
Museum purchase, Achenbach Foundation for
Graphic Arts Endowment Fund, 1982.2.54
[Fig. 66]

REMBRANDT VAN RIJN
Dutch, 1606–1669
Beggar Seated on a Bank, 1630
Etching, Bartsch 174
11.8 × 7 cm (4⅝ × 2¾ in.)
No visible watermark
Ex coll.: Victor and Lorraine Honig,
San Francisco
Victor and Lorraine Honig Collection,
1964.152.32
[Fig. 70]

Diana at the Bath, ca. 1631
Etching, Bartsch 201
17.8 × 15.9 cm (7 × 6¼ in.)
Watermark: eagle, double-headed, variant
A.a.a. (1632–1634)
Ex coll.: François Debois, Paris, 1840 (Lugt
985); Louis Galichon, Paris (Lugt 1060);
Michael Berolzheimer, Germany
Gift of Michael G. Berolzheimer in memory of
Michael Berolzheimer, 1998.201.42
[Fig. 102]

*An Elderly Woman Seated (Rembrandt's
Mother)*, 1631
Etching, Bartsch 348 ii/iii
14.6 × 13 cm (5¾ × 5⅛ in.)
No visible watermark
Ex coll.: A. G. Thiermann, Berlin (Lugt 2434);

Kupferstichkabinett der Staatlichen Museen,
Berlin (Lugt 1609, 1633); Kupferstichkabinett
der Staatlichen Museen, Berlin duplicate
(Lugt 2482); Bruno and Sadie Adriani,
Carmel, California
Bruno and Sadie Adriani Collection, 1971.28.60
[Fig. 31]

Joris de Caulerij, 1632
Oil on canvas transferred to panel
102.9 × 84.3 cm (40½ × 33³⁄₁₆ in.)
Ex coll.: Bequeathed by Joris de Caulerij to
his daughter, Josina de Caulerij, The Hague,
1661; by inheritance to her daughter, Sara de
Caulerij, The Hague, 1712; by inheritance
to her relative, George van der Poel, The
Hague, 1722–1750; possibly sale Frankfurt
am Main, October 29, 1770, no. 70, and sale
Georg Bögner, Frankfurt am Main, September
28, 1778, no. 55; Stortenbeker collection, The
Hague, 1867; J.H.J. Quarles van Ufford,
The Hague, 1881–1890; Abraham Preyer,
dealer, Amsterdam, 1890; sold to Charles T.
Yerkes, Chicago, 1890–1905 (sale New York,
April 5–8, 1910, no. 84); Jacques Seligmann
Gallery, Paris and New York, 1910–1915;
G. Rasmussen, Chicago, 1924; John Levy Gal-
lery, New York, 1937; Edwin D. Levinson, New
York, 1937–1954; by inheritance to his daugh-
ters, Edna and Evelyn Levinson, New York,
1954–1955; Knoedler and Co., New York, 1955;
Roscoe and Margaret Oakes, San Francisco,
1955; on loan to the M. H. de Young Memorial
Museum (since 1972 Fine Arts Museums of
San Francisco), 1955; gift from the couple to
the museum, 1966
Roscoe and Margaret Oakes Collection, 66.31
[Fig. 28]

The Raising of Lazarus (The Larger Plate),
ca. 1632
Etching and engraving, Bartsch 73 x/x
36.3 × 25.4 cm (14⁵⁄₁₆ × 10¹⁄₁₆ in.)
Watermark: grapes, variant H.b.
Ex coll.: Moore S. Achenbach, San Francisco
Achenbach Foundation for Graphic Arts,
1963.30.215
[Fig. 96]

*Study of a Bearded Old Man with a Wide-brimmed
Hat*, ca. 1633–1634
Pen and brown ink on brown paper, gray wash
addition by a later hand

12.8 × 10.3 cm (5¹⁄₁₆ × 4¹⁄₁₆ in.)
Ex coll.: Cornelis Ploos van Amstel, Amster-
dam (Lugt 3002); Jacob de Vos, Jr., Amsterdam
(Lugt 1450); J. Q. van Regteren Altena; F. Koe-
nigs; Paul Cassirer; Colnaghi, London, 1979;
Shaunagh Fitzgerald, Ltd., London, 1981
Museum purchase, Roscoe and Margaret
Oakes Income Fund, 1981.2.3
[Fig. 32]

The Annunciation to the Shepherds, 1634
Etching, engraving, and drypoint,
Bartsch 44 iii/iii
26.2 × 21.9 cm (10⁵⁄₁₆ × 8⅝ in.)
No visible watermark
Ex coll.: Pierre Mariette II, Paris (Lugt 1789);
Earl of Hardwicke; Lucie Stern, San Francisco
Bequest of Lucie Stern, 1973.8.2
[Fig. 119]

The Return of the Prodigal Son, 1636
Etching, Bartsch 91
15.8 × 13.6 cm (6¼ × 5⅜ in.)
No visible watermark
Ex coll.: Moore S. Achenbach, San Francisco,
June 20, 1936
Achenbach Foundation for Graphic Arts,
1963.30.183
[Fig. 103]

Self-Portrait with Saskia, 1636
Etching, Bartsch 19 iii/iii
10.6 × 9.4 cm (4³⁄₁₆ × 3¹¹⁄₁₆ in.)
Partial unidentified watermark
Ex coll.: Adam Gottlieb Thiermann, Berlin
(Lugt 2434); Berlin Kupferstichkabinett dupli-
cate (Lugt 1606); Bruno and Sadie Adriani,
Carmel, California
Bruno and Sadie Adriani Collection, 1959.40.13
[Fig. 1]

The Artist Drawing from a Model, ca. 1639
Etching, drypoint, and engraving,
Bartsch 192 ii/ii
23.3 × 18 cm (9³⁄₁₆ × 7¹⁄₁₆ in.)
Watermark: Strasbourg lily, variant E¹a.b.
(ca. 1652)
Ex coll.: R. E. Lewis & Daughter,
Belvedere, California
Museum purchase, Achenbach Foundation for
Graphic Arts Endowment Fund, 1981.1.183
[Fig. 7]

The Death of the Virgin, 1639
Etching and drypoint, Bartsch 99 iii/iii
40.9 × 31.4 cm (16⅛ × 12⅜ in.)
Watermark: Strasbourg lily
Ex coll.: Albertina, Vienna (Lugt 5g); Victor
and Lorraine Honig, San Francisco
Victor and Lorraine Honig Collection,
1964.152.30
[Fig. 107]

*A Peasant in a High Cap, Standing Leaning
on a Stick*, 1639
Etching, Bartsch 133
7.8 × 4.5 cm (3¹⁄₁₆ × 1¾ in.), cropped within
plate mark
No visible watermark
Ex coll.: Pierre Mariette II, Paris, 1657 (Lugt
1789); Adria Schulman-Eyink, New York;
Jan Lewis Slavid, San Francisco; private
collection, California
*Private collection
[Fig. 71]

*A Peasant in a High Cap, Standing Leaning
on a Stick*, 1639
Copper etching plate, Bartsch 133
8.5 × 4.5 × .15 cm (3⅜ × 1¾ × ¹⁄₁₆ in.)
Ex coll.: Clement De Jonghe, Amsterdam, 1678
(probably); Pieter De Haan, Amsterdam, 1767;
Pierre Fouquet Jr., Amsterdam, 1767; Claude-
Henri Watelet, Paris, ca. 1767–1786; Pierre-
François Basan, Paris, 1786–1797; Henry-Louis
Basan, Paris, 1797–ca. 1810; Auguste Jean,
Paris, ca. 1810–1820; Auguste Jean's widow,
Paris, 1820–1846; Auguste Bernard, Paris, after
1846–ca. 1875; Michel Bernard, Paris, ca. 1875–
ca. 1907; Alvin-Beaumont, Paris, ca. 1907–1938;
Lee Humber, New York, 1938–1970; Artemis,
London, 1993; Adria Schulman-Eyink, New
York; Jan Lewis Slavid, San Francisco; private
collection, California
*Private collection
[Fig. 72]

Sleeping Puppy, ca. 1640
Etching and drypoint, Bartsch 158 iii/iii
3.9 × 8.3 cm (1⁹⁄₁₆ × 3¼ in.)
No visible watermark
Ex coll.: Unidentified collector (Lugt 1702);
Michael Berolzheimer, Germany
Gift of Michael G. Berolzheimer in memory of
Michael Berolzheimer, 1998.201.32
[Fig. 78]

View of Amsterdam from the Kadijk, ca. 1640
Etching, Bartsch 210
10.7 × 15.4 cm (4³⁄₁₆ × 6¹⁄₁₆ in.), cropped within
plate mark
Watermark: countermark LBb (ca. 1650)
Ex coll.: Michael Berolzheimer, Germany
Gift of Michael G. Berolzheimer in memory of
Michael Berolzheimer, 1998.201.36
[Fig. 83]

The Raising of Lazarus (The Small Plate), 1642
Etching, Bartsch 72 i/ii
15 × 11.1 cm (5⅞ × 4⅜ in.)
Watermark: Arms of Amsterdam
Ex coll.: Henry Danby Seymour, London
(Lugt 176); Michael Berolzheimer, Germany
Gift of Michael G. Berolzheimer in memory of
Michael Berolzheimer, 1998.201.33
[Fig. 97]

The Landscape with the Three Trees, 1643
Etching, drypoint, and engraving, Bartsch 212
21.3 × 27.8 cm (8⅜ × 10¹⁵⁄₁₆ in.)
Watermark: countermark R.b.
Ex coll.: S. Rogers (inscribed in ink on the
verso *S. Rogers*); Thomas Emerson Crawhall,
Newscastle-on-Tyne (Lugt 467); Hans Freiheer
von und zu Aufsess, Aufsess and Nuremberg
(Lugt 2750); George Coe Graves (given to The
Metropolitan Museum of Art in 1920, credited
as "The Sylmaris Collection, Gift of George
Coe Graves, 1920"); The Metropolitan Museum
of Art, New York (Lugt 1943; accession number
in pencil on verso: *20.46.20*); deaccessioned
by exchange March 15, 1935 (duplicate stamp
Lugt 1808h); Kleeman Galleries, New York;
Gordon W. Nowell-Usticke, Christiansted,
St. Croix, Virgin Islands (not stamped); his
sale, Parke-Bernet Galleries, New York,
October 31, 1967, lot 85; private collection,
USA, 1967; C. G. Boerner, New York
*Collection of Marie and George Hecksher
[Fig. 85]

Nude Youth Seated Before a Curtain, 1646
Etching, Bartsch 193 i/ii
16.4 × 9.6 cm (6⁷⁄₁₆ × 3¾ in.)
Watermark: partial foolscap?
Ex coll.: Paul Davidsohn, Grunewald-Berlin
(Lugt 654); C. G. Boerner, New York
Museum purchase, Achenbach Foundation for
Graphic Arts Endowment Fund, 1966.80.50
[Fig. 9]

Ephraim Bueno, Jewish Physician, 1647
Etching, drypoint, and engraving,
Bartsch 278 ii/ii
20.9 × 17.8 cm (8¼ × 7 in.) with false margins
Watermark: basilisk
Ex coll.: Michel Begon, Rochefort (Lugt 360);
Artaria & Co., Vienna (Lugt 90); M. M. Daffin-
ger, Vienna (Lugt 652a); D. G. de Arozarena,
Paris (Lugt 109); Lucie Stern, San Francisco
Bequest of Lucie Stern, 1973.8.4
[Fig. 29]

*Beggars Receiving Alms at the Door of a
House*, 1648
Etching, engraving, and drypoint,
Bartsch 176 ii/iii
16.5 × 12.9 cm (6½ × 5¹⁄₁₆ in.)
Watermark: Strasbourg lily
Ex coll.: Unidentified collector (Lugt 2923b);
Lucie Stern, San Francisco
Bequest of Lucie Stern, 1973.8.5
[Fig. 73]

Medea or *The Marriage of Jason and Creusa*, 1648
Etching with drypoint, Bartsch 112 iv/v
24 × 17.9 cm (9⁷⁄₁₆ × 7¹⁄₁₆ in.)
No visible watermark
Ex coll.: D. G. de Arozarena (Lugt 109);
Michael Berolzheimer, Germany
Gift of Michael G. Berolzheimer in memory
of Michael Berolzheimer, 1998.201.41
[Page 144]

Self-Portrait Drawing at a Window, 1648
Etching, drypoint, and engraving,
Bartsch 22 v/v
15.7 × 12.9 cm (6³⁄₁₆ × 5¹⁄₁₆ in.)
Unidentified watermark
Ex coll.: Adam Gottlieb Thiermann, Berlin
(Lugt 2434); Berlin Kupferstichkabinett dupli-
cate (Lugt 1606), Kupferstichkabinett der Staat-
lichen Museen, Berlin duplicate (Lugt 2482);
Bruno and Sadie Adriani, Carmel, California
Bruno and Sadie Adriani Collection, 1959.40.19
[Fig. 10]

The Shell (Conus Marmoreus), 1650
Etching, drypoint, and engraving,
Bartsch 159 ii/iii
9.7 × 13.2 cm (3¹³⁄₁₆ × 5¹⁄₁₆ in.)
No visible watermark
Ex coll.: Baron Jan Verstolk van Soelen, his
sale, Amsterdam (J. de Vries, A. Brondegeest,

C. F. Roos), October 26, 1847, ff., lot 405; James
Reiss (Lugt 1522), his sale, London (Christie's),
May 6–10, 1910, lot 577 (described as from
the Verstolk collection); Rudolf Busch (Lugt
2190, not stamped), his sale, Frankfurt (C. G.
Boerner, Jos. Baer & Co., J. Lang), May 3, 1921,
lot 167, cat. pl. XIII; Joseph R. Ritman, Amster-
dam, sold from his collection by C. G. Boerner/
Artemis, London and New York, 1997
Museum purchase, gift of Dr. T. Edward and
Tullah Hanley by exchange, Achenbach Foun-
dation for Graphic Arts Endowment Fund and
Anonymous Bequest, 1997.42
[Fig. 43]

*Landscape with Trees, Farm Buildings, and a
Tower*, ca. 1650–1651
Etching and drypoint, Bartsch 223 iv/iv
12 × 32.2 cm (4¾ × 12¹¹⁄₁₆ in.)
Watermark: foolscap with five-pointed collar
variant C.a.a. (ca. 1651–1652)
Ex coll.: Eldridge R. Johnson (sale, Parke-
Bernet, April 3–4, 1946, no. 135); Gordon W.
Nowell-Usticke (sale, Parke-Bernet,
October 31–November 1, 1967, no. 93);
Craddock and Barnard, London
Museum purchase, Achenbach Foundation for
Graphic Arts Endowment Fund, 1968.13.5
[Fig. 86]

The Blindness of Tobit (The Larger Plate), 1651
Etching and drypoint, Bartsch 42 i/ii
15.7 × 12.6 cm (6³⁄₁₆ × 4¹⁵⁄₁₆ in.)
Watermark: Seven Provinces variant C.a.b.
Ex coll.: R. E. Lewis & Daughter,
Belvedere, California
Museum purchase, Achenbach Foundation for
Graphic Arts Endowment Fund, 1963.32.13
[Fig. 114]

The Flight into Egypt: A Night Piece, 1651
Etching and drypoint, Bartsch 53 v/vi
12.8 × 11 cm (5 × 4⅜ in.)
No visible watermark
Ex coll.: Unidentified collector (Lugt 1701);
Michael Berolzheimer, Germany
Gift of Michael G. Berolzheimer in memory of
Michael Berolzheimer, 1998.201.34
[Fig. 120]

A Scholar in His Study (Faust), ca. 1652
Etching, drypoint, and engraving,
Bartsch 270 iii/iii

21.1 × 16 cm (8⁵⁄₁₆ × 6⁵⁄₁₆ in.)
No visible watermark
Ex coll.: Crowned figure in oval (unidentified,
not in Lugt); Adam Gottlieb Thiermann, Ber-
lin (Lugt 2434); Kupferstichkabinett, Staatliche
Museen zu Berlin (Lugt 1609); Kupferstichkabi-
nett, Staatliche Museen zu Berlin (Lugt 1633);
Kupferstichkabinett, Staatliche Museen zu
Berlin (Lugt 2482); Bruno and Sadie Adriani,
Carmel, California
Bruno and Sadie Adriani Collection, 1959.40.22
[Fig. 113]

Christ Crucified Between Two Thieves
(*The Three Crosses*), 1653
Drypoint, Bartsch 78 iv/v
38.5 × 45.3 cm (15³⁄₁₆ × 17¹³⁄₁₆ in.)
No visible watermark
Ex coll.: Edward Hopper, Boston (purchased in
the 1890s); Fanny H. Curtis, Marblehead, Mas-
sachusetts; Greely S. Curtis; purchased from
Maynard Walker Gallery, New York
Museum purchase, Achenbach Foundation for
Graphic Arts Endowment Fund, 1964.142.40
[Fig. 121]

The Flight into Egypt (altered from Hercules
Segers), 1653
Etching, engraving, and drypoint,
Bartsch 56 vi/vii
21.3 × 28.3 cm (8⅜ × 11⅛ in.)
Watermark: Strasbourg lily
Ex coll.: Gustav von Rath, Crefeld (Lugt 2772);
British Museum duplicate, London (Lugt 300;
Lugt 305); Mtp (unidentified, not in Lugt); S in
circle (unidentified, not in Lugt); Helmut H.
Rumbler, New York
Museum purchase, Achenbach Foundation
for Graphic Arts Endowment Fund and
the Friends of Ian White Endowment
Fund, 2007.80
[Fig. 108]

Saint Jerome Reading in an Italian Landscape,
ca. 1653
Etching, engraving, and drypoint,
Bartsch 104 ii/ii
25.6 × 20.9 cm (10¹⁄₁₆ × 8¼ in.), cropped within
plate mark
Watermark: foolscap with five-pointed collar
Ex coll.: Karl, Prince of Paar, Vienna (Lugt
2009); unidentified or Dr. F. Pokorny, Vienna

(Lugt 2763); Michael Berolzheimer, Germany
Gift of Michael G. Berolzheimer in honor of
Mr. and Mrs. Marshall Wais, 1998.201.40
[Fig. 109]

*Christ Returning from the Temple with His
Parents*, 1654
Etching and drypoint, Bartsch 60
9.5 × 14.6 cm (3¾ × 5¾ in.)
No visible watermark
Ex coll.: William Esdaile, London (Lugt 2617);
James Reiss, Manchester and London (Lugt
1522); Selah Chamberlain, San Francisco
Gift of the heirs of Selah Chamberlain,
1961.64.4
[Fig. 111]

The Descent from the Cross by Torchlight, 1654
Etching and drypoint, Bartsch 83
21 × 16.2 cm (8¼ × 6⅜ in.)
Watermark: foolscap with five-pointed collar
Ex coll.: Naudet, Paris, 1805 (Lugt 1937); AC
(unidentified) (Lugt 84); David John Carnegie,
Earl of Northesk, London and Ethie Castle
(Forfarshire) (Lugt 1952); R. E. Lewis, Belve-
dere, California; Edgar and Marion W. Sinton,
Hillsborough, California
Bequest of Mrs. Edgar Sinton, 1981.1.104
[Fig. 122]

Christ Preaching, ca. 1654–1657
Etching, engraving, and drypoint, Bartsch 67
("black sleeve" impression)
15.3 × 20.7 cm (6 × 8⅛ in.), cropped within
plate mark
No visible watermark
Ex coll.: Mr. and Mrs. Herman Phleger,
San Francisco
Gift of Mr. and Mrs. Herman Phleger,
1976.1.445
[Fig. 112]

Abraham Entertaining the Angels, 1656
Etching and drypoint, Bartsch 29
16 × 13.2 cm (6⁵⁄₁₆ × 5³⁄₁₆ in.)
No visible watermark
Ex coll.: v. E. (Lugt 2512); A. G. Thiermann,
Berlin (Lugt 2434); Berlin Kupferstichkabinett
duplicate (Lugt 1606); Bruno and Sadie
Adriani, Carmel, California
Bruno and Sadie Adriani Collection, 1959.40.26
[Fig. 42]

Jan Lutma, Goldsmith, 1656
Etching, drypoint, and engraving,
Bartsch 276 ii/iii
19.9 × 15 cm (7¹³⁄₁₆ × 5⅞ in.)
Watermark: foolscap with seven-pointed collar
Ex coll.: Collection d'Arenberg, Bruxelles and
Nord-Kirchen (Westphalie) (Lugt 567); Lucie
Stern, San Francisco
Bequest of Lucie Stern, 1973.8.8
[Fig. 30]

*A Medallion Portrait of Muhammad Adil Shah of
Bijapur*, ca. 1656–1661
Pen and brown ink on Japanese paper
9.7 × 7.6 cm (3¹³⁄₁₆ × 3 in.)
Ex coll.: Jonathan Richardson, Sr., London
(Lugt 2184); his sale, London, Cock's, 18th
night, February 11, 1747 (1746 old style), part
of lot 70, "a book of Indian drawings by Rem-
brandt 25 in number"; Sir Joshua Reynolds,
London (Lugt 2364); anonymous French
collection, sold Drouot, Paris, April 24, 1984,
lot 6, repr.; Mrs. Christian Aall, New York;
Dr. William K. Ehrenfeld, Marin, California
Museum purchase, Dorothy Spreckels
Munn Bequest Fund and Partial Gift of
Dr. William K. Ehrenfeld, 2000.70
[Fig. 41]

Woman Bathing Her Feet at a Brook, 1658
Etching on Japanese paper, Bartsch 200
16.2 × 8.1 cm (6⅜ × 3³⁄₁₆ in.)
Ex coll.: Moore S. Achenbach, San
Francisco, 1958?
Achenbach Foundation for Graphic
Arts, 1963.30.129
[Fig. 40]

CONSTANTIJN DANIEL VAN RENESSE
Dutch, 1626–1680
The Fall of Man, ca. 1650
Pen and brown ink, brown and gray
washes, and opaque watercolor over red
and black chalks
21.2 × 16 cm (8⅜ × 6⁵⁄₁₆ in.)
Ex coll.: C. R. Rudolf; his sale, Sotheby's,
Amsterdam, April 18, 1977, no. 73 (ill., cata-
logued by George Keyes); Colnaghi's, London;
private collection (to 1986); W. M. Brady & Co.,
New York, 1988
Museum purchase, Achenbach Foundation for
Graphic Arts Endowment Fund, 1988.2.27
[Fig. 105]

JUSEPE DE RIBERA
Spanish, active in Italy, 1591–1652
Large Grotesque Head, ca. 1622
Etching with engraving, Brown 11 i/ii
21.6 × 14.3 cm (8½ × 5⅝ in.)
Ex coll.: Thomas Jefferson Coolidge, Jr.,
Boston (Lugt 1429); Lyn and Leonard Baskin,
1964 (not in Lugt); Sotheby, April 26, 1978, no.
132, via David Tunick; Mr. and Mrs. Marcus
Sopher, Berkeley, California
Mr. and Mrs. Marcus Sopher Collection,
2000.212.1
[Fig. 38]

Study of a Man with Upraised Hand (Orator?),
ca. 1625
Pen and brown ink
19.4 × 14 cm (7⅝ × 5½ in.)
Ex coll.: Joseph Green Cogswell, Cambridge,
Massachusetts; Mortimer Leo Schiff, New
York; Moore S. Achenbach, San Francisco
Achenbach Foundation for Graphic
Arts, 1963.24.615
[Fig. 37]

Drunken Silenus, 1628
Etching, Brown 13 i/ii
26.6 × 33.8 cm (10½ × 13⁵⁄₁₆ in.), cropped within
plate mark
Ex coll.: Henri Baron de Triqueti, Paris
(Lugt 1304); cruciform shape (unidentified,
not in Lugt); William H. Schab Gallery, Inc.,
New York Museum purchase, Achenbach
Foundation for Graphic Arts Endowment
Fund, 1965.68.74
[Fig. 101]

ROBERT ROBINSON
English, 1651–1706
After Lambert Sustris (Italian and Dutch,
ca. 1515–1591)
Leda and the Swan, ca. 1685
Published by John Smith
Mezzotint, Ganz 20
22.4 × 28.6 cm (8¹³⁄₁₆ × 11¼ in.), cropped within
plate mark
Ex coll.: Moore S. Achenbach, San Francisco,
May 6, 1953
Achenbach Foundation for Graphic Arts,
1963.30.10224
[Fig. 130]

GEERTRUYDT ROGHMAN
Dutch, 1625–before 1657
Woman Cooking, from a set of five domestic
occupations, ca. 1648–1650
Published by Claes Jansz. Visscher
Engraving, Hollstein 4 i/ii
20.9 × 16.7 cm (8¼ × 6⁹⁄₁₆ in.)
Ex coll.: Perterson (?) or Ploos van Amstel,
Amsterdam (Lugt 2034); Friedrich August II,
King of Saxony (Lugt 971); Hill-Stone, Inc.,
New York
Museum purchase, Prints and Drawings Art
Trust Fund, 2000.146.1
[Fig. 77]

SALVATOR ROSA
Italian, 1615–1673
The Genius of Salvator Rosa, ca. 1662
Etching and drypoint, Wallace 113 iii/iii
45.9 × 27.8 cm (18¹⁄₁₆ × 10¹⁵⁄₁₆ in.)
Ex coll.: William H. Schab Gallery, Inc.,
New York, February 1975, cat. 55, n116; Mr.
and Mrs. Marcus Sopher, Berkeley, California
Mr. and Mrs. Marcus Sopher Collection,
1988.1.273
[Fig. 17]

PETER PAUL RUBENS
Flemish, 1577–1640
Saint Catherine in the Clouds, ca. 1625–1630
Etching, Hollstein 1 iii/iii
29.4 × 19.9 cm (11⁹⁄₁₆ × 7¹³⁄₁₆ in.), cropped within
plate mark
Ex coll.: Cabinet Brentano—Birckenstock,
Vienna and Frankfurt (Lugt 345); David
Tunick, Inc., New York, and R. E. Lewis &
Daughter, Belvedere, California
Museum purchase, Achenbach Foundation for
Graphic Arts Endowment Fund, 1973.9.25
[Fig. 3]

PRINCE RUPERT OF THE RHINE
German, 1619–1682
After Pietro della Vecchia (Italian,
1603–1678)
"The Little Lansquenet" or *Standard-Bearer*,
ca. 1660
Mezzotint, Hollstein 17
18.3 × 16.4 cm (7�³⁄₁₆ × 6⁷⁄₁₆ in.)
Ex coll.: Mr. and Mrs. Marcus Sopher,
Berkeley, California

Mr. and Mrs. Marcus Sopher Collection,
1990.1.398
[Fig. 127]

JAN SADELER I
Flemish, 1550–1600
After Pieter Stevens (Flemish, active in
Bohemia, ca. 1567–after 1624)
*Landscape with a Couple Threatened by Death
and Cupid*, 1599
Engraving, Bartsch 7001.527
21.8 × 27.1 cm (8⁹⁄₁₆ × 10¹¹⁄₁₆ in.), cropped within
plate mark
Ex coll.: Moore S. Achenbach, San Francisco
Achenbach Foundation for Graphic Arts,
A014146
[Fig. 82]

JAN SAENREDAM
Dutch, 1565–1607
After Hendrick Goltzius (Dutch, 1558–1617)
*Allegory of Sight and of the Art of Painting (An Art-
ist and His Model)*, ca. 1598–1601 (published 1616)
Published by Johannes Janssonius
Engraving, Hollstein 106 iii/iii
24.1 × 18 cm (9½ × 7¹⁄₁₆ in.), cropped within
plate mark
Ex coll.: Moore S. Achenbach, San Francisco,
May 6, 1953
Achenbach Foundation for Graphic
Arts, 1963.30.10477
[Fig. 6]

PIETER SCHENCK
Dutch, born in Germany, 1660–ca. 1718
After John Smith (English, 1652–1743) after
Godfrey Kneller (English, born in Germany,
1646–1723)
Pieter van der Plass, ca. 1700–1710
Published by Pieter Schenck
Mezzotint, Hollstein 845 i/ii
24.3 × 18.2 cm (9⁹⁄₁₆ × 7³⁄₁₆ in.)
Ex coll.: Mr. and Mrs. Marcus Sopher,
Berkeley, California
Mr. and Mrs. Marcus Sopher Collection,
2003.159.42
[Fig. 25]

JOHN SMITH
English, 1652–1743
After Godfrey Kneller (English, born in
Germany, 1646–1723)

Grinling Gibbons, ca. 1690
Published by John Smith
Mezzotint, Chaloner Smith 105 i/ii
34.4 × 25.9 cm (13⁹⁄₁₆ × 10³⁄₁₆ in.)
Ex coll.: Mr. and Mrs. Marcus Sopher,
Berkeley, California
Mr. and Mrs. Marcus Sopher Collection,
1990.1.352
[Fig. 24]

After Godfried Schalcken (Dutch, 1643–1706)
Self-Portrait of Godfried Schalcken, ca. 1694
Published by John Smith
Mezzotint, Chaloner Smith 226
34.2 × 25.1 cm (13⁷⁄₁₆ × 9⅞ in.)
Ex coll.: Mr. and Mrs. Marcus Sopher,
Berkeley, California
Mr. and Mrs. Marcus Sopher Collection,
1990.1.381
[Fig. 126]

ANDRIES JACOBSZ. STOCK
Dutch, ca. 1580–after 1648
After Hendrick Hondius the Elder
(Dutch, 1573–1650)
Death with Falconer and Animals, title
page to *Memento Mori* (a series of animal
skeletons), 1626
Published by Hendrick Hondius the Elder
Engraving, Hollstein 4
15.3 × 9.6 cm (6 × 3¾ in.), cropped within
plate mark
A014668
[Fig. 50]

DAVID TENIERS II
Flemish, 1610–1690
Peasant Walking, ca. 1670
Oil on panel
26 × 20.5 cm (10¼ × 8¹⁄₁₆ in.)
Ex coll.: Julius Weitzner, New York, in 1935;
Mrs. Herbert Fleishhacker, San Francisco
Gift of Mrs. Herbert Fleishhacker, 45.33.1
[Fig. 64]

PIETRO TESTA
Italian, ca. 1611–1650
Self-Portrait, ca. 1645
Published by François Collignon
Etching, Cropper 106
22.2 × 16.6 cm (8¾ × 6⁹⁄₁₆ in.), cropped within
plate mark

Ex coll.: R. E. Lewis, Belvedere, California,
January 23, 1974; Mr. and Mrs. Marcus Sopher,
Berkeley, California
Mr. and Mrs. Marcus Sopher Collection,
1986.1.345
[Fig. 11]

WALLERANT VAILLANT
Dutch, 1623–1677
Self-Portrait, 1660–1675
Mezzotint, Hollstein 200 ii/iii
Image: 25.9 × 18.9 cm (10³⁄₁₆ × 7⅜ in.)
Ex coll.: Mr. and Mrs. Marcus Sopher,
Berkeley, California
Mr. and Mrs. Marcus Sopher Collection,
1990.1.433
[Fig. 128]

ANTHONY VAN DYCK
Flemish, 1599–1641
Justus Sustermans, from *The Iconography,*
ca. 1630–1632
Etching, New Hollstein 11 i/v
25.1 × 16.7 cm (9⅞ × 6⁹⁄₁₆ in.)
Ex coll.: Johann Jakob von Franck, Vienna,
April 1818 (Lugt 946); Gustav von Franck,
Vienna (Lugt 1152)
Anonymous gift in honor of Dr. and
Mrs. Charles Del Norte Winning,
1962.62.3
[Fig. 2]

And anonymous engraver (active in
17th century)
Lucas Vorsterman, from *The Iconography,*
ca. 1630–1632
Etching and engraving, New Hollstein 12 iv/vii
24.5 × 16.9 cm (9⅝ × 6⅝ in.)
*Collection of Timothy and Margaret Brown
[Fig. 13]

And Jacobus Neeffs (Flemish, 1610–ca. 1660)
Self-Portrait, title page from *The Iconography,*
ca. 1645
Published by Gillis Hendricx
Etching and engraving, New Hollstein 1 iv/vii
24.7 × 15.9 cm (9¾ × 6¼ in.)
Ex coll.: Harry and Herta Weinstein,
Berkeley, California
Gift of Herta Weinstein, 2011.69.11
[Fig. 22]

ADRIAEN VAN DE VELDE
Dutch, 1636–1672
Cow Resting, from a series of various
animals, 1657
Etching, Hollstein 2 i/ii
10.9 × 13.2 cm (4⁵⁄₁₆ × 5³⁄₁₆ in.), cropped within
plate mark, with false margins
Ex coll.: Joseph-Guillaume-Jean Camberlyn,
The Hague and Brussels (Lugt 514); Moore
S. Achenbach, San Francisco, December 6, 1935
Achenbach Foundation for Graphic Arts,
1963.30.12654.2
[Fig. 81]

JAN VAN DE VELDE II
Dutch, ca. 1593–1641
After Willem Buytewech (Dutch, 1591–1624)
The White Cow, 1622
Etching and engraving, Hollstein 368 i/ii
16.9 × 22.4 cm (6⅝ × 8¹³⁄₁₆ in.), cropped within
plate mark
Ex coll.: Christopher Mendez, London
Museum purchase, Achenbach Foundation for
Graphic Arts Endowment Fund, 2006.64
[Fig. 117]

The Sorceress, 1626
Published by Gillis van Schagen
Etching and engraving, Hollstein 152 iii/iii
21.3 × 28.6 cm (8⅜ × 11¼ in.), cropped within
plate mark
Ex coll.: C. G. Boerner, Dusseldorf
Museum purchase, Achenbach Foundation for
Graphic Arts Endowment Fund, 1964.142.136
[Fig. 118]

AFTER ADRIAEN VAN DE VENNE
Dutch, 1589–1662
Couple Carrying Their Belongings on a Stretcher,
folio 17 (recto) in the section Vrouwe (Wife)
of the book *Hovwelyck* (*Marriage*) by Jacob
Cats (Middelburgh: Jan Pietersz. van de
Venne, 1625)
Engraving, Hollstein 182
13.7 × 13.8 cm (5⁵⁄₁₆ × 5⅜ in.)

Ex coll.: Abigail Rickeseis, 1630; Fleur White,
Lichfield, 1816; unknown monogram (TOA),
1832; Moore S. Achenbach, August 30, 1939
Achenbach Foundation for Graphic Arts,
1963.30.38902.28
[Fig. 76]

CORNELIS VISSCHER
Dutch, ca. 1629–1658
The Large Cat, 1657
Published by Claes Jansz. Visscher
Engraving, Hollstein 42 ii/ii
14.4 × 18.6 cm (5¹¹⁄₁₆ × 7⁵⁄₁₆ in.)
Ex coll.: James I. Rambo, San Francisco
Museum purchase, Achenbach Foundation for
Graphic Arts Endowment Fund, 1967.22.13
[Fig. 79]

CATALOGUES RAISONNÉS CITED

Bartsch, Adam, et al. *The Illustrated Bartsch.*
 New York: Abaris Books, 1978–.
Blum, André. *L'Oeuvre gravé d'Abraham Bosse.*
 Paris: Editions Albert Morancé, 1924.
Brown, Jonathan. *Jusepe de Ribera: Prints and
 Drawings*, exh. cat. Princeton, New Jersey:
 Princeton University, 1973.
Chaloner Smith, John. *British mezzotinto
 portraits, being a descriptive catalogue of these
 engravings from the introduction of the art to
 the early part of the present century.* London:
 Henry Sotheran and Co., 1883–1884.
Cropper, Elizabeth, et al. *Pietro Testa, 1612–1650:
 Prints and Drawings*, exh. cat. Philadelphia:
 Philadelphia Museum of Art, 1988.
Ganz, James A. "Robert Robinson (1651–1706):
 Painter-Stainer and Peintre-Graveur."
 PhD diss., Yale University, 2000.
Godefroy, Louis. *L'Oeuvre gravé de Adriaen van
 Ostade.* Paris: Published by the author, 1930.
Hinterding, Erik. *Rembrandt as an Etcher.*
 Translated by Michael Hoyle. 3 vols. Stud-
 ies in Prints and Printmaking, vol. 6.
 Ouderkerk aan den IJssel, Netherlands:
 Sound and Vision Publishers, 2006.

Hollstein, F.W.H. *The New Hollstein: Dutch and
 Flemish Etchings, Engravings and Woodcuts,
 1450–1700.* Rotterdam: Sound & Vision Inter-
 active; Amsterdam: Rijksprentenkabinet,
 Rijksmuseum, 1993–.
Hollstein, F.W.H., et al. *Dutch and Flemish Etch-
 ings, Engravings and Woodcuts, ca. 1450–1700.*
 Amsterdam: Menno Hertzberger, 1949–.
Hollstein, F.W.H., et al. *German Engravings,
 Etchings, and Woodcuts, ca. 1400–1700.*
 Amsterdam: Menno Hertzberger, 1954–.
Hollstein, F.W.H., et al. *The New Hollstein:
 German Engravings, Etchings, and Woodcuts,
 ca. 1400–1700.* Rotterdam: Sound & Vision
 Interactive, 1996–.
*Inventaire du fonds français. Graveurs du xviie
 siècle.* Paris: Bibliothèque nationale, 1939–.
Lieure, Jules. *Jacques Callot.* Paris: Editions de
 la Gazette des Beaux-Arts, 1924–1927.
Mannocci, Lino. *The Etchings of Claude Lorrain.*
 New Haven: Yale University Press, 1988.
Mazel, Jean A. *Catalogue raisonné de l'oeuvre
 gravé de Jean Morin (env. 1605–1650).* Paris:
 Éditions de la Marquise, 2004.
Roethlisberger, Marcel. *Claude Lorrain: The
 Drawings.* Berkeley: University of California
 Press, 1968.
Roethlisberger, Marcel Georges. *Abraham
 Bloemaert and His Sons: Paintings and Prints.*
 Translated by Diane L. Webb. Aetas aurea,
 no. 11. Doornspijk, Netherlands: Davaco
 Publishers, 1993.
Schulz, Wolfgang. *Lambert Doomer: Sämtliche
 Zeichnungen.* Berlin and New York: Walter
 de Gruyter, 1974.
Vesme, Alexandre de. *Stefano della Bella
 Catalogue Raisonné.* New York: Collectors
 Editions, 1971, 1906.
Walch, Nicole. *Die Radierungen des Jacques
 Bellange: Chronologie und kritischer Katalog.*
 Munich: Robert Wölfe, 1971.
Wallace, Richard W. *The Etchings of Salvator
 Rosa.* Princeton, New Jersey: Princeton
 University Press, 1979.

Index

Page numbers in **bold** refer to illustrations.

Published in 2013 by the Fine Arts Museums
of San Francisco and DelMonico Books,
an imprint of Prestel Publishing, on the
occasion of the exhibition *Rembrandt's Century*.

DE YOUNG MUSEUM
January 26–June 2, 2013

Rembrandt's Century
was produced through the
Publications Department of the
Fine Arts Museums of San Francisco.
Leslie Dutcher, *Acting Director of Publications*
Danica Hodge, *Editor*
Lucy Medrich, *Associate Editor*

Fine Arts Museums of San Francisco
Golden Gate Park
50 Hagiwara Tea Garden Drive
San Francisco, CA 94118-4502

Prestel, a member of Verlagsgruppe
Random House GmbH

Prestel Verlag
Neumarkter Strasse 28
81673 Munich
Germany
Tel: 49 89 4136 0
Fax: 49 89 4136 2335
www.prestel.de

Prestel Publishing Ltd.
4 Bloomsbury Place
London WC1A 2QA
United Kingdom
Tel: 44 20 7323 5004
Fax: 44 20 7636 8004

Prestel Publishing
900 Broadway, Suite 603
New York, NY 10003
Tel: 212 995 2720
Fax: 212 995 2733
E-mail: sales@prestel-usa.com
www.prestel.com

Wilsted & Taylor Publishing Services
 Project management: Christine Taylor
 Art management: Jennifer Uhlich
 Production assistance: LeRoy Wilsted
 Copy editing: Melody Lacina
 Design and composition: Yvonne Tsang
 Proofreading: Nancy Evans
 Indexing: Andrew Joron

Printed in China by C&C Offset Printing
Separator: GHP Media

Rembrandt's Century is published with the assistance of the
Andrew W. Mellon Foundation Endowment for Publications.

Unless otherwise noted, all artworks reproduced in this catalogue
are from the collection of the Fine Arts Museums of San Francisco.

Unless otherwise indicated below, all photography is by Joseph McDonald,
courtesy of the Fine Arts Museums of San Francisco. Fig. 45: courtesy of
the owner; fig. 113: photo by Jorge Bachmann, courtesy of the Fine Arts
Museums of San Francisco.

LIBRARY OF CONGRESS CATALOGING-IN-PUBLICATION DATA
Ganz, James A.
 Rembrandt's century / James A. Ganz.
 pages cm
 Issued in connection with an exhibition held at the de Young Museum,
January 26–June 2, 2013.
 Includes bibliographical references and index.
 ISBN 978-3-7913-5224-4 (alk. paper)
 1. Art, European—17th century—Exhibitions. 2. Rembrandt Harmenszoon
van Rijn, 1606–1669—Exhibitions. I. M. H. de Young Memorial Museum.
II. Title.
 N6756.G36 2013
 740.9'03207479461—dc23

FRONTISPIECE: Lambert Doomer, *Salt Flats at Le Croisic*,
ca. 1671–1673, detail of fig. 88.

PAGE IV: Rembrandt van Rijn, *Saint Jerome Reading
in an Italian Landscape*, ca. 1653, detail of fig. 109.